WHO OWNS HISTORY?

GEOFFREY ROBERTSON

WHO OWNS HISTORY?

ELGIN'S LOOT AND THE CASE FOR RETURNING PLUNDERED TREASURE

Biteback Publishing

First published in Great Britain in 2019 by
Biteback Publishing Ltd
Westminster Tower
3 Albert Embankment
London SE1 7SP
Copyright © Geoffrey Robertson 2019

ISBN 978-1-78590-521-6

10 9 8 7 6 5 4 3 2 1

A CIP catalogue record for this book is available from the British Library.

Set in Adobe Garamond Pro

Printed and bound in Great Britain by
CPI Group (UK) Ltd, Croydon CR0 4YY

MIX
Paper from
responsible sources
FSC
www.fsc.org
FSC® C020471

CONTENTS

PREFACE

You Verres will plead that your statues and pictures have adorned the city and the forum of the people of Rome ... a decoration splendid to the eye, but painful and melancholy to the heart and mind: I looked at the brilliant show that was made by your thefts, by the robbing of our provinces, by the spoliation of our friends and allies ... a large number of persons from Asia and Greece, who happened at the time to be serving on deputations, beheld in our forum the revered image of their gods that had been carried away from their own sanctuaries and recognising as well the other statues and works of art, some here, some there – would stand gazing at them with weeping eyes ... objects wrenched from our allies by criminals and robbers.

CICERO, INDICTING VERRES[1]

As long ago as 70 BC the case against the looters of artworks was put by the great Roman barrister in his prosecution of Gaius Verres, whose plunder of Sicily while he served as Roman governor in peacetime bears some similarity to more modern spoliations: of India by the East India Company; of Greece by Lord Elgin; of China by his son; and of African kingdoms by the armies of Britain, France, Belgium, Germany and Portugal. Cicero was not merely a great advocate,

but a legal philosopher who worked into his arguments (more usually, for the defence) a broader view of what justice requires. Verres had used his three-year term as governor of the Greek province of Sicily to seize public as well as private artworks on a massive scale (he said he needed to do this for one year to make his own fortune, for a second year to reward his cronies, and for a third to bribe his jury). He had decorated his own home with his thefts, and some had gone on display in the Forum – the Roman Empire's open-air equivalent of the British Museum. This could be no justification, Cicero explained, for robbing a people of their heritage, their temple sculptures, their public monuments, their tapestries, their furniture, even their domestic dinner services. Justice required punishment. After listening to Cicero's opening speech, Verres fled Rome and could never return from banishment: his estate was ordered to pay compensation to his victims for his thefts.

Cicero's speech, and others that he would have delivered had the trial continued, were published and have echoed down the ages.[2] They introduce the idea that great art is not just property, but has a special quality – that of heritage – because of its continuing significance to the people from whom it has been wrested, and a cultural value because of its religious or political context or connotation, or through the historical memories it evokes. He did not challenge the Roman army practices (he did not have to) of dividing up 'booty' and carrying it (together with human booty) in triumphs, but he did emphasise, through precedents created by the great military leaders, that gathering war spoils had limits – temples and private homes must not be plundered, and any artworks confiscated as a result of war must be fully accounted for and donated to the public rather than kept or given to friends. As for peacetime occupation of territories won by conquest or by consent, Cicero

articulated the principle that representatives of an occupying power had no right to take, or to purchase at an undervalue, cultural items of significance to the people of those territories. It was pointless for Verres to contend that his acquisitions had been gifts or willingly sold at a low price – no individual citizen and no city would willingly part with such cherished mementoes. For Cicero, art had an importance as heritage which could only be fully appreciated in its true and original context: well might the Sicilian deputies weep and demand justice when they saw their statues on display in a foreign museum. He represented them in court, and they had their retribution when Verres fled from hearing his words.

* * *

This is a book about culture – the word that made Hermann Göring reach for his gun and Chairman Mao misdescribe a revolution which almost destroyed it. It is about how people can lose or misunderstand the heritage of their own country when it is kept under lock and key in foreign museums. Their experience of seeing it abroad is akin to that of the Sicilian deputies described by Cicero, who would 'stand gazing with weeping eyes', full of shame at the loss of their gods, their civic spirit, their public pride, and their human right to enjoy their heritage. Yet remedy for loss is unavailable today: mighty 'encyclopaedic' museums like the Met and the British Museum and the V&A and the Louvre and the Getty and soon the Humboldt Forum lock up the precious legacy of other lands, taken from their people by wars of aggression, theft and duplicity, and there is no forum to which they can turn to get them back, at least if they were wrongfully obtained before 1970, the date of

UNESCO's first and only convention on the subject. This means the most valuable treasures of antiquity are withheld from the people whose ancestors created them and which could inspire their youth anew with the story they tell and the knowledge that their progenitors could once create such beauty.

Personally, I love museums and visit, as a tourist, whenever I can to get that 'gee whiz' experience – that 'Wow, they did that 3,000 years ago!' kind of feeling – on looking at an object that actually witnessed history in the making, or contributed to it: Tolstoy's typewriter, Churchill's half-smoked cigar, the blood-flecked stretcher that carried the body of Che Guevara or the rock on which Jesus Christ rested his head (or was said to – a qualification one must always make about relics in Jerusalem). I was much struck, on a recent trip to Cuba's National Museum, to see the *Granma*, that small fishing boat bought by Fidel Castro from a Texan dentist, which took his gang of eighty desperados on their historic voyage from Mexico to Cuba, to defeat the might of the American-backed military, and to face down America itself. The boat is well guarded in the museum and evocative – you can imagine Fidel and Che arguing in the captain's tower – but only when you get round to reading your Lonely Planet guidebook do you realise you have been fantasising over a replica – the real boat disappeared long ago. Does that make the experience you had at the time less valid? Were the British Museum to return its sacred *moai* to Easter Island, taken by its navy without permission, and replace the statue with an exact replica (one has been offered in exchange by the Rapa Nui people), it would still provide the museum's favourite selfie spot. It would exemplify Rapa Nui sculptorship without wrenching away the spirit of the heroic ancestor on whom it was modelled.

The real thing has a special meaning for those from whom it has been stolen, which cannot be shared by tourists who pass it in a Western museum. It is the difference, I suppose, between hearing a famous rock group and a rather good tribute band – in the latter case, something is missing: the awe that comes from authenticity. To which is added a further emotion, a sense of national pride, or at least of justice, if the heritage object has come 'home', not merely on loan (which Western museums sometimes offer to excuse their thefts) but as possessions of the people from whom they once were taken. Offering stolen heritage back on loan – for however long – is a post-colonial insult.

Love of country can produce dreadful and deadly consequences, which have nothing to do with the rights of people to possess and enjoy their own heritage. 'I'm a nationalist, OK?' says President Trump as he exhorts his base. 'Use that word!' They do, but in a way which conduces to populism, that far-right feeling that has produced Trump and Brexit and Modi and Orbán and Bolsonaro, and has left white, English-speaking 'progressives' having to choose, if they want to live under a good government, between Canada and New Zealand. There is nothing wrong in allowing people of every modern state some pride in it, and in its place in the world, by seeing their own history through the heritage objects that have been witness to it. It is important to distinguish between history and heritage: the former is the story of the past told as accurately as present information allows (future discoveries may amend it), while the latter symbolises and enlivens the past but is purposely a celebration (sometimes, a mourning) of it, 'a profession of faith in a past tailored to present-day purposes'.[3] Insofar as those purposes are genuine and not propagandistic, restitution of stolen legacy objects matters: they have a meaning that a replica could not – well, replicate.

For a museum visitor in another country, it does not matter – or matter so much – whether the object is an original or an exact copy – the feeling it evokes is much the same – appreciation, without the sense of possession and pride. That is what Cicero tried to explain to a Roman jury that liked its triumphs and its Forum exhibition of the spoils of its empire: theirs are fleeting and evanescent feelings, compared to those of the people who must grieve for their loss and demand justice for the crime of their despoliation. As a tribute to this greatest of barristers, we should devise a law that would be the logical conclusion of his argument: a law providing for the repatriation of wrongfully taken cultural property.

Much as I would like to describe myself, like Diogenes, as 'a citizen of the world', I was born and bred in Australia, where I was told by teachers that the country had no culture other than sport, no history worth teaching and no heritage other than ANZAC Day, a celebration of the death and defeat of its youth at Gallipoli (not far from Troy). So I studied British imperial history, which was thought to be a wonderful thing because it spread civilisation and Christianity and the rule of law to lots of places that were coloured red on the school atlas and were called 'the British Commonwealth'. In order not to spoil the imperial story, we were not told about the brutality of the British army, with its 'punishment raids' which destroyed the people of Benin and Maqdala and burned down the Old Summer Palace in Beijing, or about the Opium Wars, a wicked conspiracy with the East India Company to supply heroin to addict millions of Chinese in order to redress a trade imbalance caused by the British demand for tea.

This is not a history book (which I can prove by confessing to having checked some of its facts on Wikipedia), but reading the accounts

of colonial barbarities (not just by the British) has drawn me to the view of the art historian Bénédicte Savoy when she resigned from the board of Germany's new 'universalist' museum, the Humboldt Forum, that these institutions that exhibit the stolen spoils of their empires are truly 'museums of blood'. There can be no humanist message told by exhibits plundered from those who wove them or waved them or wielded them, as puny defences against armies with far superior weapons committing the war crimes of aggression and pillage and plunder. Politicians may make more or less sincere apologies for the crimes of their former empires, but the only way now available to redress them is to return the spoils of the rape of Egypt and China and the destruction of African and Asian and South American societies. We cannot right historical wrongs – but we can no longer, without shame, profit from them. The big Western museums, which have no shame, in 2002 drafted a declaration which resisted any repatriation on the grounds that they should still take their morality from that which prevailed at the time of the heist. But you have only to read the British parliamentary debates in 1816 to see how Lord Elgin was blasted for his immorality and impropriety in taking the Marbles from the Parthenon (Parliament bought them, but at a price that denied him any profit) and to read William Gladstone's speech in the House of Commons evincing shame at the looting of cultural heritage in Maqdala to realise that the British army, the East India Company and Elgin could have chosen to act honourably. It is because they chose to act otherwise that history condemns them and justice demands the handback of their spoils.

* * *

The first inkling that I might harbour any concerns for the heritage of my own native land came when I was invited to give a lecture to commemorate its 'Bicentennial', marking 200 years since the settlement of convicts at an open prison called Sydney. The experiment survived mainly thanks to the genius of its founding father, Captain Arthur Phillip, whose seamanship took a floating prison 12,000 miles across oceans in 1788 and whose leadership capabilities, egalitarianism and compassionate treatment of the indigenous people set a standard rarely found in his successors. On his retirement he returned to England with two young Aboriginals to whom he had reached out: Bennelong and Yemmerrawanne. The former had the good sense to return as soon as possible, but the latter stayed – the first Australian expatriate – to die of pneumonia in south London. Phillip paid for his medical treatment and, from guilt, bought an expensive tombstone which still stands in the church at Eltham. It struck me, as there was much talk at the time of reconciliation with Australia's indigenous people, that it might be a good idea to bring the bodies of Phillip and Yemmerrawanne back to Sydney, give them a state funeral with their coffins draped respectively in the Australian and Aboriginal flags, and re-bury them in Sydney's botanical gardens overlooking the harbour. The idea caught the imagination of the New South Wales premier, and he appointed me as his secret agent to try to effect it.

All went well at first. The British had not cared a hoot for Phillip's great achievement, and had denied him burial in Westminster Abbey or even the abbey in Bath (the place of his retirement): his body lay in a crummy church in the village of Bathampton, where a sign on a ledger stone informs Australian tourists that his resting place is beneath it. The Bishop of Bath and Wells could not have been more helpful

– the Church of England consistory court had recently declared that heroes of foreign countries could be exhumed and taken back to the nation that most appreciated them, and he appointed a church expert to report on the logistics of removing Phillip's coffin. Meanwhile I had located Yemmerrawanne's grave, with its fine tombstone, in the church-yard in south London and the local bishop was excited at the project and the prospect of officiating at a funeral in Sydney. Alas! He called me despondently a couple of weeks later to report that Yemmerrawanne was not beneath his tombstone: the church had needed more space for its wealthy parishioners and his bones had been thrown out. ('We do have lots more bones?' he added helpfully, but with the advent of DNA testing this was a hint I dared not take.) At least I could bring back Phillip, but when the expert report came through, its bombshell conclusion was 'the statement on the ledger stone is untrue' – his coffin could not be found. The Church of England had lost the plot – in fact, had lost two plots – and my mission to bring back the bodies had failed abjectly.

I returned to the Eltham churchyard with a television crew some years later to tell the story of Yemmerrawanne, and we watched as the splendid tombstone – a piece of Australian heritage – was used for urination practice by local drunks, just opposite the bus stop where Stephen Lawrence was murdered in Britain's most notorious racist killing. Although the comparison is inexact, I felt something of the sadness in my stomach of the Sicilian diplomats at the Roman Forum, and of those tourists from Africa and China who came across their looted heritage in European museums. I actually tried to buy the tombstone and take it back to display at Sydney University, but the Church declined my offer. It even refused a request from the Australian

High Commission to place it inside the church, to bring it in from the urine.

The next request to save human remains for my nation had more success. The call, from an Aboriginal activist friend, Michael Mansell, came on a Thursday night: could I stop the Natural History Museum from performing genetic experiments, planned for the following Monday, on the skulls and bones of his ancestors who were Tasmanian Aboriginals? Almost the whole tribe, 8,000 of them, had been wiped out by British soldiers and settlers in the 'black wars' of the 1830s: he and his colleagues at the Tasmanian Aboriginal Centre owed their existence to the fact that just fifty women had survived and had been exiled to an offshore island where they procreated with seal fishermen and kept the race, thus diluted, still going. It was a hard call – there were no directly relevant laws or precedents, but on the Sunday a High Court judge was persuaded to grant a temporary injunction. On Monday morning, lawyers for the museum stormed confidently into court: the remains – bodies stolen from graves, and skulls sold to adorn Victorian mantelpieces – were in the possession of the museum, which was therefore entitled to do what it termed 'destructive testing'. It had not bothered to get the permission from the Aboriginal community, which envisaged souls of their departed in torment unless and until laid to rest with customary ceremony in traditional lands. In any event, declaimed counsel for the museum, 'we are just going to cut the bones about a bit'. 'What they are going to do', I replied, 'is to experiment with the bodies of victims of genocide.'

That way of describing the exercise did not look good in the next day's papers, neither to the museum's donors, nor to the judge, who extended the injunction and expressed the wish that a solution might be found

through mediation. That did not at first attract the museum, whose scientists held the view (as did Dr Mengele) that the pursuit of knowledge is an overriding good in itself. This, I argued, was not necessarily the case when experiments were made to measure racial characteristics and were to be carried out on the remains of human beings killed in the course of a crime against humanity and which had been unlawfully, or at least immorally, imported and acquired by the museum. By that time the UN Declaration on the Rights of Indigenous Peoples (2007) entitled such peoples to 'the right of repatriation of human remains' and to the restitution of spiritual property 'taken without their free and informed consent or in violation of their laws, traditions and customs'. It was a declaration, not a convention, so it was not binding, but it was a new human rights principle confronting museums that had for centuries stored the donated skulls and bones of conquered native tribes, occasionally exhibited to suggest racially pejorative features of 'primitive' people with small brains, heavy brows and flat heads. The museum claimed that it was engaging in 'genetic prospecting' of racial characteristics to determine 'human diversity', but our expert evidence decoded this as a means of putting Tasmanian Aboriginals on the lower rung of the museum's 'evolutionary ladder of diverse humanity', a project of no abiding value except to those who wished to denigrate a people that Claude Lévi-Strauss described as 'so far ahead of the rest of mankind' in organising harmonious family life and community relations. I asked to see the remains in question and was shown to a dusty storeroom in the museum where the skulls and bones were stored in shoeboxes, jumbled and distinguished only by numerals. How could this comport with the right to dignity implicit in human rights and race relations laws?

These laws, and (I suspect) the nervousness of their donors at

prospecting on genocide victims, made the museum amenable to mediation, which was duly held by the former chief justices of England and New South Wales. The young Aboriginals who attended were passionate but principled in their quest for their ancestors. It is to the credit of the museum scientists, too, that they sincerely changed their position and accepted not only that the remains must return for ceremonial burial in Tasmania, but so should the DNA already extracted from them, which should not have been taken without the consent of their representatives. The museum had made a rationalist case for the acquisition of scientific knowledge, but had to recognise that human dignity required that indigenous people have a right to rebury their dead, robbed from graves and exhibited for curiosity. The case served as a precedent: soon the ethics standards of most European museums required the return of human remains and funerary or sacred objects to countries or groups that could legitimately claim them: Germany, for example, has returned to Australia all its Aboriginal remains and to Namibia all the skeletons of Herero people that were collected during its 1905 genocide. The US has laws that require return of Indian remains to their current indigenous representatives. It can now be said that international law requires this class of a nation's heritage to be uplifted from the shoeboxes in museum storage and returned home for decent burial.

It was this result in the case against the Natural History Museum that brought the government of Greece, in the person of Demetri Dollis, its Deputy Minister for Foreign Affairs, to my Doughty Street Chambers door in 2011: might international human rights law help to retrieve the Parthenon Marbles?

Together with Professor Norman Palmer, an expert on cultural property, and Amal Alamuddin, a brilliant young barrister who had just

joined us, we opined that an international rule had by now emerged requiring restitution of cultural treasures of great national significance which had been removed illegally – either by looting or theft, or else by permission of an occupying power that had no right to give such permission. It could be argued that a country's right to possess 'the keys to its history' (a phrase that recurs in landmark judgments on cultural repatriation, as we shall see in Chapter Six) was an attribute of its national sovereignty, and that human rights law protecting dignity and privacy rights (including a right to cultural identity) would entitle the people of Greece to have their heritage returned. In those pre-Macron days, I pointed out that these rules 'would require the return of the Parthenon frieze and objects of similar cultural status, but would not result in the emptying of Western museums that have lawfully acquired material having some, albeit not unique, cultural significance'. I was gripped by that innate British dread of emptying the British Museum.

Our opinion found favour with Greek Prime Minister George Papandreou, who even set aside a budget for legal action, although his government fell shortly after and the project stalled. It was picked up by David Hill, head of the International Association for the Restitution of the Parthenon Marbles, who contacted a later Prime Minister, Antonis Samaras. He invited us to Athens to inspect the New Acropolis Museum and to advise his government on how to retrieve the Marbles. Our visit was much publicised and quite emotional – I found myself protecting Amal from all the old ladies who wanted to hug her. We inspected the new museum, with its dismembered gods and goddesses waiting to be reunited with the rest of their marbled bodies, severed by Elgin's workmen. I studied the evidence carefully, and it became clear that their removal was contrary to Elgin's licence (which allowed him to take

only 'stones' he found lying on the ground). He had lied to Parliament when he said he had saved them from the Turks whom he had observed stealing them – he did not arrive in Athens to observe anything until the demolition he had ordered, with several hundred workmen ripping them off the walls, was well underway. We came away from Athens convinced of the case for reuniting the Marbles, especially after seeing them in the British Museum on a secret visit – although by then it was difficult to do anything secret with Amal as she is always recognised and asked for selfies. We held a private meeting with museum director Neil MacGregor to discuss a way forward, but all paths were blocked by his passionate insistence that the Marbles should stay for ever in the museum's possession.

We met Samaras on several occasions. He was a leader who could talk about legal action to get back the Marbles while calling the IMF to cadge loans to prevent his country sinking into bankruptcy. After 150 years of diplomatic requests, only legal action could shake the British, and he found a philanthropic ship owner who would fund us to prepare a full legal case, to be taken up by Greek lawyers, and a shorter paper that I would write for publication. It was a considerable undertaking: I researched the history of the Parthenon, the legality of Elgin's actions and the status of the Marbles in the British Museum; Amal studied the full history of the Greek demands for restitution and the remarkable time when the Foreign Office actually accepted them, while Norman delved into the lawbooks of many countries to come up with precedents. In the end our opinion came to about 600 pages, with my popular pamphlet 140 pages long. Our work was not ready until June 2015, and in January there had been a change in government. An obscure journalist became culture minister and, doubtless wishing to

see his name for the first time in the world's newspapers, announced in March that he had rejected our report and would rely instead on diplomacy. This did indeed receive world attention – Amal Clooney's advice rejected! – but was surprising because our report had not yet been finished. The Ministry of Culture, ashamed by the presumption of its new minister, apologised to us, but when our report was delivered a couple of months later, we received no thanks from anyone. My pamphlet was never published, although a version was leaked to *The Guardian* and may still be up on some obscure website. I lost interest – the gumptionless Greeks of the Tsipras government would never get back their ancient gods.

I had second thoughts during the prolonged Brexit negotiations. There are clauses in EU treaties boasting of European culture and requiring its officials to take European culture into account in all negotiations. Since the apex of Euroculture was the Parthenon, I argued that the Marbles should be put onto the negotiating table. It would be a win–win situation if, by surrendering them to Greece, Britain could be granted a discount in the £39 billion cost of departure. My article, in *The Guardian*, trended astonishingly and caused questions to be asked in the Greek Parliament, but was ignored by the European negotiators: Jean-Claude Junker and his bureaucrats had no interest in culture at all. As for the British (I am a dual citizen), we are too proud of our plunder to part with it.

But while British politics remained constipated by Brexit, in 2017 there came a revolutionary announcement by President Macron that he would return to African states all treasures plundered by French troops – or even by British troops if the stolen goods had made their way into French museums after colonial wars. He set up an inquiry,

under the Senegalese economist Felwine Sarr and French art historian
Bénédicte Savoy, and endorsed their report in 2018. It concluded that
sub-Saharan states had the right to reclaim their cultural legacy, 90
per cent of which is in Europe, for the benefit of their people and the
practical benefit of their children (60 per cent of the population of
Africa being under twenty). 'African cultural heritage can no longer
remain a prisoner of European museums,' Macron declared, throwing
down a gauntlet to museums full of it in Belgium, Germany and Great
Britain. Jeremy Corbyn then said that when he became Prime Minister,
he would consider returning the Elgin Marbles as well. But the present
UK government has made clear it will not allow a single marble to
return to Greece, nor shall any loot taken in war crimes in colonial
conflict be repatriated. In my view, both should go back, on the prin-
ciple discerned by Cicero and now emerging from the law of human
rights – that peoples of the world have a right to enjoy their heritage
and hence a right to have it returned if it has been wrongfully removed.

That principle is easy to express, but difficult to state, as it has to be,
in a convention that will be necessary if it is to become a workable part
of international law. I have tried in the final chapter to devise one, with
some of the ifs and buts, the provisos and exceptions, that must be writ-
ten into such a document. This is not, however, a textbook, and I have
tried to deal with the law simply, but without becoming simplistic.
Locking up other people's heritage is unconscionable, but in some cases
it is excusable and I have spelled out the excuses that might weigh in
the balance against repatriation. In Chapter Seven, I consider the case
for repatriation of other legacy objects, beside the Parthenon Marbles,
to Egypt, Australia, India, Turkey, China, Chile and various nations
in Africa. These are well-known examples, and I could have dealt with

many other countries with good or better claims – Mexico, Ecuador, Peru, Iraq, New Zealand, Guatemala, Tahiti, Indonesia, Papua New Guinea, to name a few, not to mention all the Asian nations looted by the Japanese army during the Second World War. But this would require a much longer book, and the principles that should decide such cases may be satisfactorily extrapolated from those I have analysed.

Every country has a law which punishes theft, and usually a civil law that entitles restoration or at least compensation to those cheated or inequitably deprived of valuable property. In English law, a thief, and any receiver of stolen property, is regarded as a constructive trustee for its return, no matter how long it has been held or how much it has been enhanced in value. The demand for repatriation of heritage is, as Cicero proclaimed in his prosecution of Verres, a cry for justice, which is why the offer of a touring exhibition or a loan (long-term or not) simply will not do. Trustees of Western museums hold wrongfully taken property in trust for the people from whom they have been taken, and have a duty – moral, and (as this book argues) legal – to return possession to those entitled to it. They might then pay to rent items they wish to exhibit, but possession must belong to the state from which they have been plundered. There will be some exceptions, and I have attempted to define them, but museums (and, I might add, private collectors) have a duty to apply them conscientiously. The Museums Association has a vague 'Code of Ethics', but its only rule (Article 2(7)) is that its members must 'deal sensitively and promptly with requests for repatriation both within the UK and from abroad'. It gives no guidance whatsoever about how to 'deal sensitively', no rules or codes of practice (a polite and immediate refusal would comply with its rule). This book will provide guidance as to how such requests should be resolved.

I live opposite the British Museum and watch from my window the winding queue of tourists awaiting their bag search: the line has been swelled recently by eager faces on the unofficial 'British Museum Stolen Goods Tour', which stops at the 'Elgin' Marbles, Hoa Hakananai'a, the Gweagal Shield, the Benin Bronzes and other pilfered cultural property. That these rebel itineraries are allowed is a tribute to the tolerance of this great institution, which would be even greater if it washed its hands of the blood and returned Elgin's loot.

Geoffrey Robertson AO QC
Doughty Street Chambers
September 2019

CHAPTER ONE

WHOSE HISTORY IS IT?

I want to know how much blood is dripping from each artwork.
Without this research, no Humboldt Forum and no ethnological
museum should open.

BÉNÉDICTE SAVOY, RESIGNING FROM HUMBOLDT
FORUM ADVISORY BOARD, JULY 2017

BACKGROUND

The great contemporary question in the world of art and culture touches upon ethics and politics and, inevitably, law. It concerns the return of 'treasure' taken without consent in earlier times by conquerors or colonial masters or by deception, from subjugated peoples who now regard these antiquities as a key to their history or a vital part of their heritage and want them returned – usually from museums or private collectors in Europe or the US. Controversy has perennially raged over the marble gods of the Parthenon, whose return from the British Museum was first requested by Greece in 1833, just after it obtained independence, and has been unavailingly demanded ever since. President Macron galvanised the debate in 2017 by declaring that 'African cultural heritage can no longer remain a prisoner of European museums' and then endorsed a report that recommended the return of

most ethnographic items in French collections which had been taken 'immorally' in colonial times – by theft, looting ('spoils of war') or trickery, or under duress. Even lawful 'taking' is not exempt from the moral imperative to return: King Harald of Norway, on a state visit to Chile in 2019, brought back cultural artefacts (stone statues, axes, human remains) removed from the Rapa Nui people of Easter Island by Thor Heyerdahl on his famous Kon-Tiki expedition.[4] He was accompanied by Heyerdahl's son, who said, 'Dad never intended these items to be permanently removed,' although they had been displayed in an Oslo museum for the past sixty years. At much the same time, a university museum in Sydney announced that it was returning to Egypt a stolen funeral artefact dating from 280 BC, with significant hieroglyphics. It pointed out that there was no legal or ethical requirement to do so – no museum yet has a policy of automatic return of illicit or unprovenanced antiquities acquired before 1970 (the date of the UNESCO Convention) – but it hoped to be the first.[5] The ancient piece would be replaced by a replica – a gesture that many wish the British Museum would follow in the case of its own statue of the Easter Island god Hoa Hakananai'a, removed by the British navy as a gift for Queen Victoria.

What has produced this sea-change in the 'finders' keepers' mentality, which has in centuries past allowed the heist of valuable antiquities by dilettantes like Elgin and brutal soldiers like his son, and then by massively wealthy collectors and museums, taken from poor or colonised countries that have now achieved independence?

The only 'right' to protection of cultural heritage is found in the law of war, which prevents churches and museums from being targeted: when they are, should not the treasures pillaged during hostilities be

returned? Ironically, in 1815, just a year before the British Parliament appropriated the 'Elgin Marbles', the Foreign Secretary was insisting, after Waterloo, that Napoleon's loot should be returned to Italy and other European countries from which it had been stolen to adorn the Louvre. This was propounded by the British as a principle of justice: the aggressor (in practice, the losing side) should not profit from its aggression. Towards the end of the Second World War there was Allied agreement on reclaiming cultural property seized by the Nazis, and 'monuments men' set off to recover their loot, although one ally – Joseph Stalin – insisted on keeping as 'spoils of war' every German treasure his Trophy Brigades could lay their hands on (and, in Stalin's view, 'spoils of war' included the right to rape women). In 1954, a Hague Convention re-formulated the centuries-old rule of battle to the effect that cultural property should not be attacked or expropriated by warring parties, bound by the law against pillage (a rule overlooked by US soldiers in Baghdad in 2003, who turned their backs while its National Museum was vandalised).

These rules are not enforceable – Russia still refuses to repatriate art treasures seized at the end of the war from German museums and civilians ('Priam's Treasure', for example, it keeps in Moscow); Pakistan ignores requests to return Bengali artefacts confiscated during the genocide its generals committed in 1970 that led to the birth of Bangladesh; and Turkey refuses to return sacred items to the Armenians expropriated during the genocide in 1915. The International Criminal Court in 2015 did jail a jihadist for blowing up ancient Sufi shrines in Timbuktu – a war crime routinely committed when religious fanaticism is in play (for example the dynamiting of Buddhas in Bamiyan and temples in Palmyra) but for which retribution is rare. In any event, the rules of

war do not cover antiquities looted from graves and temples in times of peace.

In the latter part of the twentieth century, archaeologists and their supporters in UNESCO became concerned that sites in developing countries were being robbed and valuable artefacts stolen for trafficking to art dealers and museums in the West – their money an irresistible inducement to grave robbers and corrupt local authorities. In 1970, UNESCO promulgated a convention which now has 140 states as parties, requiring the return of antiquities which were 'stolen' or exported in breach of local law, but only since that year or even later, after the countries concerned have ratified the convention. This left important antiquities obtained before 1970, like the Marbles (1801) and the Benin Bronzes (1897) and numerous valuable artworks, at the mercy of the ethics (if they had any) of museums and galleries in responding to requests for repatriation. Another convention (UNIDROIT) in 1995 set out 'minimum legal rules' for states to seek through court proceedings the return of cultural objects extracted or exported in breach of their national laws. This convention applies only in the case of theft or wrongful export and has in any event been ratified only by forty-six countries.

The 1970 UNESCO Convention defines 'cultural property' as that property specifically designated by states as 'being of importance' to its archaeology, history, literature, art or science: it deserves protection because, so the preamble says (somewhat optimistically), it 'increases the knowledge of the civilisation of man, enriches the cultural life of all peoples and inspires mutual respect and appreciation among nations'. No item of cultural property can begin to achieve these goals unless set in a context which explains its origins and traditions, which is why the

convention enjoins states to protect their own heritage items against theft and clandestine exportation. The convention was directed at governments, which it urged 'to become increasingly alive to the moral obligations to respect [their] own cultural heritage[s] and that of all nations'. The UNIDROIT Convention sets out some procedures for a robbed state to use the court systems of other states to seek orders for return. Both conventions aim to stop, or at least deter by prosecution, those who currently trade in stolen antiquities, including the museums and agents who have bought and sold unprovenanced (transferred without evidence as to origins or previous owners) antiquities obtained dishonestly (by theft from graves or museums) or by illicit diggings.

Although there is a general 'mind how you go' message for museums and dealers in these two conventions, the 1970 UNESCO Convention lacks enforcement provisions while UNIDROIT lacks members. Crucially, they are not retrospective: they do not cover antiquities acquired prior to 1970. Their purpose is plain enough: to promote the principle that unprovenanced and illegal artefacts should not be trafficked and that those which are should be restored to countries that can claim them as part of their cultural heritage – a principle that could, were another convention designed for this purpose, be applied to antiquities discovered or taken before the arbitrary year of 1970, particularly if they still had cultural resonance for the people of their country of origin.

UNESCO and UNIDROIT were responses, by an international community now swelling with newly decolonised states suddenly alive to their previous history, to a worldwide scandal: the looting of archaeological sites driven by a commercial demand for antiquities to be sold on for profit by dealers in the West. As the archaeologists' battle cry put it, 'collectors are the real looters'. For all their pretence of civilised

sophistication, American billionaires and their tax-deductible museum donations began to be viewed with the same distaste as wealthy American hunters of big game: collectors of expensive thrills, for status and profit. When, in the 1980s, US tax law was briefly changed to reduce the deductions for charitable donations, gifts to museums dropped by 30 per cent[6] – evidence of the commercial interests behind the mask of philanthropy.

The moral force of the restitution principle was enhanced in this period by declarations and case law requiring restitution of art treasures expropriated by the Nazis but which later came into the unwitting (or so they said) possession of private collectors and museums. Horror at the Holocaust infused the 1998 Washington Conference on Holocaust Era Art, which urged museums and collectors to check the details of items acquired between 1933 and 1945 for signs of Nazi taint and to purge their collections by restoring these pictures to the families of their original Jewish owners, even if this might mean removing an old master from public display. Restitution is fundamentally a demand for justice, which means that victims of crime must be accorded retribution. This can be inconvenient: the Belvedere in Vienna held out for many years against the family from whom Gustav Klimt's masterpiece *Portrait of Adele Block-Bauer* had been extorted by the Nazis. It was the epitome of a glittering, intellectual Viennese society that flourished early in the twentieth century, thanks to a number of wealthy Jewish patrons – not to mention Sigmund Freud, Gustav Mahler and Felix Salten (author of *Bambi* – later burned by the Gestapo) – a society exterminated after the Anschloss, its remnants forced to flee abroad or put to death in concentration camps. Adele had been a daughter of wealthy industrialists, her portrait by Klimt a gift for her parents: should it be displayed for ever

in a gallery which had loyally served the Nazi cultural programme, with a specially built basement to store looted artworks until they could be transferred to the projected 'Führermuseum' in Hitler's home town of Linz? A gallery, moreover, which had given the painting a deracinated name, *The Lady in Gold*, to hide the fact that Adele was Jewish, and, even after the war ended, had pretended that it came to them by a legitimate bequest rather than by Nazi confiscation and an accompanying letter which began, 'Heil Hitler'? On the other hand, if it went back to the family, it could be sold to a wealthy private collector and be seen no more by the public.

The case became iconic when family survivors in America sued Austria, and the US Supreme Court agreed that the action should go ahead.* Austria was forced to arbitrate, and lost. Although the heirs in America were free to sell the repatriated painting to a private collector, they were determined it should remain on public exhibition: felicitously, it was bought (for $135 million) by the owner of the Neue Gallery in New York, opposite the Metropolitan Museum of Art, where it is now displayed with other Klimt masterpieces. But other artworks lost in the Holocaust have been restituted and sold to private collectors. Justice for victims of a crime against humanity requires punishment and compensation, and it is only fair that Austria should be deprived of a symbol of a society that its pro-Nazi majority destroyed, although there is a public element to justice that should, in a rational system of restitution, condition return on a requirement for eventual public exhibition. That would have been Adele's view – she became a socialist and advocate for

* Austria relied on a state's immunity from legal action, but the US Supreme Court, in 2004, decided that this case was an exception because Austria, after the war, had banned the export of looted artwork without government permission, thereby effectively expropriating them. See *Republic of Austria v. Altmann*, 541 US 677 (2004).

7

the poor, and before her early death had asked her husband to make sure her Klimt portrait was on public display; it is unlikely she would have wished that display to be in the country responsible for erasing her family and friends.[7]

In the UK, strength of public feeling about restitution of Nazi loot pressured Parliament to pass the Holocaust (Return of Cultural Objects) Act of 2009, which allowed museum trustees to 'de-accession' from their collections, exceptionally, any works that had been expropriated by the Nazis. The Tate, without any legal obligation, even paid a six-figure sum as 'conscience money' to a Jewish family whose mother had sold an old master at a knock-down price to a reputable dealer because she was 'struggling to survive in a hostile environment and faced the threat of starvation'. The gallery had acquired it perfectly legitimately, and the mother had not been forced to sell it by the Nazis, but by the circumstances their anti-Jewish policies created. Such was the moral imperative to return that began to attach to any acquisition related to Nazi crimes, and it raised the question of why art and antiquities pillaged in the process of other crimes against humanity should not also be candidates for restoration – if not to families long past, then to descendant peoples.

THE CULTURAL PROPERTY DEBATE

In due course, important states brought in legislation to implement the UNESCO Convention by giving effect to the anti-looting laws of other countries. The Dealing in Cultural Objects (Offences) Act 2003 in Britain penalised 'acquiring, disposing of, importing or exporting tainted cultural objects' if it was known that they had been stolen or illegally excavated or removed from any monument 'contrary to local

laws'. This had also been the crux of the 1983 US Convention on Cultural Property Implementation Act, which allowed foreign nations to request US import restrictions on unprovenanced cultural objects and enabled American prosecutors to proceed against crooked or reckless dealers who were smuggling artefacts out of countries where they had been illegally dug up. These measures were hailed by archaeologists but resented and reviled by collectors and museums, especially in the United States, home of 'American exceptionalism' to international law. It was said that freedom of trade ran in their bloodstreams and an 'implementation act' which allowed the laws of a foreign state to trump the right of its citizens to trade in antiquities was un-American. There was much vitriol directed towards 'crusading' and 'fanatical' archaeologists, tools of socialism (socialist countries usually contrive to vest antiquities in the state) and an entirely unfair imposition to expect American dealers to know the law of the country they were dealing with. The American Council for Cultural Policy published a book in 2005 entitled *Who Owns the Past?*: its answer was, in effect, wealthy Americans and their museums. They should not be bound by their own law to obey local laws of backward or socialist states trying to preserve their cultural heritage.

These were bad arguments, but soon the museums and their intellectual supporters came up with better, as restoration demands increased by the turn of the twenty-first century and even the British Parliament was listening to calls for the return of the 'Elgin' Marbles. The case against what he termed 'the archaeologists' crusade' was powerfully made by a Stanford law professor, John Henry Merryman, who inveighed against UNESCO and its anti-market (i.e. anti-capitalist) bias and the politics of 'socialist source countries who were passing laws to preserve their

heritage, to the hindrance of the art markets in the West'.[8] There are dangers if nationalist narratives of the past are imposed on museums by governments or ruling cliques, but Merryman never mentioned the existing dangers of 'universalist' museums in the West falsifying history as they try to justify or at least excuse their exhibition of colonial loot, while his legal scholarship, influential in persuading many that the British Museum held impregnable title over the Marbles, was deeply flawed (see pages 126–32).

It was soon necessary for big museums to find an argument less dependent upon pro-market political ideology, and they came up with an idea to which they still fervently cling: that of the 'universal' or 'encyclopaedic' (or 'enlightenment' or 'cosmopolitan') museum. This is the notion deployed by Neil MacGregor, long-serving director of the British Museum until 2017, to justify retention of the Marbles: the examples (which make little sense) are discussed on pages 116–18. The most powerful proponent is James Cuno, ex-director of the Getty, who describes the promise of 'encyclopaedic' museums in portentous but meaningless words: 'as liberal, cosmopolitan institutions, they encourage identification with others in the world, a shared sense of being human, of having in every meaningful way a common history, with a common future.' Cuno does not understand that this future might be better if museums took a moral approach to it, with a common commitment to honour human rights, or that 'identification with others in the world' might involve giving back their stolen property.[9] MacGregor simplistically says that the museum's mission is 'to show the world to the world'. But showing the old world to the modern world must take into account that the modern world has some human rights rules about where that exhibition is best held.

Cuno writes well, and his fine words have fed the language of cu-
rators as they resist demands to restore heritage items to peoples and
places from which they have been plundered. But his great 'enlight-
enment' institutions seem to exist only in capital cities in Europe and
in Los Angeles, Chicago and New York. Moreover, he fails to explain
why his 'cosmopolitan' visitor has a better experience when looking at
a particular work of art alongside other particular works of art stolen
from different countries, cultures and historic periods, rather than
appreciating it along with other works from its own country, culture
and period displayed within a context that makes them collectively and
historically meaningful. His is the 'one Terracotta Soldier' view of cul-
tural display, the 'cosmopolitan' museum as a cabinet of curiosities in
cities with a cosmos determined by their present wealth or past military
powers, rather than an inspiring account to a people – or to all peo-
ples – of their past. It does, however, lead to one question which these
'universalists' rarely ask themselves: where can citizens of the world best
appreciate its treasure? The answer, in the case of the Marbles, means
reuniting them in the New Acropolis Museum below the Parthenon
and beneath the blue Attic sky, rather than in a room in central London
dedicated to a fraudster.

THE RIGHT OF STATES – AND PEOPLES

Another problem with the case for the 'enlightenment museum' is that
its proponents are not very enlightened. They are, to put it bluntly,
impervious to shame, by receiving stolen property and overlooking
the sometimes barbaric circumstances in which their cultural artefacts
were taken away. Some were seized in the course of crimes against hu-
manity, others at the point of a conqueror's sword or gun, others in

circumstances which to some extent parallel the Nazi looting of Jewish property. These items are not merely of artistic value, but are freighted with the meaning of their removal, because they are not only emblematic of a civilisation but of the end of that civilisation – a story not told by the 'universal museum', where they are jumbled with other objects from other times or have their provenance told by an anodyne sentence in a display case. Take James Cuno's bloodless description of a Benin Bronze: 'It was forcibly removed from the West African Kingdom of Benin in 1897 by British troops seeking retribution for the deaths of their colleagues,' and that our response to it 'must take into account its place in the history of a particular imbalance of power at the end of the nineteenth century'. This is typical museum-speak, which talks in euphemism. What our response should take into account – and would, in a Nigerian museum – is that it was seized by British soldiers in the course of a 'punishment raid', a war crime even in 1897, where women and children were put to the bayonet and an historic city and temple burned to the ground, as soldiers seized its treasures, which the British government later sold to defray the expenses of their crime against humanity. Its place is not 'in the history of a particular balance of power' but rather in the bloodstained history of colonialism and the particular barbarity of the British army while forcing imperial domination. Benin Bronzes, sold to pay for their seizure, can be found in 'cosmopolitan' museums throughout Europe and the US with whitewashed labels: they would be more honestly described and better appreciated by any sensitive viewer in the city once burned for its treasure. Cuno is the incarnation of the 'sophisticated' connoisseur: anger at a British war crime does not figure in his appreciation of the Benin Bronzes. They are exquisite, certainly, as accomplished seventeenth-century metalwork,

but 'cosmopolitanism' apparently does not want to know very much about the colonial mentality that motivated their plunder. These museums can claim no right to possess the stolen heritage of other peoples that are displayed in their galleries, often bought from the family estates of rapacious soldiers or deriving from wealthy collectors in need of tax deductions.

Meanwhile, courts and parliaments in developed countries were busy demolishing the 'finders' keepers' defence, which was never a legal answer to an accusation of theft. Courts began to rule that nation states had 'sovereignty' over – a powerful right to possess – items important to their people's heritage, and in consequence had an enforceable right to restitution. This was the ruling of the International Court of Justice in 1962, in a dispute over an ancient temple situated on the border of Cambodia and Thailand: the court decided in favour of Cambodia and ordered Thailand to return any sculptures, monuments and pottery that had been taken by mistake. Then the chief justice of Ireland ruled that 'ownership by the state of objects which constitute antiquities of importance' is a 'necessary ingredient of sovereignty' – a precedent followed by higher courts in England, Indiana and Italy in respect (respectively) of illicitly traded cultural objects claimed by Iran; mosaics from Northern Cyprus (which were ordered to be returned to the church from which they had been taken); and the Venus of Cyrene, taken by Italian troops during the annexation of Libya in 1913. These later decisions were influenced by the 1970 UNESCO Convention, but the courts harnessed it to a rule that every nation must be accorded a sovereign right to possess the 'keys to its history', and that such possession should in principle be restored to it by other states in which the property happened now to repose. There would have to be some

qualifications – no one would want to restore a Venus to war-torn Libya right now – but the Italian Council of State decision in 2008 actually declared as a norm of customary international law that states were obliged to return cultural objects which had been taken as a result of war or colonial domination.

By this time, 'universal museums' were beginning to lose some of their universality, thanks to recognition of the rights of indigenous people. The George W. Bush administration in 1990 passed the Native American Graves Protection Act (NAGPRA) to give Native American leaders the right to re-possess human remains and what they regard as their 'sacred objects' from museum showcases. The Act has outraged museums and upset archaeologists as well, disrupting their plans to submit skulls and bones of ancient American natives to DNA testing. The Act asserts (as they put it) 'the taboos of animist superstitions and spirit beliefs' to prevent their study of the past. But Native American remains are human remains and as such are entitled to respect: they should be the subject of experiment only with the consent of their indigenous descendants. NAGPRA was a reminder to museums, which had long displayed skulls and bones as part of their 'native' or 'primitive' collections, that there were religious and spiritual feelings about human bodies – no matter how long they had been dead – and they must be taken into account.

This was the message delivered to the Natural History Museum in London, just as it was to begin DNA experiments on the remains of Tasmanian Aboriginals. As mentioned in the Preface, an injunction obtained by Aboriginals, backed by the Australian government, stopped the experiments, and to avoid a lengthy court case (and a fall in donations) the museum agreed to a mediation. The museum scientists,

so anxious at the outset to maintain their position that the pursuit of knowledge was an absolute good, yielded to the moral claim of the indigenous representatives and agreed to return all the remains for ritual burial in Tasmania, and apologised for failing to obtain consent for DNA testing from their descendants.

The case for repatriation of human remains from museums is now widely accepted, whether or not the death came as a result of colonial oppression. France returned to South Africa the remains of Sarah Baartman, who had been exhibited at funfairs in the early nineteenth century as 'the Hottentot Venus', and Germany has ceremonially returned the skulls and bones taken from Namibia in the course of the genocide it inflicted on the Herero people. In 2019, it handed over to the Australian government and tribal representations the Aboriginal remains in its museums. If skeletons demand to be repatriated, why not the objects that decorated their tombs or were intended to remain with them in the hereafter? Why not go further, and return to countries and cultures that value their past all the heritage that had been wrongly taken from them before 1970?

MACRON'S CHALLENGE

It is against that background that we come to the current debate, revved up in 2017 by the revolutionary declaration of President Emmanuel Macron of France that 'colonisation was a crime against humanity' and that 'African cultural heritage can no longer remain a prisoner of European museums'. The following year he endorsed the report he had commissioned from Felwine Sarr and Bénédicte Savoy, 'The Restitution of African Cultural Heritage: Toward a New Relational Ethics', which relates to African relics held in French museums (although its

reasoning would apply to all museums and to colonial countries other than France). It begins with the facts that '90 per cent of the material cultural legacy of sub-Saharan Africa remains preserved and housed outside of the Africa continent' and 60 per cent of the African population is under the age of twenty. Thus, it infers the great importance of giving young Africans access by right to their 'culture, creativity and spirituality', held and stored in museums and countries completely out of the reach of these people, who often are unaware not only of the richness and creativity of this legacy, but even of its existence. The moral, or the new relational ethics, is movingly expressed:

> To fall under the spell of an object, to be touched by it, moved emotionally by a piece of art in a museum, brought to tears of joy, to admire its forms of ingenuity, to like the artwork's colours, to take a photo of it, to let oneself be transformed by it: all these experiences – which are also forms of access to knowledge – cannot simply be reserved to the inheritors of an asymmetrical history, to the benefactors of an excess of privilege and mobility.[10]

The Sarr–Savoy report makes the most powerful case to date for the restitution of heritage items. Although directly relevant to sub-Saharan Francophone countries, its facts incriminate the colonisers of others, with details of German atrocities in Namibia, Italian looting in Libya and Ethiopia, British brutality in Kenya and Nigeria and the deaths of millions in the Congo at the hands of Belgium's monstrous King Leopold II – not to mention the Dutch in Indonesia, the Portuguese in Angola and Mozambique and the British and French in the Opium Wars against China. All such conquests provided a vast number of

valuable antiquities to line the walls of European museums, particularly the British Museum, the Louvre and the Vatican (its museums have 70,000 items taken by missionaries on their 'civilising' missions). The British Museum holds 69,000 objects from sub-Saharan Africa, the Weltmuseum in Vienna 37,000, and the new Musée royal de l'Afrique centrale in Tervuren, Belgium, holds 180,000, mainly seized during Leopold's tyranny over the Congo. 'Cultural amnesia' extends to Germany, where the new Humboldt Forum in Berlin has been designed to hold the Prussian ethnographic loot from Namibia, Tanganyika and other German colonies. The report identifies these and other collections as a form of rape of oppressed people – defeating them unfairly (using deadly new weapons they themselves did not possess) and brutally, in 'punishment raids' if they resisted, then disposing of or carrying off the products of their intellectuals and artists, and depriving them of spiritual nourishment. Restitution would be no more than simple justice, in the form of returns to various of the 500 or so museums in sub-Saharan countries, some of them (in South Africa, Nigeria, Mali and Senegal) in excellent condition, others (in Benin and Cameroon) under improvement.

Hitherto, European museums have controlled the narrative of their colonial history and have rarely told it objectively. The time has come, in fairness, to allow the victims the opportunity to re-state it, or at least to tell their own story of the brutal circumstances in which looting (particularly after 'punishment raids', a euphemism for a brutal reprisal or as cover for aggression or invasion) 'left profound traces in the collective memories of the countries concerned'.

The report provides powerful intellectual support for Macron's claim that cultural objects seized in the course of colonial crimes against

humanity should be restored, as a matter of retributive justice given the barbaric behaviour of colonial armies in nineteenth-century Africa. But what about treasures bought at a time – in the 1930s – by which the morality of museums had advanced and they and their dealers were expected to give some recompense to the owners? For an answer, the report relies on Cicero's rejoinder when prosecuting Verres, the tyrannical Roman governor of Sicily, who said he had paid for some of his acquisitions. Purchase by a conqueror of the art he covets does not legitimate the transaction, Cicero proclaimed, because the victim, 'if he had the faculty of choice at his disposal ... would never have chosen to sell what resided in his sanctuary and which had been left to him by his ancestors'. Besides which, investigations of documented purchases of objects in the Musée du quai Branly – Jacques Chirac in Paris (why name an ethnographic museum after a politician convicted for corruption and infamous for nuclear bomb tests on nearby colonies in the South Pacific?) showed they had been bought at remarkable undervalue – a 200 BC morphic mask purchased for the price of a dozen eggs had been worth twenty-five times as much, and so on. 'Under these conditions', say Sarr and Savoy, 'it is hard to interpret the actual amount of money paid as a sign of consent.' Within the colonial context, 'the authority of the White Man' put intolerable pressure on local peoples to accept low offers from missionaries and ethnographic expeditions, and to part with prized possessions as 'gifts'. The report concludes that scientific missions to collect African cultural items to stock French museums 'rationalised systems of exploitation, in some ways comparable to the exploitation of natural resources'.

This report, endorsed by President Macron before he had to watch his own iconic cultural heritage – the Cathedral of Notre-Dame – go up in

flames, comes up with criteria for determining which property should be the subject of restitution. In the first place, swiftly and thoroughly and without exception or further research, are 'any objects taken by force or presumed to be acquired through inequitable conditions'. This would include items taken as spoils or trophies by military aggression and items taken or confiscated by colonial or military administrations, by grasping missionaries or by 'scientific expeditions' in Africa during a colonial period extending from 1885 (when the Congress of Berlin began the 'scramble for Africa') to 1960. Items that were acquired by museums after 1960 should be examined to see whether they fall into the above categories: if so, they should also be returned. An exception would be made for African art objects and cultural heritage if the host museum could prove that they had been acquired through a document-ed transaction consented to on equitable terms, or they otherwise con-formed with the rules in the 1970 UNESCO Convention. Gifts from foreign heads of state could remain the property of France, unless the donors were guilty (as many were) of misuse of public funds.

As a schema for the return of cultural property this was at least a start, although it failed to deal with many circumstances to which a more precise test would have to be applied. It did apply directly to the Benin Bronzes and the art of Dahomey, objects taken respectively by British and French armed forces in brutal (indeed, criminal) mili-tary aggression and hence candidates for immediate return. But what about the Rosetta Stone, that trilingual slab of granite used in Egypt as building material, picked out peacefully by French scientists and then surrendered to the British, in whose Museum it is now the most visited exhibit? While there, its two ancient and hitherto inscrutable languages – its hieroglyphics and Coptic text – were deciphered by a

French Egyptologist building on the work of a brilliant English scientist. The miracle of the Rosetta Stone – our linguistic gateway to a great civilisation long before democratic Greece – happened in London and Paris while it was in the British Museum. So why should it not stay there? (See page 179.) The 'test' suggested by the report is vague and inconclusive.

Nor does the Sarr–Savoy schema much help in evaluating completing claims for return of the most brilliant jewel in the British Crown, the Koh-i-Noor diamond, proudly worn for centuries by princes warlording over places which are now Iran, Afghanistan, Pakistan and India. In 1813, it was on the arm of a mighty Sikh maharaja (who took it from an Afghan prince): after his death the Sikh forces in the Punjab Kingdom were defeated by British forces in the pay of the East India Company, greedy to exploit its land. His ten-year-old heir was forced to sign the 'Act of Submission', with a provision that 'the gem called *Koh-i-Noor*' should be 'surrendered by the Maharaj of Lahore to the Queen of England'. It was undoubtedly a spoil of war, extracted from a child-prince who was given no choice in the matter, and quickly and secretly taken by the East India Company to the British queen. She had some scruples about wearing it, so once the child's mother had been thrown into prison and he had been effectively groomed by his Company guardians, at age fifteen he was induced to 'give' it to the Queen, whereupon she wore it on state occasions, literally as *the* jewel in her crown. It featured in coronations – most recently in that of Elizabeth II, as the centrepiece in the crown worn by her mother – and is now on display for tourists to view in the Tower of London. As soon as India obtained independence in 1948 it demanded the return of the diamond, as later did Prime Minister Zulfikar Ali Bhutto on behalf of Pakistan and the Taliban on behalf of

Afghanistan. The last British Prime Minister to visit the Punjab, David Cameron, batted away questions about returning it: 'If you say "yes" to one request, you suddenly find the British Museum would be empty'[11] (thereby stating the traditional case for keeping the Parthenon Marbles, and everything else). There is certainly a prima facie case for restoration of the Koh-i-Noor diamond, but does a gemstone, however large, count as 'cultural property' when it has been dredged from an unknown locality and has not been created or enhanced by human artistry? If it counts as culture, and at least as a valuable asset with a history, then it satisfies the test and should go back – but to where? There will be an international clamour from India and Pakistan when it appears at the next coronation, in Queen Camilla's crown (see pages 197–9).

Britain remains adamant that it will not give up its ownership of other countries' treasures. As recently as April 2019 its Culture Secretary, a nondescript criminal barrister named Jeremy Wright, rejected President Macron's initiative, claiming that 'if you followed the logic of restitution to its logical conclusion there would be no single points where people can see multiple things'.[12] His incoherent comment seemed to mean that museums should stay as they are, and he rejected proposals to allow Britain's museums to 'de-accession' (officially remove or dispose of) their 'things', whether looted by armies or whether sought by foreign museums where they would be better seen or studied, and he did not understand that restitution is sought for treasures rather than 'things'. For the British establishment, whose wealthy members make up the great majority of unelected museum trustees, possession of imperial artefacts must be for ever: they might be briefly loaned for 'cultural diplomacy', although not to nations like Greece which might challenge their title. 'There is a huge cultural benefit to the world in having places in the world where people

can see these things together,' said Wright, unconsciously making the case for one such place – the New Acropolis Museum – where people could see the Parthenon Marbles put together.

THE MARBLES

Of all the claims for restitution of cultural property, the demand of Greece for the return of that better half of the Parthenon Marbles which resides in the British Museum has been the loudest and the longest – and it remains the most compelling. Although they were not directly seized in war, Lord Elgin exploited Ottoman gratitude for Britain's alliance against Napoleon, and some of the Marbles were carried off in British warships after this British ambassador had bribed the Turkish authorities in Athens to turn a blind eye while his workmen stripped the temple. Elgin acted on motives that became mixed over time: as merely a Scottish lord, he craved an English peerage, which he thought to obtain by importing original classical architecture for study in Britain; later, bankrupt and distressed, he sold the Marbles to Parliament to pay off his creditors, insisting only that they be described in law as the 'Elgin Collection' – which they were not, as his taking possession of them had been both wrongful under the licence he had obtained from the Ottomans and wrongful as an abuse of the power invested in him as a British ambassador. Nonetheless, their capture was a *fait accompli*: Parliament bought them at an undervalue (so Elgin could not be seen to profit from his abuse of his diplomatic status) and entrusted them permanently to the trustees of the British Museum.

In time, the museum authorities fell under the financial spell of a corrupt art dealer, Joseph Duveen, who wanted 'the Elgin Marbles' displayed in a gallery that commemorated himself in a colour (white)

that he liked, perhaps because of the darkness in his own life. He had them scoured and scraped and displayed under bright lights, a world away from the blue sky above them for so many centuries while on the Parthenon. The British government at one point secretly acknowledged that they belonged to Greece and should be returned in thanks for its help in the Second World War, but Margaret Thatcher disagreed and ever since the government and the trustees have adamantly refused all Greek demands and even UNESCO requests to mediate over their future.

The Parthenon and its Marbles are unique. In 1987, UNESCO listed the Acropolis as a World Heritage Site, because these masterpieces from the fifth century before Christ 'are universal symbols of the classical spirit and civilisation and form the greatest architectural and artistic complex bequeathed by Greek antiquity to the world'. The Parthenon was even adopted as the logo for UNESCO. The British Museum does not deny their unique cultural importance: 'The marbles rank above the highest achievements of mankind ... not only for their aesthetic qualities ... but also for their central place in the cultural history of ancient nations.'[13] This admission refutes the argument that their departure to Athens would necessarily be followed by other looted antiquities, but a decision to return them could set a standard by which other demands could be judged.

More importantly, the demand is not merely for restitution, but for re-unification – the most powerful of restitution demands, because it invokes the principle of integrity of public monuments, recognised in all European states which have laws against interference with structures of historic or architectural interest. (Britain has had such laws since the Ancient Monuments Protection Act 1882, with heavy penalties on

removing fixtures from listed buildings.¹⁴) There may have been no Greek equivalent in 1801, but the principle was recognised and no one – not even Elgin – doubted that a decree (called a *firman*) was required from the Ottoman Sultan before his workmen could begin chiselling. (He never obtained one, and the licence he was given permitted him only to draw, mould and collect stones from the ground; it did not allow the fixed marbles to be removed from the building.) Re-unification means that the world could at last appreciate the full power and beauty of this 'greatest architectural and artistic complex'.

Most of the Doric columns of the Parthenon still stand on the Acropolis, as an enduring symbol of the glory that was ancient Greece in the time of the great statesman Pericles and the inspired sculptor Phidias. Below it is a more recent architectural wonder – the New Acropolis Museum, its capacious third floor specially designed to receive the missing marbles when they return from London. These comprise just over half of the frieze together with fifteen of the stand-alone sculptures on its sides (the metopes) and seventeen gods from its east and west triangular pediments, together with sculptures taken from other buildings forming part of the Acropolis ensemble, notably a caryatid and column from the Erechtheion and sculptures from the Temple of Athena Nike. They are locked away in the British Museum, except for a panel in the Louvre and some fragments which may be found in the Vatican and in several European museums.

The case for removing them from the British Museum and reuniting them with their fellow Marbles in the New Acropolis Museum must begin with an assessment of the importance of this enterprise to understanding and appreciating the development of human civilisation. The sections of the frieze that were ripped down from the Parthenon

columns by Lord Elgin's workmen are now anachronistically displayed under harsh light in the Duveen Gallery, but even here they give the impression of an ancient newsreel, a three-dimensional record of people walking and talking, drinking and playing, in the first society that was democratic and committed to peace. Reuniting them with other sections of the frieze which survive in the New Acropolis Museum, custom-built to receive the Marbles and to display them where visitors can look at the Parthenon, would be akin to putting together the torn pieces of an ancient photograph, allowing us to see, through the art of the sculptor Phidias, a moving image, as in an old magic lantern, of people in a procession – a people whose philosophy, culture and politics came to influence the intellectual development of the world.

The uniqueness of this wonder requires acknowledgement at the outset. Putting the Parthenon back together in Athens is not the equivalent of restoring a cultural icon to a nation robbed of it when under imperial domination, although this would be an application of the same principle. Rather, it is a case of allowing a wonder of the world to be appreciated in the most authentic way that is now possible. The experience of seeing part of the Parthenon Frieze in the Duveen Gallery is as nothing compared to the prospect of seeing all that is left of it, looking up at the gods on its roof, the heroes sculptured on the level below, and its people processing on the frieze, while above them all is the Parthenon and the blue Attic sky.

Neil MacGregor claims that exhibition of the sculptures in his 'world museum', rubbing marbled shoulders, as it were, with sculptures from other periods and civilisations, somehow aids their appreciation. On the contrary, their appearance in a museum which so jumbles its artefacts that tourists can walk from the Duveen Gallery to the mummies of the

pharaohs, via the Sutton Hoo burial ship, the giant-nostrilled Eastern Island *moai*, goddess Tara from Sri Lanka, Captain Cook's seizures in Tahiti and Islamic pottery (not to mention the Benin Bronzes in the basement and the chessmen from the Isle of Lewis) simply reduces the Marbles to one tit-bit in a cultural smorgasbord.

The universalist case for 'encyclopaedic' museums comes apart especially when it is applied to the Marbles – a unique treasure that can only be properly experienced when reunited in a museum devoted to it, and to other treasures of classical Greece. The British Museum denies the citizens of the world the opportunity to see that treasure whole, in the place where they can best appreciate it.

Since 1833, Greece has repeatedly and consistently sought the return of the Marbles, through public and private written and oral requests and exhortations. It has delivered bilateral requests and initiated attempts to negotiate and has agreed to engage in a mediation recommended by UNESCO. All to no avail: the British government disingenuously refuses, pretending that any decision is a matter for the museum trustees, well knowing that the trustees are forced by statute law not to de-access any property entrusted to them. They may of course loan them out, and the marbled river god Ilissos departed for the Hermitage Museum in St Petersburg for six months in 2014–15. They may remove them or display them in different galleries – some were removed in 2018 to be matched with Rodin sculptures in a special exhibition (which led many to think Phidias the greater artist) – but the museum has made clear that it will not consider a loan to Greece until that country formally renounces any claim to the title and admits Elgin's right to remove them and to pass a good title on to the museum trustees – which would fly in the face of the facts, as Chapter Three will explain.

So, at present, half the extant panels of the frieze, and many of the surrounding statues, are to be found in a large room named after a fraudulent art dealer who had them disfigured to suit his taste. They are locked away by law (Section 3 of the 1963 British Museum Act) which prohibits their de-accession, by yielding possession of them to anyone else. Statues are not immutable, of course: when Australia wanted its constitution back, locked in the British archives for a century, the UK Parliament passed a special law to de-accession it, a concession it made also (and only) to allow the return of indigenous human remains and looted Nazi art. The Prime Minister, who has the power to appoint most of the trustees, could replace the current body of wealthy philistines with philhellenes. Jeremy Corbyn, if he becomes Prime Minister, may have to do this: 'It is very clear to me that they belong to Greece,' he said of the Marbles in 2018. He added, 'As with anything stolen or taken from occupied or colonial possession, including artefacts looted from other countries in the past, we should be engaged in constructive talks with the Greek government about returning them.'

The British Museum, however, is adamant that the 'Elgin' Marbles, as it has always called them, must remain for ever in its possession. The New Acropolis Museum, it tells tourists as they enter the Duveen Gallery, 'allows the Parthenon sculptures that are in Athens to be appreciated against a backdrop of ancient Greek and Athenian history … The sculptures are part of everyone's shared heritage and transcend cultural boundaries … The current division (between the British and the New Acropolis Museums) allows different and complementary stories to be told.' This is absurd because the sculptures are part of the glory that was Greece – and their inspiration has certainly transcended cultural boundaries but for reasons which can only be fully understood and

appreciated when they are exhibited together, as Pericles and Phidias intended, and beneath the Parthenon. The 'different' story which the museum tells is actually a string of carefully constructed lies and half-truths, about how they were 'saved' or 'salvaged' or 'rescued' by Lord Elgin, who came into possession of them lawfully (although this story has changed as its 'facts' have been disproved). And it is certainly not 'complementary' to the true narrative in the New Acropolis Museum. But the 'universality' defence is the best the British Museum can do, now that time has overcome most of its other objections to re-unification, based for many years on the potential damage that might be caused to them if placed back on the Parthenon from fog and traffic pollution in Athens. The New Acropolis Museum, designed by Bernard Tschumi and opened in 2009, has a modern structure and is a work of architectural merit in its own right. The gods look good here and the citizens of Athens, enjoying their annual procession in celebration of the city, would all be back in the right place.

A HUMAN RIGHTS APPROACH

That is the place to which international law can restore them. There is an increasing jurisprudential recognition of the critical value of cultural treasures to national sovereignty, identity and dignity and consequently a developing recognition of a right of nations to possess and enjoy the keys to their ancient history – by way of recovering from foreign museums or private collections their national cultural symbols. Chapter Six explains how case law is reflecting an emerging sensitivity to the 'value' (in non-commercial terms) of cultural objects and their importance to nations, in a way which can override claims of private property asserted by organisations or individuals, especially where such objects had been

acquired by theft or imperial domination, or simply by the wealth that incites illegal digging and grave robbing. International law is evolving towards a position which recognises, as part of the sovereignty of a state, its right to reclaim unique cultural property of great historical significance which was wrongfully taken in the past.

The Sarr–Savoy report is a convincing and even moving argument for justice, to be achieved by return of cultural property seized or inequitably taken from African countries during the colonial period. Its test can usefully be applied to military seizures in other theatres of nineteenth-century colonial conquest and aggression – most notably, perhaps, the Opium Wars, in which Britain, to reduce the debt incurred by its people's love of Chinese tea, deliberately addicted the Chinese to opium and fought a war to force them to maintain an open market in a substance that degraded and killed many millions. The British army's destruction of the Old Summer Palace outside Beijing in 1860 can be reckoned even higher on its list of atrocities than the ransacking of Benin City and Maqdala, and many of the Ming and Qing dynasty vases that adorn upper-class mantelpieces in Kensington were directly or indirectly first acquired as a result of the Opium Wars. Is this enough for China to demand restitution of objects that have changed hands so often and for increasing value over 150 years?

In respect of the value of the 'cultural property' in question, there needs to be some limitation. The term is always widely defined. The Sarr–Savoy scheme would cover it all, while other declarations are limited to items with 'important' or 'significant' cultural or historical resonance. Cultural properties may at the highest be unique (the Parthenon Marbles) or exquisitely beautiful or full of historical associations or national (and international) legends and legacies. They may also be

commonplace (endless funeral steles or amphorae or drinking cups) or even mass-produced for ancient tourists (as in Greece, for Roman visitors inspecting the Empire of Augustus). The business of getting back or handing back antiquities involves negotiations, diplomatic intervention, even commencement of legal action: if there is to be a law that dispossesses museums and private collectors of objects they have bought with reckless disregard for the rules, they must have real meaning for people of the state obtaining their return.

And for all the passion for justice that Sarr and Savoy express (for example, in the passage quoted above about the birthrights of African youth), there must be a pragmatic exception relating to the security of the items in their new (i.e. old) home. No Venus should be returned to Libya at present, no matter how unlawful its seizure by Italian aggressors in the past: the wars in that country have put the safety of any valuable cultural object at risk. There must be a clear-headed inquiry into the capacity of the nominated host museum: financial sustainability, independence from government, vulnerability to climate factors and particularly its safeguards against corruption. Notoriously, when Belgium made gestures to improve its relations with Zaire in the 1970s by returning several thousand cultural items to the National Museum in Kinshasa, most of them disappeared – only to re-appear on the international art market a few years later. There is simply no point in returning cultural property to places where that property will be at real risk, whether from terrorist fanatics or crooked curators.

There is a further, perhaps overarching, question. Return of cultural property as a measure of justice has come to be supported as a human right – the sovereign right of a people to hold and study the keys of its own history, to use them to make its own narrative of its social and

political development and to inspire its youth with such self-esteem as may come from that narrative. Of course it may be a contested narrative, with a nationalist purpose, but that is the sovereign entitlement of that people, unless it is clear that items, if and when returned, will be used for propaganda (as notoriously happened with Neil MacGregor's naïve exercises in 'cultural diplomacy': he loaned the Cyrus Cylinder to Iran, and its government exploited the occasion to celebrate its brutal Basij militia; he loaned the Parthenon's river god Ilissos to the Hermitage Museum, permitting Vladimir Putin to puff his chest beside the god's pectorals shortly after he had invaded Ukraine). If restitution is a human right, what is the justification for restoring cultural objects to states which deny human rights? This is a serious question with regard to restoration of antiquities to Egypt: they are safe enough under the dictatorial regime of President Sisi, but the people in whose name they are being demanded are not allowed rights to peaceful protest or fair trial. The same question must be asked about China and Iran, where artists and human rights lawyers are sentenced to years in prison and where sources of information about the outside world – Wikipedia, for example – are banned. There must be no retreat to the crude American protests against returning looted art to socialist countries and complaints about the anti-capitalist bias of UNESCO, but nonetheless in any weighing of the pros and cons of returning heritage, the human rights record of the claimant state especially in regard to free speech and cultural freedom should be one factor in the balance. A state does not deserve to have its cultural property returned until artistic freedom is a respected part of its culture.

These factors should be balanced and weighed in respect of each of the many claims for restitution – some notable examples are assessed

in Chapter Seven. Although international law imposes a duty to return wrongfully obtained heritage of other nations, this will only come about as the result of a UN convention of the kind outlined in Chapter Eight. Would it empty the British Museum? The great scandal of Western 'universalist' museums is how much of their cultural property never sees the light of day – the British Museum, for example, hoards no fewer than 8 million items, only 80,000 of which are exhibited, leaving 7.92 million in storage.[15] Another scandal is how unrepresentative the trustees of these museums are – the Metropolitan Museum has seventy-five, with a total net worth estimated by *The Economist* at $50 billion, while most of those at the British Museum are chosen by government from the biggest businesses (see pages 252–3). These individuals are distinguished, no doubt, but they are wholly unrepresentative of the people whom museums should serve and inspire, and are unwilling to grapple with the ethical questions involved in claims for return of stolen cultural property. A few museums are beginning to salve their collective consciences by offering heritage items back on loan, but, as Sarr and Savoy point out, this is symbolic of a lingering colonialist mindset – a determination to possess and to impose conditions. It is an example of *la politique de l'autruche* – the ostrich attitude of museums that cannot bring themselves to confront demands for justice. It is that demand – beginning with the Parthenon Marbles and extending to other victims of the crimes of colonialism – that must now be answered.

CHAPTER TWO

THE GLORY THAT WAS GREECE

The Parthenon stands, as it has for almost two thousand and five hundred years, atop the rocky hill of the Acropolis in the centre of Athens. Its marbled pillars radiate, warm and honey-brown in the rising sun for breakfasters on the top floors of the hotels overlooking Syntagma Square; by evening its luminescent columns dominate the city, to remind of the time in the fifth century BC when it served as the backdrop to humankind's earliest ethical debates. The theatres that survive on this hill saw the plays of Aeschylus and Sophocles, Euripides and Aristophanes; in the marketplace beneath, Socrates posed eternal questions and Pythagoras pondered theorems and Herodotus started writing something called history. They talked of logic and of physics, discussed how justice and freedom might be reconciled with government and the needs of the community, and started to think of themselves as stoics or cynics or epicureans, but above all as democrats: their tyrants had been disposed of at the turn into the fifth century, and they had repelled the barbarians at their gates in the battles of Marathon (490) and Salamis (479). By 448 they had peace and the wealth that came with it. In that year the elected Athenian Assembly was persuaded by its great statesman Pericles to build the Parthenon to serve as a war memorial, as a temple to

Athena (goddess of wisdom and protector of the city) and as a museum to showcase its art, in the form of the marble statues of the pediment and the frieze – adornments built into its walls and conceived as part of the building by its architect-in-chief, the sculptor Phidias.

The structure of the Parthenon and the Marbles that were its treasure took fifteen years to build, between 448 and 432 BC. It originally comprised fifty-eight Doric columns, supporting a roof with triangular pediments at each end, displaying three-dimensional statues. At one end they represented the birth of Athena from the cleft head of Zeus, in a tableau featuring horses that pulled the rising sun and, exhausted, the setting moon. At the other end, Athena and Poseidon competed to become the sacred patron of the city, the sea god's offer of saltwater being voted down in favour of an olive tree vouchsafed by the goddess. So far, so mythical, although it is notable that Athena's victory came by the choice of its citizens. Around the building, and integral to it, were large sculptures (the metopes) interactively representing legendary battles – the Trojan War, and fights between gods and giants, against Amazons and (most dramatically) between guests at a wedding and centaurs attempting to gate-crash the feast. Inside the building, in a special chamber, stood the goddess, 40 feet high and carved by Phidias from gold and ivory. Running around the inside walls of the building was a frieze, 524 feet (160 metres) in length and about 3 feet in height, depicting an annual parade – the Panathenaic procession – of Athenian citizens (some mounted, others carrying wine jugs or musical instruments, others shepherding cattle for sacrifice) as they walked up the sacred way to the Parthenon, to present their goddess-statue with a new, finely woven robe (the *peplos*).

This astonishing and innovatory frieze, like nothing ever found on

other Greek temples, was spread over 114 rectangular blocks, an order-
ly pageant always moving forward, with musicians and wine bearers,
horses and riders and chariots, officials and magistrates, sheep and cows
and female votaries and richly costumed women, all painted in colour.
There were gods in the background, observant but not intrusive: the
focus of this animated frieze, almost a Kodachrome documentary,
was on people – the citizens of the first democracy – delighting in the
pleasures of a well-ordered society. The characters – 378 citizens and 245
animals – were carefully planned and beautifully carved from marble,
painted in vibrant living colours. Even today, whitened and decapitated
and stripped of context in the Duveen Gallery, the Parthenon Marbles
represent the epitome of High Classic art.

That is certainly the view of the European Union, which in 2007
designated the Parthenon as its most important monument, and of
UNESCO, which adopted the façade as its emblem and ranked it first
in world heritage, giving five reasons for its listing:

(i) it is the supreme expression of the adaptation of architecture to a
 natural site, creating a monumental landscape of unique beauty
 consisting of a series of masterpieces of the fifth century BC;
(ii) its monuments have exerted an exceptional inspirational experi-
 ence not only in Greco-Roman antiquity but in contemporary
 times as well;
(iii) it bears unique testimony to the religions of ancient Greece from
 which sprang fundamental legends about the city and it brings to
 us the Athenian religion in all its complexity;
(iv) it illustrates civilisations of Greece over a period of more than a
 millennium; and

(v) it is directly and tangibly associated with events and ideas which
 have never faded over the course of history. Its monuments are still
 living testimonies to 'the memory of a precious part of the history
 of mankind'.

So where are the Marbles now, those unique sculptures that survived
for 2,000 years until most were ripped off the building by Lord Elgin's
workmen in 1801 and the following two years? Of the ninety-seven sur-
viving panels of the frieze, fifty-six were chiselled or sawn off by Elgin's
workmen and shipped, by hired vessels or British warships, to London,
where in 1816 they were bought by Parliament and placed in the British
Museum. Forty frieze panels remain in Athens, in the New Acropolis
Museum 300 metres below the Parthenon, while one was stolen by the
French consul and is now in the Louvre. A leg and foot of the goddess
Artemis has somehow walked to a museum in Palermo, while the heads
of two elderly men absorbed by watching the parade now peruse the
statuary in a museum in Vienna. The Vatican Museum has a metope
head, as does a museum in Copenhagen, while the Louvre has two heads.
(Were the British Museum Marbles to be reunited with those remaining
in Greece, these museums could hardly resist returning the fragments.)
 Elgin carried off the fifteen best-preserved metopes, making them
look two-dimensional by cutting off their carefully sculptured backs for
ease of carriage. He despoiled the pediments by seizing twenty of the
figures, leaving only eight behind for the Greeks. The statue of Athena
had been removed to Constantinople, plundered for its gold and ivory,
and is now lost, and the missing panels of the frieze had been destroyed,
along with the roof and some columns of the buildings, in a Venetian
bombardment in the seventeenth century.

Elgin's loot comprises half of the extant artwork (his agents chose the best that had survived by 1801). The first claim to have it back was made by the newly independent Greek government in 1833 and made formally by the King in 1836. The British Museum tried to fob them off by sending moulds. This was perceived (and may have been intended) as an insult, although these moulds (a little dog-eared and anachronistically white) may still be seen in the New Acropolis Museum, deputising until the originals are prised from the Duveen Gallery. The demand for return of the originals has been made with greater force since the opening of the museum in Athens in 2009, where they would be safe from petrol fumes and fog and would look out on the Acropolis.

In order to evaluate the Greek claim, it is necessary first to describe the significance of the Parthenon in the history of Greece and of intellectual and artistic endeavour in the mid-fifth century BC. The building, as will emerge, was planned and constructed as a single entity, its artworks and sculptures a vital part of the edifice as a whole. Since re-unification means putting the Marbles back together in a modern Greek museum which provides the best place to see and to study them, it will be important to our understanding and appreciation of the early development of human civilisation.

A BRIEF BACKGROUND

The ancient world comes down to us most dramatically through Homer's two epic poems, the *Iliad*, covering the fall of Troy, and the *Odyssey*, which traces the long voyage home of the cunning Odysseus. These poems are believed to have been composed about 725 BC and were being recited on ceremonial occasions in Athens by 550 BC onwards. Their stories provided a rich mythological background for the designers of the Parthenon,

who featured the city's founding myths on a pediment (the triangular top of the building), its gods – the human-like gods of Greek religion – on its metopes, and its citizens on the frieze, running around the inner wall. By 448 the laws originally laid down by Solon had been codified in the first written constitution and the city of Athens had become a self-governed community. After the slaying of the last despot (by subsequently honoured 'tyrannicides') in 508, Athens had become a democracy. The city was divided into ten constituencies which elected representatives to an assembly of 500 citizens that took political decisions. It elected nine chief magistrates and pulled by lot names of the citizens who would do jury service (and be paid for it).

This democracy even elected its generals, who were entrusted with military strategy for upcoming battles against the Persians (from modern-day Iran) led first by Darius and later by his son, Xerxes. Their invading army was defeated by Athenian guile and courage at the great battle of Marathon in 490. Darius had been intent on reinstating a despotic ruler, and the armies of the ten tribes fought the first battle for democracy – and won. According to Herodotus, only 192 Athenian soldiers lost their lives, compared with 6,300 Persians before the invaders scurried back to their ships. There are exactly 192 soldiers on the Parthenon frieze – in memory, doubtless, of the heroes of Marathon.

Out to avenge his father's rout, Xerxes swept down ten years later with a massive invasion force: the Athenians fled their city, which was devastated and pillaged, and the small temple to Athena which Solon had erected on the Acropolis was burned down. The citizens re-grouped on the offshore island of Salamis, where their clever generals had built a navy, which in turn vanquished the Persian fleet in a sea battle. On returning to their city, they found it in ruins – although on the bleak

Acropolis in the charred temple of Athena, the sacred olive tree had put out a green shoot.

Athens developed over the following decades as a city state with a sea power which dominated the Peloponnesian Peninsula, protecting several hundred Greek cities and islands in an alliance called the Delian League because its treasury was initially kept on the island of Delos. In 454 BC the Athenian Assembly directed that the treasury should be kept in Athens – it had been swollen by forced contributions from members of the league in return for Athenian protection from further Persian incursions. It was at this point that democracy produced its first great statesman, the austere and revered general Pericles, who dominated Athenian politics between 461 and his death in 429. It was he who convinced the Assembly to spend their war chest on the celebration of peace – through a building programme that would, most spectacularly, provide a new temple on the Acropolis for their own protector, the goddess Athena, to replace her temple that had been destroyed by the Persians in 479. It was, he argued, against objections from some members of the league, legitimate and right to spend the revenue surplus on glorifying Athens itself, which had fulfilled its obligations as leader of the league, and would continue to do so, with an army and navy maintained at its own expense. Moreover, as a programme of public works, building the Parthenon would ensure full employment for some years of the city's artists and artisans, stonemasons and sculptors, and their counterparts from league members would be permitted to reside in the city and work on the project. The Parthenon would serve not only as a temple and a war memorial, but as a reminder to the world of the creative capacity of its people.

In a panegyric delivered at the funeral of some soldiers who had

fallen in defence of Samos in 439, Pericles (as recorded by Thucydides) set out his vision of the state and its ethos:

We are called a democracy, for the administration is in the hands of the many and not of the few [note the origin of Jeremy Corbyn's slogan]. But while there exists equal justice to all and alike in their private disputes, the claim of excellence is also recognised; and when a citizen is in any way distinguished, he is preferred to the public service, not as a matter of privilege, but as the reward of merit. Neither is poverty an obstacle, but a man may benefit his country whatever the obscurity of his condition. There is no exclusiveness in our public life, and in our private business we are not suspicious of one another, nor angry with our neighbour if he does what he likes; we do not put on sour looks at him which, though harmless, are not pleasant. While we are thus unconstrained in our private business, a spirit of reverence pervades our public acts; we are prevented from doing wrong by respect for the authorities and for the laws, having a particular regard to those which are ordained for the protection of the injured as well as those unwritten laws which bring upon the transgressor of them the reprobation of the general sentiment.

And we have not forgotten to provide for our weary spirits many relaxations from toil; we have regular games and sacrifices throughout the year; our homes are beautiful and elegant; and the delight which we daily feel in all these things helps to banish sorrow. Because of the greatness of our city the fruits of the whole earth flow in upon us; so that we enjoy the goods of other countries as freely as our own.

This is, no doubt, an idyllic picture of Athenian democracy in the way

Pericles wanted it to be commemorated by building the Parthenon. It was true enough for the 30,000 male citizens entitled to vote, although less so for their womenfolk and not at all for their slaves, who did most of the manual work. There was sewage in the streets, occasional epidemics (such as the plague from which Pericles died in 429) and high infant mortality, even though medicine was beginning – Hippocrates soon would have an oath for its practitioners – and the benefits of physical exercise were appreciated for sport, war and health. On the Parthenon frieze, people are playing games before taking the sacred path up to the Acropolis, on which there was also a health sanctuary for the goddess Hygeia. The city devised its own policy on immigration, permitting foreign traders and skilled craftsmen (some are to be seen in the procession) to reside and have rights so long as they paid tax on their earnings, although they could not vote. The tyrannicides who paved the way for democracy by killing the despots were honoured by public statues, and any return to tyranny was prevented by the prospect of ostracism – a democratic process by which the Assembly could impeach an overweening politician who had become too big for his sandals, after which a popular vote could force him into exile.

Athens in this period tends to be idealised today for its intellectual achievements – Euripides, Sophocles and other great playwrights were competing for theatrical laurels, historians like Thucydides and Herodotus were recording its past, and philosophers were earning money from thinking aloud in the marketplace (the Agora, just below the Acropolis). But cultural life was still influenced by religious beliefs and rituals, and myths were accorded some credibility. Whether or not the rationalists in the Agora believed the pictures on the Parthenon pediments above them, they nonetheless joined in the temple rituals

and sacrifices that were part of community worship. They believed in a god-driven providence discernible from signs and oracles, although this was not, interestingly, in order to attain a heavenly life after death – no paradise awaited dead Greeks, or even their slain heroes, but merely an afterlife as a shadow in a cave, occasionally visited by a mortal as daring as Odysseus.

Religious ritual was a central part of community life that democratic government must respect and encourage, and so its great statesman persuaded the Assembly to spend their money (and the money of other members of the Delian League) on a temple to replace that built by Solon, which had been desecrated and destroyed by Xerxes. It was planned as a temple complex, with the tall statue of Athena, by Phidias, at one end and the treasure of the Delian League in a special strong-room at the other. Outside were to be smaller temples, one dedicated to Athena Nike (goddess of victory) and the other, the Erechtheion, with six goddesses, the Caryatids, guarding the sacred olive tree (after Elgin there were only five – the sister he severed and seized stands forlornly in an annexe to the Duveen Gallery). Nearby was the altar which served, at the end of the ceremony, as the barbecue for the sacrificial cows and lambs.

The gods themselves were real in the sense that their ambitions and quarrels helped to explain the world, and given their excitable temperament, they required a lot of assuaging and placating. Hence their place in the Parthenon Marbles, as observers of the greatest ritual that men had devised in their honour. This was the Panathenaia, the festival procession on the birthday of the city's goddess. It assembled at the Agora for athletic games and musical competitions, and later moved up to Athena's Temple on the Acropolis, to wrap her icon, fashioned

from sacred olive wood, in a newly made robe (the *peplos*). Then there would be hymns and prayers and sacrifices on the altar of the bones and fat of the herded cattle (the best meat was reserved for mortal feasting, thanks to a deal the cunning Prometheus had once made with Zeus whereby the gods would only get the offal). As John Boardman, former Oxford professor of classical archaeology and art, points out, 'This was no military parade: elders and citizens walked the Panathenaic Way, as well as troops of soldiers, cavalry and clattering chariots, and citizens viewed its progress and ceremonies. There was no real distinction between participants and viewers in the city's celebration of itself and of its divine patron.'[16]

The city had many festivals, for feasting and celebrating its various gods (Dionysius in particular), but every four years came the grandest of all, the Great Panathenaia. It was chosen to represent the confidence and happiness of democracy. 'Our government does not copy our neighbours, but is an example to them,' boasted Pericles, and the Parthenon frieze was devised to provide that example, the first time that celebration of humanity had been permitted in a temple dedicated to the worship of gods. The design is clear: on the pediments, the mythic history of the city. From the metopes, success (with the help of the gods) in battles with barbarians. And inside, the moving newsreel depicting the joys of human existence in democratic society.

BUILDING THE PARTHENON

Pericles persuaded the Assembly to spend its revenue surplus on the building programme. The Parthenon was constructed on the highest point of the Acropolis to house a new, 40-foot-high statue of Athena, wrought in gold and ivory by the sculptor Phidias. The building

comprised fifty-eight outer Doric columns, supporting a marble beam on which rested sculptured panels (the metopes) beneath triangular pediments which featured groups of carved figures. Around the top of another set of inner columns ran the frieze, 524 feet long, depicting the festival procession. The construction was overseen by Iktinos, an architect brought in from the Ionian Islands, where a more decorative style of temple design was in vogue. Kallikrates, master builder of the wall between Athens and Piraeus (behind which the Athenians had sheltered from the Persian invaders), was involved in hiring the hundreds of craftsmen brought in from other cities to swell the local workforce (which probably included the young Socrates, apprenticed at the time to a stonemason) and the building began in 447 BC. It took fifteen years – the records show that the last workmen were paid off in 432, although the temple and most of its sculptures were in place for an official opening in 438, after just nine years.

The design process for the Parthenon is unrecorded: the only records that survive are some accounts of expenditures inscribed on marble pieces later found in the rubble. Pericles and the architects – Phidias, Iktinos and Kallikrates – must have agreed on the overall design and the choice of subject matter for the frieze and the statues, although Phidias would have been responsible for assigning individual sculptures to particular artists and supervising the quality of their work, from clay modelling to the chiselling of the design from marble blocks. Many of the sculptures had metal appendages – spears, for example, and harnesses for the horses – which had to be cast and then affixed. Most important was the paint. As Boardman explains:

Dress, weapons and backgrounds had to be painted, and the waiting

metopes had already received their colours. A dark red background helped to lift figures even more realistically off the stone. Reds, blues and yellows picked out the dress and trappings, and the hair, eyes, brows and lips of the figures were painted so that their features stood out boldly even at the great distance from which they would ultimately be viewed. And on the dress, intricate patterns were depicted, borders and figurines.[17]

Amazing as this may be to those schooled by the British Museum's distorted presentation of the 'white' Marbles against the grey-walled Duveen Gallery, the fact is that the frieze was a riot of colour. The paint, which brought the sculptures to life in a way that could never be wrought in cold white marble or in bronze, was important to the overall impact, which showed men and women living and playing in harmony with their gods. As Boardman writes:

> The mortal figures behaved with the calm assurance of Gods, and the Gods fought or observed with an almost human indifference to their supernatural powers or immortality. Never before had the divine and human been so closely assimilated, even confronted, and the heroic figures, of which there were many on the metopes, and whose status lay between Gods and men, seem to demonstrate that spiritually as well as physically there was more in common between them than divisive.[18]

This is the true genius of the architects of the Parthenon – their conception of a monument to humankind, blessed by gods and by military victory, but showing ordinary citizens reaping together the pleasures of peace.

Public works, as politicians long after Pericles would discover, were a good way of ensuring full employment. As his Roman biographer, Plutarch, writing about AD 100, explains:

> The great general saw to it that his soldiers were well paid from public funds, but was anxious that the unskilled masses, who had no military training, should not be debarred from benefiting from the national income, yet should not be paid for sitting about and doing nothing. So he boldly laid before the people proposals for immense public works and plans for buildings which would involve many different trades and industries … his object being that those who stayed at home no less than those serving in the fleet or the army should be enabled to enjoy a share of the national wealth.[19]

The Parthenon provided work for many tradesman and artists, as Plutarch records:

> The raw materials were stone, bronze, ivory, gold, ebony, cypress-wood; and to fashion and work them were the craftsmen – carpenters, moulders, coppersmiths, stone-workers, goldsmiths, ivory-sculptors, painters, pattern-weavers, relief-makers. Then there were the men engaged in transport and carriage, merchants, sailors, helmsmen by sea, and by land cartwrights, and men who kept yokes of traction-animals, and drovers; rope-makers, flax-workers, shoemakers, roadlayers, and miners. Each craft, like a general with his own army, had its crowd of hired labourers and individual craftsmen organised like an instrument and body for the service to be performed; so, all in all, the various

needs to be met distributed and spread prosperity through every age and condition.[20]

By the time the Parthenon was completed, it had used up 22,000 tons of marble (considered today to be of the highest quality), quarried and transported from nearby Mount Pentelicus. It not only housed the great gold and ivory statue of Athena – now lost to posterity – but served additionally as the treasury for the Delian League, which had been partly emptied in order to build it. The modest cult statue of the goddess that had always been worshipped, cut from the sacred olive wood, was moved with the sacred olive tree to the Erechtheion, famous for the beautiful life-size statues of six (post-Elgin, five) Caryatids standing on its porch. At each end of the Parthenon was a triangular pediment depicting the city's founding myths: the birth of Athena and the struggle between Athena and Poseidon for supremacy in Attica. Another section depicted the sack of Troy. Pediment statues, later taken by Elgin, include the powerful figure of the river god Ilissos, with Putinesque chest (controversially transported on loan to St Petersburg's Hermitage Museum in 2014). Also held hostage in the Duveen Gallery are two draped and embracing (but headless) females – probably Demeter and Persephone – and 'perhaps the best-loved of all the Elgin Marbles',[21] as a former museum keeper puts it – the head of an exhausted horse, sinking into the sea after it has carried the moon's chariot across the heavens. The torso of its charioteer, and indeed the chariot and the marble sea, are now in the Acropolis Museum; the horse would be even more loved were it able to join them there.

One matter of some legal significance to the return of the Parthenon Marbles, and to the refutation of the British Museum's argument for

keeping the two lots of Marbles apart, relates to the planning and execution of the Parthenon project. All the Marbles – the sculptures on the frieze and pediments, and the ninety-two metopes – were designed as an integral part of the temple. They were a crucial part of the concept from the very outset, their subject matter and stories selected to glorify the history and the prestige of the city and its protector. They were fashioned from the same marble, from the same quarry, as the high Doric pillars of the temple, and their placing must have been incorporated in the original design. The decision to have an Ionic rather than a Doric frieze must have been carefully considered, as permitting a more realistic representation of the smooth movement of the procession. Throughout the first nine years it took to build the Parthenon, the frieze and the metopes were created at the same time as the columns were being chiselled and erected, and then hauled into their carefully prepared high places as part of the structure of the temple. These were not added adornments, but an essential part of the composition and structure of the building, sculptured precisely to fit and hard-wired into it through a careful scientific process in which holes were drilled in the marble slabs and in the columns, by workmen on scaffolds 40 feet from the ground. Buckets of molten lead were hoisted up and then poured around iron clamps and dowels of iron or wood, by which the wall-blocks and column-drums were fastened to one another.[22] The British Museum's claim that the sculptures can be appreciated individually, or in bits and pieces exhibited alongside treasures from other civilisations, simply fails to recognise that they were designed as a unity, to convey the message that, with respect for the gods and in a democracy dedicated to peace, humans could achieve happiness.

Before building even began, the master designer – whether Phidias

(described by Plutarch as 'directing all the projects and the overseer of all the artists' due to his friendship with Pericles) or a committee chaired by Pericles – had a number of crucial decisions to make. For example, the radical choice to place an Ionic frieze on a Doric building, and then to decide what subjects could be depicted in a procession so as to fit into a height of 3 feet and carry on processing for a length of 524 feet. As one expert infers:

> Since there was no precedent for a frieze of this magnitude, what inspiration did the designer draw upon to come up with the plan? Given the complexity of the frieze with over 600 figures and animals, it goes without saying that considerable forethought went into its planning in the form of either detailed drawings or full-scale models.[23]

There is, as already noted, a unity of subject matter along the four sides of the Parthenon – and this must have been planned in detail from the outset.

There were other challenges to overcome: how to fill a 524-foot frieze with a single subject and yet not bore the viewers? There had to be a decision as to which aspects of the procession should be omitted, and which could be speeded up – the horses must move at different paces, and the participants move over time (a whole day), up the sacred path to the top of the Acropolis. There are still lively disputes over interpretation of the art: there is one panel of the frieze depicting two women who seem to carry folded cloth and an older man folding a robe, helped by a youth. Parthenologists do not all agree on the meaning – is it the end of the *peplos* presentation, as most assume, or a representation of a dark side of Greek mythology, when a king was told by the oracle to kill

one of his daughters to save the city by winning in battle and the other two daughters decided to die with her? (This suggested interpretation is surely mistaken, as it would be out of sync with the festive mood of the frieze.)[24]

Whatever the theme, it was decided by the grand designer. At the British Museum, the curator, who has probably looked at the Marbles longer than anyone else, admits, 'We see the mark of a single intellect and the bringing together of thought and image in a process that attests to the vision of a single genius.'[25] The vision of the single genius was implemented by the sculptors (there were nine paid to work on the frieze) and understood by the worshippers and visitors craning their necks to follow its narrative around the wall. The frieze story, juxtaposed with the surrounding metopes and book-ended by the gods of the pediments, is one great work of art, the loss of half to the British Museum being the sculptural equivalent of tearing the *Mona Lisa* in two.

The unity of the Parthenon design refutes the museum's claim that the art it accepts to be a unique 'representation of timeless humanity' can be cut up and doled out to wealthy 'encyclopaedic' museums. It belongs on the foothills of the Acropolis, where the New Acropolis Museum enables the viewer to imagine seeing the frieze as it was meant to be seen on the temple. In London, the British Museum houses the frieze anachronistically, as if in a rectangular courtyard, and 'cut up into sections interrupted by doorways and voids. This arbitrary segmentation has, over the past 200 years, profoundly affected the ways in which the frieze has been read and misread, obscuring its character as a continuous narrative.'[26] As Professor Joan Breton Connelly puts it:

The sculptures derive their original and essential meaning from their

immediate context of one another, the sanctuary they share, and the city for which they were created. Apart from one another they are merely relics, however finely wrought … The wholeness of the Parthenon demands our respect and warrants our every effort to reunify it, such as we can. Let us, for a moment, consider the state of the central figures of the west pediment. Poseidon's shoulders are held in London while his pectoral and abdominal muscles remain in Athens. Athena's battered head, neck, and right arm are displayed in the new Acropolis Museum while her right breast remains in the British Museum. This deliberate and sustained dismemberment of what are some of the most sublime images ever carved by humankind brings shame on those who work to uphold this state of affairs.[27]

The Parthenon was, to outward appearance, a temple, of gratitude to the goddess whose benevolence had saved the city and promoted its prosperity – hence the myths of her birth and selection as city patron represented on the pediments, and her shrine and statue within. But it was also a war memorial, celebrating victories against barbarian invaders: the metopes enacted one battle against Amazons (dressed as Persians), another by wedding guests against the beastly intruders (the centaurs), and the defeat of the giants. Then beneath them was the frieze, its theme entirely secular (and unique for a temple), representing the human happiness attainable by all ranks of citizens living in an ordered democracy – a festival beginning with sport and games, continuing with talking and walking and ending in a feast in which all would enjoy the barbecued red meat and the wine carried up the slope. They also took stools for the elderly to sit upon (this is a picture of a caring community) and immigrants were depicted on the frieze,

participating in the festival. The purpose of this great artwork may be deduced from the funeral speech of Pericles (see page 40). It was to endorse his vision of democratic government, ruled by laws passed by the people and implemented by the elected marshals and magistrates who judged the festival games and kept order in the procession. It is a picture of a confident society, governed by and for 'the many, not the few' – a hackneyed phase, but since Pericles originated it, not inappropriate to describe the purpose of his project. Of course, 'the many' did not include slaves, and Marxist historians claim that power in Athenian democracy was really wielded by the wealthy – *plus ça change*. Nonetheless, the message of the frieze was to salute the Periclean ideal of democratic governance, and it can best be understood and appreciated if as much of it as remains can be put back together and seen beneath the shadow the Parthenon has cast for 2,500 years.

Britain in 2019 has an opposition leader with a commitment to government by and for 'the many not the few' and a promise to reunite the great work of Pericles and Phidias, and a new Prime Minister whose hero-worship of Pericles is said to exceed even his admiration for Churchill.[28] Whether Mr Johnson will reverse his party's refusal to countenance repatriation remains to be seen. Pericles himself emerges from history, largely written three centuries later by Plutarch, as a model leader, 'disinterested and immune to bribery' who 'did not make of his estate a single drachma more than his father left him'. In a democracy which allowed free speech he suffered the sexual scuttlebutt endured by modern politicians (his enemies said that Phidias would procure female acolytes for him when he came to check progress on the Acropolis, and they made hay with the past of his second wife, the exotic Aspasia). As for the great Phidias, he is said to have ended in prison as punishment

for carving his own likeness on a statue of a god. But their immortal work, although diminished by time and bifurcated by Elgin, continues to awe and inspire, as it reportedly did for John Keats when he contemplated them in the British Museum in 1817, and heard them say:

> Beauty is truth, truth beauty – that is all
> Ye know on earth, and all ye need to know.*29

Perhaps the greatest tribute to the skill of the architects of the Parthenon and their craftsmen, masons and inspectors is that the frieze remained on the building for over 2,000 years, until Lord Elgin's workmen used great force to saw it into pieces and pull large parts of it down from the building, damaging them in the process. The Marbles survived the civil wars with Sparta, the onset of Alexander the Great, and even the end of Athenian democracy in 322 BC. They were there to be remarked upon by Plutarch in AD 100 and to be described in a 'travel guide' to Athens published for tourists from Rome and its empire. In 395 it survived unscathed the invasion of the Goths. With the arrival of Christianity, circa 450, the building was turned into a church. It had lasted, by this stage, 900 years, and it survived this change of religion largely intact, although several of the 'pagan' metopes were deliberately broken in the process. When the Ottoman Turks conquered Athens in 1458 and built a mosque inside the Parthenon, they showed great respect for its sculptures, which were still in place in 1674, when they were carefully sketched by Jacques Carrey, an artist who visited with the

* These concluding lines are from 'Ode on a Grecian Urn', but this urn came from the poet's imagination and included other elements ('that heifer lowing at the skies') from Keats's study of the Parthenon frieze.

French ambassador. It was a war between the Turks and the Venetians in 1687 which occasioned the only significant damage before the arrival of Lord Elgin, when a shell from a cannon hit the building and caused an explosion of gunpowder the Turkish army had stored there. The roof and some of the middle colonnades collapsed and part of the frieze was damaged, and the ground was covered with rubble, including the many pieces of marble from the fallen columns and some pieces of the statues.

Otherwise the Marbles stuck to the Parthenon, through thick and thin, for 2,300 years. They were an essential part of its composition, its form and its meaning, as a temple for worship at the dawn of democracy, as the defining symbol for the Ionian race of their contribution to human progress, and now as a reminder to the modern world of a time when humankind achieved a life we call 'civilised'.

CHAPTER THREE

ELGIN: THIEF OR SAVIOUR?

For many Greeks, their governments and even their school textbooks, Thomas Bruce, Seventh Earl of Elgin, is a perfidious British ambassador who plundered the Acropolis and stole its precious Marbles for personal aggrandisement, without even offering to pay for them. For the British Museum and its stalwarts, it is a case of 'No Elgin, no Marbles'. They refer to 'the sculptures salvaged by Lord Elgin from the wreck of the Parthenon'.[30] The museum makes so much of its claim that without Elgin's 'rescue' there would be no Marbles to speak of that it is worth remembering that as a matter of English law, a robber cannot avoid conviction by arguing that he took better care of the stolen goods than the owner he had robbed. A thief is treated as a trustee of the property, and is bound in law to return it to its true owner. The issues that arise in this chapter are whether Elgin misused his authority as a British plenipotentiary in order to gain personally from wrenching the Marbles from the Parthenon and shipping them to Britain, and whether in law or morality he had any right or permission to do so.

THE ACROPOLIS BEFORE ELGIN

Greece was forcibly occupied by the Ottomans in 1458 and that status continued until its people set up an independent government in 1828,

thanks in particular to British victory at the sea battle of Navarino in 1827 (the war of independence did not officially end until 1832, with the Treaty of Constantinople). International law throughout this period required occupying powers to respect temples and places of worship or of historical or cultural significance, and it must be said that until Elgin's depredations, the Turks did protect the Parthenon from despoliation. Its religious significance was maintained by building a small mosque within its columns, although the Acropolis itself was a strategic position and there was a barracks where troops were stationed and an arsenal maintained.

Athens by the time of Elgin had shrunk from a city state to a town of some 10,000, mainly orthodox Christians with their own archbishop, ruled by a Turkish governor (the *Voivode*), with a military governor (the *Disdar*) who commanded the troops on the Acropolis and consequently controlled entry to the site of the Parthenon. The Turkish minority were ruled by Muslim civil law determined by the *Cadi* (the Chief Judge), while the archbishop had ecclesiastical law powers over local Greek Christians. Britain, France and a few other countries had appointed consuls, whose main job was to assist visitors. The ambassadors of these and other countries were a week or two's travel time away, in the Ottoman capital of Constantinople – now Istanbul – where they were accredited to the Sublime Porte. The Acropolis, as a military site, fell under the authority of the Sultan and his Ottoman government.

The Parthenon stood among rubbish that had been left after the attack and brief occupation by the Venetian army in 1687. Marble fragments lay on the ground after the explosion and a subsequent attempt by the Venetians to pillage the statues on the west pediment. This war crime failed – their cables broke and several of the massive statues were

smashed and left lying on the ground (two heads from pediment figures were taken to Venice and are now in the Louvre; one head from a fallen metope was also taken, and is now in Copenhagen). But although the Parthenon lost its roof and some of its Doric ribs in the explosion, it was far from skeletal: the greater part of its frieze and sculptures were still attached to the building by the time (1801) that Elgin's team arrived to rip them down.

Drawings of the Parthenon at that time show that the debris resulting from the 1687 explosion had not been cleared and was still cluttering the ground: slabs of the broken columns, large and small, were all around.

In the eighteenth century, tourists lured by stories of the still-standing Parthenon would scavenge around its rubble, to find and souvenir small pieces of detached marble, so long as they paid a bribe to one or other of the governors. Small pieces of the Marbles were turning up in European cities and a clandestine trade in Parthenon antiquities was under way by the time Elgin's team arrived, although the pieces were very small and the illegality of their export was emphasised by the bribe that was necessary to induce officials to turn a blind eye. No one was permitted to detach any of the sculptures, still firmly attached to the walls.

The most important, and directly relevant, precedent came in 1780, just twenty years before Elgin, when the French ambassador sent an artist and an architect to Athens, initially to make drawings and casts of the Parthenon sculptures. French influence in Constantinople was high and his enterprise was permitted, over the objection (ironically) of the British ambassador.[31] However, most significantly, the Ottoman officials refused to give the French ambassador a licence to remove any of the Marbles from the walls of the building. The best evidence of

the Ottoman government's position comes from a British MP, John Morritt, who visited Athens in 1795 and wanted to souvenir a part of a metope which was hanging loosely from the building. He told the House of Commons Select Committee in 1816 that he had been absolutely prohibited from touching it – 'they [the Marbles] were looked on as the property of the state' and the Turkish soldiers interfered to stop anyone from approaching them. The Greek populace was 'decidedly and strongly desirous that they should not be removed', and he rejected stories later put about by Elgin and his supporters that the Turks used the Marbles for target practice (and there is no evidence of bullet damage on the surviving Marbles). In other words, the occupying Ottomans were abiding by international law of the time, protecting monuments from despoliation, although local officials were prepared (for a bribe) to allow tourists to souvenir pieces that had fallen to the ground.[32] Turkish administration at local levels was wayward and corrupt, but the Sultan and his government would not countenance taking away the temple sculptures. As that is precisely what Elgin did, twenty years later, the question must be asked: how did he do it?

The preliminary answer, given unequivocally by a parliamentary select committee and its experts when considering purchase of the 'Elgin Marbles' in 1816, was that he only did it – no one else could – because he was the British ambassador, at a time when geopolitical developments had made Britain by far the most favoured nation in Constantinople. The Ottoman Empire extended to Egypt, ruled for several hundred years on its behalf by their unruly surrogates, the Mamelukes. In 1798, the French invaded, led by their triumphant young general, Napoleon Bonaparte – who brought, along with his army, 125 'savants', including Egyptologists who would gather cultural

58

treasures (they picked up the Rosetta Stone) for display in Paris. To the fury of the Ottomans, Napoleon swiftly won the battle of the Pyramids, but was then snookered by the other hero of the time, Sir Horatio (later Lord) Nelson, who completely destroyed the French fleet at the battle of the Nile. Britain formed a military alliance with the Sultan, Napoleon ignominiously fled from Egypt and all the looted antiquities (including the Rosetta Stone) collected by his experts were surrendered by treaty to the British army. When Lord and Lady Elgin arrived in Constantinople in 1799, they received the warmest of welcomes, just as French residents were being expelled. The select committee reported that, in consequence, the Turks were 'beyond all precedent, propitious to what was desired on behalf of the English nation'. Diplomats confirmed that no individual Briton (or anyone else) could have prevailed on the Turks to grant a licence of any sort in respect of the Parthenon, other than to the British ambassador and other than in gratitude for the British navy and army driving the French out of Egypt. This explains why, years later, Elgin would be accused of personally profiting from his ambassadorial position, but does not answer the question of how he actually managed to take the Marbles – in other words, what sort of licence he obtained, and whether the spectacle in Athens in 1801–03, of his workmen pulling down attached parts of this famous temple, was lawful or otherwise justifiable.

LORD ELGIN'S MISSION

Elgin was by most accounts an under-bright but overambitious Tory, a Scottish nobleman who never succeeded in his life's ambition to be made an English peer with a permanent seat in the House of Lords. He drove himself deeply into debt by building a lavish country house,

Broomhall in Scotland, although his money problems were solved when he married an heiress, the bubbly Mary Nisbet (who called him 'Eggy'). He had an uneventful diplomatic posting to Prussia and was chosen to go as ambassador to Constantinople. He may not even have heard of the Parthenon until Thomas Harrison, the architect who had built Broomhall 'in the Greek style', fired his imagination with the prospect of adorning the mansion with plaster casts of the Parthenon sculptures and paintings. It was an idea that Elgin took up with the foreign minister, and even with William Pitt, the Prime Minister, in the hope that the government would pay for his artists and workmen to travel to Athens and bring back objects 'beneficial to the progress of the fine arts in Britain'. But they declined, pointing out that there were already plenty of sketches of the ruined Parthenon. Elgin, undeterred, decided to hire a small team of experts and send them to Athens at his own expense.

Elgin's motives were not at the outset mercenary, and he had no intention of extracting or taking away any of the sculptures. He envisaged that his team would draw them and take plaster casts and that he would bring those back to Broomhall. He would benefit personally, of course, because Harrison had assured him that Broomhall would then be a beacon for classical art and would encourage more use of Hellenic style in British architecture, and this public service would help towards his quest for an English peerage. But he set out to do no more than the French ambassador had been permitted to do in 1780, namely have his artists draw and mould. Elgin would certainly have known that it was wrong to take away any original sculptures, because the French ambassador and others like Mr Morritt had been refused permission to do so. He never thought of offering to purchase them (years later, the select

committee would value them at £35,000) for the simple reason that he knew the Ottomans would not and could not sell – as an occupying force they were bound to protect temples.

In August 1800, Elgin's artists arrived in Athens, led by the Italian painter Giovanni Battista Lusieri, and began their work from a distance. It took six months before they were allowed to enter the Acropolis, and that was achieved only when they bribed the *Disdar*, paying him £5 per day. But he refused to allow them to erect scaffolding or take moulds – there were fears of a French attack on Athens, and work on the Acropolis, he explained, would require the special permission of the Sublime Porte. At this time – May 1801 – relations with Britain in Constantinople could not have been better: the Ottomans were still rejoicing in Nelson's victory at the battle of the Nile, and the British had driven the French out of Egypt, so it was a good time to ask for favours. After Elgin (who had at this stage not even bothered to visit Athens) was told by Hunt and by Lusieri that his workmen would need what they described as a *firman* to be able to access the site, he instructed a young clergyman in his employ, Reverend Philip Hunt, to draw up a request.

Now, the crunch question – was Elgin's behaviour in despoiling the ancient temple lawful? – has been answered in different ways in hundreds of books and articles, although few by lawyers. The evidence comprises only one document – a letter from a high government official received in response to Hunt's request in early July 1801. It survives in Italian (then the diplomatic *lingua franca*). Otherwise, there is no document authorising or approving the removal of the sculptures, or permitting their export by sea from Athens, although they were exported in 1801–03 and a final, delayed shipment left from Piraeus in 1810. There is a large

volume of correspondence to and from Elgin, Hunt, Lusieri and others involved in the exercise, which was made public on the centenary in 1916 of the British Museum's acquisition of the 'Elgin Collection' by its own curator, A. H. Smith, who had been retained by Elgin's family (he was a relative) and supplied with his papers for the purpose of a hagiography. Smith published an edited version, not as a book but as a book-length article in a journal,[33] in which he treats Elgin as a heroic saviour of the artworks, and he omitted anything which would cast his hero in a less than flattering light. It can, however, certainly be said that he would omit nothing that could support the museum's claim that Elgin's taking was legitimate, and the failure of any such document to make an appearance in his edited collection suggests that none exists. Curiously, Smith's research did not discover an important document unearthed many years later by Professor Robert Browning, namely a letter from Elgin himself to Prime Minister Spencer Perceval, which refers to the fact that Elgin's successor as ambassador, Robert Adair, had been told that 'the Porte denied that the persons who sold those marbles to [Elgin] had any right to dispose of them'. This, to judge from the evidence set out below, is broadly correct, although the Marbles were not 'sold' – Elgin never offered to buy them, because he knew his offer would be refused. What he did was lavishly to bribe local officials to turn a blind eye while his workmen pulled down the ornaments of the temple and took them away in crates, first to the courtyard of the British consul and thence to boats (including British warships) in the harbour at Piraeus, labelled for shipment to 'Lord Elgin. c/o Foreign Office, Downing Street, London'. In short, Elgin stripped the temple and took away its treasures in the knowledge that he had no legal right to do so. The only document he could ever produce he falsely described as a *firman*.

THE SO-CALLED *FIRMAN*

The lawfulness of Elgin's behaviour must be judged by the rules that applied in Athens in 1801. That governing law was the 'holy law of Islam' (sharia), which the Sultan (the legislator) could enunciate or amend by a formal decree, known as a *firman*. Such a document, signed and sealed by Sultan Selim III and copied in the Ottoman archives, would have been necessary to authorise the despoliation of a temple under Ottoman occupation, and neither a *firman* nor anything to this effect was ever decreed, although the archives have been repeatedly and authoritatively searched. Confusion – and historians and commentators in Greece and Britain have been thoroughly confused – has been caused by Elgin and Hunt – Englishmen abroad – claiming that they had a *firman*. Their mistake – or their lie – was taken up by the select committee, and for two centuries the debate has centred on whether Elgin exceeded the terms of his '*firman*'. So let it be clear – he never had one. What he did have was a letter – from a friend who was a high Ottoman official, but was not the Sultan – responding to Hunt's request for access, by a dispatch to the governor of Athens.

To repeat, by mid-1801 Lusieri and his workers were having trouble with the military governor, the *Disdar*, who gave them access (on payment) but did not allow them to erect scaffolding to draw and mould. So they needed a specific licence, and Hunt returned to Constantinople and drew up a request for permission for

artists ... in the service of the British Ambassador ... to enter freely within the walls of the Citadel and to draw and model with plaster the ancient temples there, to erect scaffolding and to dig where they may wish to discover ancient foundations and liberty to take away

any sculptures or inscriptions which do not interfere with the works or walls of the Citadel.[34]

It is important to note that this request asked only to model and mould, and disavowed any intent to interfere with the 'works or walls' of the Parthenon – the walls to which the sculptures and the frieze were attached. Broken sculptures dug from ancient foundations were the only objects that were requested to be taken away. The response it elicited, which Hunt and Elgin wrongly called a *firman*, must be interpreted in light of this request. It was conveyed to the Sublime Porte by the dragoman (the official Turkish interpreter at the British embassy), and the response was given in a letter of July 1801 addressed to the *Voivode*, the civil governor. It was signed by a high official, the Acting Grand Vizier Kaimakam Pascha, who had become friendly with Elgin. The original Turkish document has never been found, although Hunt kept a copy of the Italian translation. If this copy of the Italian, as translated into English, does reflect the original Turkish order, then it is clear Elgin disobeyed it.

The letter recites the request for five painters to enter and draw, and to take mouldings, and '*to dig the foundations to find inscribed blocks that may be preserved in the rubbish*', and adds that no obstruction should be given if they '*wished to take away some pieces of stone with old inscriptions*'. The five painters should be allowed '*to make moulds from their ladders around the ancient temple*' and be permitted to copy, model and '*dig according to need the foundations to find inscribed blocks among the rubbish*'; no opposition should be made '*to the taking away of some pieces of stone and inscriptions and figures*'.[35]

The reference to 'the taking away of some pieces of stone' relates to the pieces of marble that had been lying in the rubble ever since the gunpowder

explosion in the war with Venice, and which can be seen strewing the ground in all contemporary drawings. It cannot relate to stripping the walls of their fixtures, either as a matter of language or of context. The document goes on to laud the Ottoman friendship with England which justifies the granting of the request, '*particularly as there is no harm in the said figures and edifices being thus viewed, contemplated and designed*'. There was massive harm to the building in what Elgin's team was to do to it, and to suggest that this document in any way permitted that harm, or is ambiguous and might be interpreted as allowing it, is laughable. It went on expressly to prohibit interference with the artists if they set up scaffolding '*in modelling with chalk or gypsum the said ornaments and visible figures thereon, or in measuring the fragments and vestiges or other ruined edifices; or in excavating, when they find it necessary, the foundations in search of inscriptions among the rubbish*'. This was permission to enter, measure and mould, and to grub in the rubble for '*pieces of stone* [qualche pezzi di pietra] *with inscriptions or figures*' exactly as Hunt's written request had sought. What Elgin did, employing several hundred workmen, was not merely 'mission creep' – an excessive interpretation of a licence – but amounted to a taking away without permission – in other words, to theft.

It is abundantly clear from the Italian translation that neither the seeker nor the granter of permission envisaged that Elgin's men would rip down and carry off large sections of the frieze, or any of the metopes and pediment statues. The permission was carefully limited to drawings, mouldings and items found as a result of digging, i.e. 'excavating', in the rubbish. 'Inscribed blocks' and 'pieces of stone with inscriptions' were references to fragments of the Athenian treasury lists on which the payments to workmen were recorded and were being found among the rubble. But nothing was to be taken from the building, and there

was no permission given to remove or damage its frieze or sculptures. Letters from Elgin and his wife to Hunt and the artist Lusieri, written in 1801 just after the issue of the letter, give no indication of or instruction about doing more than digging for pieces of marble and 'medals'. Seizing and exporting metopes or parts of the frieze they could never have contemplated – other than as unlawful actions, requiring a real *firman* from the Sultan, which they knew would not have been granted.

Recent scholarly analysis of this Italian-language document has refuted the constant claim – even in recent articles – that it is in fact the translation of a *firman*. It contains none of the tell-tale insignia and protocol that attended such a solemn decree. For a start, it was not signed by the Sultan but by his army chief, the Acting Grand Vizier, Kaimakam Pascha, a friend of Elgin. It is not headed by the Sultan's emblem and does not carry his distinctive monogram (his name, his father's name and the prayer for perpetual victory, which was always written in Arabic). Nor does it include the routine compliments in Arabic to all who are mentioned, and, most tellingly, the formal preambles always present in a decree are entirely missing, as is the ritual formula which introduces the Sultan's command. It is not dated in Arabic, unlike all other *firmans*, and does not have the routine reference to its place of issue. However accurately it was translated into Italian, it was not a *firman*.[36] It was a letter to the governor in answer to Hunt's specific request, making clear that Elgin's team was to be allowed access to paint, mould and collect pieces fallen to the ground – not to take away the sculptures on the building. This is confirmed by the fact that in 1809 the Ottoman authorities informed the British ambassador, Robert Adair, that Elgin was never given permission to remove the Marbles. His claim that he had a *firman*, when asked to prove his title by the select committee in 1816, was either a deliberate lie

or (to give him the benefit of the doubt) a mistake in so far as foreigners were apt to refer to all government permissions as '*firmans*'.[*]

The Acting Grand Vizier was of high rank and his order should have carried weight with the *Voivode*, to whom it was addressed. He should have taken it as reason and authority to require the *Disdar* to allow the sketching and moulding and rubble-grubbing around the Acropolis to which it refers. He could not, at least without the lavish bribes he in fact received, have been induced to believe the letter directed him to give Elgin permission to strip the Parthenon. For many reasons, then, this document – the only one Elgin could ever produce to support his title to the Marbles – provides no support for the British Museum's claim that Elgin acted lawfully. On the contrary, it proves that he acted unlawfully, without permission and in full knowledge that he had no permission. It does no more than direct the governor to grant Hunt's original request for Elgin's workforce to enter without charge, to take plaster casts and pieces of marble dug from the ground. There was no agreement with the government to cut off and take away a single metope, let alone most of the frieze and the pediment sculptures. To do so was, in a word, theft.

* * *

It was in early July 1801 that the Ottoman government delivered this letter in reply to Hunt's request. It was an order addressed to the Ottoman authorities in Athens, by the Acting Grand Vizier Kaimakam Pascha. It was provided to Hunt himself, while he was still in Constantinople, and he

[*] In a presentation given on 19 February 2019 at the New Acropolis Museum, two Turkish historians (Zeynep Aygen and Orhan Sakin). who had examined all documents in the Ottoman archives relating to this period, reported that Elgin never had and never could have had, a *firman*.

returned with it to Athens accompanied by a Porte official, Mohammed Raschid Aga, whom Hunt described as 'a kind of *ad hoc* man', sent to ensure that the letter reached the local authorities and was obeyed. On 21 July, they both attended the office of the civil governor, the *Voivode*, to deliver this order that Elgin's workmen must be allowed to draw and mould – activities that the *Disdar* had barred. The *Voivode* explained to them that the ban was all the fault of the *Disdar*, who was immediately sent for. He was away, but his son arrived and was berated for his father's truculence – Raschid Aga threatened the youth that his father would be sent as a slave on the galleys if he denied access again to Elgin's workmen. The terrified youth later passed the threat on to his father, on whom it had more than the desired effect: not only were they allowed (as Hunt wrote to Elgin) to 'possess all the power of the place', but just ten days later, on 31 July 1801, these cowered officials failed to stop them from severing the seventh metope – a Greek lapith fighting a centaur – from the wall of the temple.

Raschid Aga, meanwhile, appears to have returned to Constantinople, his mission accomplished, which was no more than to ensure that the order was brought to the *Voivode's* attention and was obeyed. In all the years of debate and masses of scholarship over Elgin's seizure of the Marbles, no one thought twice about Raschid Aga – Hunt had dismissively called him an '*ad hoc*' man – until the British Museum recently began to tell tourists that it was Aga who gave Elgin permission to rip the sculptures from the temple. This, as we shall see (pages 122–4), is an invention, and a preposterous one.

From the outset, both the *Disdar* and the *Voivode* were heavily and repeatedly bribed, with money and expensive 'presents'. Hunt had cynically boasted in a letter to Elgin at the time that 'I did not even mention my having presents for him till the metopes were in motion' – although

the *Voivode* doubtless expected them. The seventh metope was cut off the Parthenon wall and lowered by twenty workmen with chains and windlasses, and then carted down to Piraeus and put on board a British ship. When it was put to Hunt by the select committee, years later, that both he and the *Voivode* must have known that the order, which they called a *firman*, did not permit such expropriation, Hunt replied, with a clergyman's care not to incriminate himself, 'That was the interpretation which the *Voivode* of Athens was induced to allow it to bear.' The inducements were of course bribes ('presents', whose cost, Hunt told the committee, he could not remember), but the bribes to the *Voivode*, the *Disdar* and even the *Cadi*, the local judge, continued for several years, mainly of money, but sometimes of horses and gold watches, telescopes, silver snuff boxes and expensive items of clothing from London tailors, and the *Voivode* received a splendid set of duelling pistols. The devious cleric assured these officials that Elgin's influence at the Porte would protect them from any consequences.

Elgin was undoubtedly 'in' on the conspiracy: 'success beyond our most ardent hopes', he wrote after Hunt told him what had happened, and he proceeded to obtain in Constantinople large saws for his workers to use to cut off the sculptured backs of the metopes to make them easier to transport from the yard of the British consul (where most of the sculptures were hidden) to be put aboard the ship.[37] Once the seizure of the seventh metope was successfully accomplished, Hunt and Lusieri's team quickly proceeded to strip the temple. They ripped off its walls six continuous slabs from the frieze and two more metopes. ('I have been obliged to be a little barbarous,' reported Lusieri nonchalantly, about sawing the backs off the metopes.[38]) Another metope was broken in the haste of removing it, and one slab of the frieze was broken on the way to Piraeus.

Elgin, residing in luxury hundreds of miles away in Constantinople, maintained an enthusiastic correspondence with Hunt, greedily urging him on to greater despoliation:

I should wish to have examples of the actual object of each thing and architectural ornament – of each cornice, each frieze, each capital – of the decorated ceilings, of the fluted columns – of metopes and the like, as much as possible … everything in the way of sculpture, medals and curious marbles…[39]

He knew he was plundering, but was unconcerned at the extent of the damage. He wasn't even in Athens to witness it until the middle of the following year. On his instructions, his workmen removed 274 feet of the frieze around the inner chamber, fifteen of the metopes from the outer entablatures, and seventeen statues from the pediments, and severely damaged the physical structure of the building by removing the large architraves above the frieze in order to break the metal pins holding the marble in place. The east pediment was partly destroyed – and lost forever – in levering and winching the statues off the building.[40] When Elgin wrote to the British government asking permission for a man-of-war to carry his booty back to London, he made no mention of how he had acquired it, simply extolling 'the valuable piece of architecture' the warship would take 'for service to the Arts in England', and adding proudly, 'Bonaparte has not got such a thing from all his thefts in Italy' – an admission, surely, that the French despoiler would be outclassed by his own 'thefts' in Athens.[41]

There is some evidence that the local Turks felt guilty. An English traveller, observing the ropes and pulleys that were carrying off a

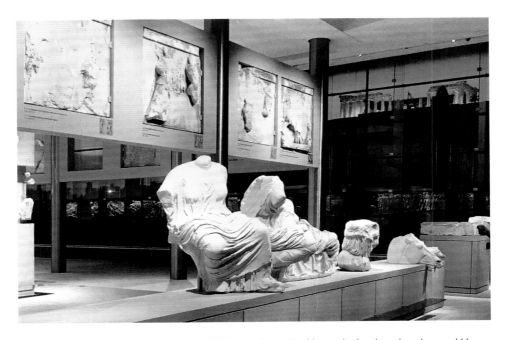

The New Acropolis Museum, top floor, where half the Parthenon Marbles are displayed much as they would have originally been seen. Along the inner wall runs the frieze; the metopes hang above and the pediment gods are upfront, looking at the Parthenon through the glass. © Acropolis Museum, photo by Socratis Mavrommatis

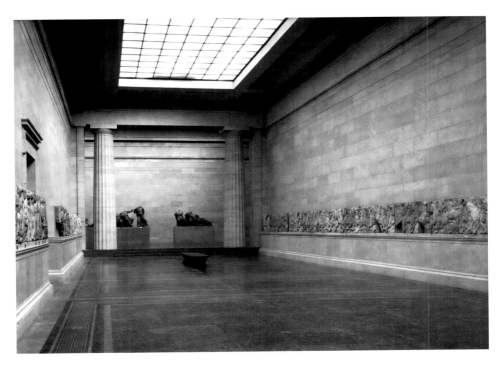

The Duveen Gallery in the British Museum where the Parthenon Marbles, stolen by Lord Elgin, have been placed around its walls. © Keystone Press / Alamy Stock Photo

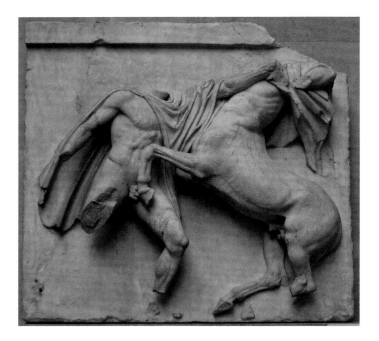

'Beyond our wildest dreams' was Elgin's reaction when metope VII was the first to be winched down from the wall on 31 July 1801. A mythical Greek youth (a Lapith) battles a drunken centaur. © Erin Leach

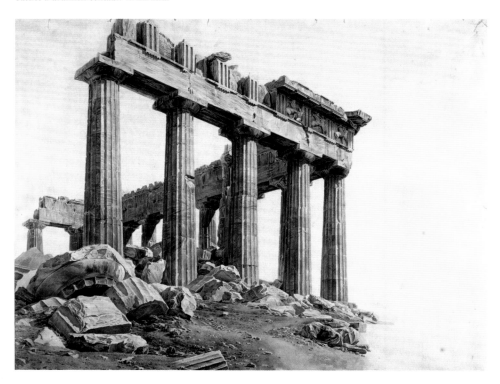

Lusieri's watercolour sketch of the south-east corner of the Parthenon in 1803 after he had torn down many of its statues. Note the blocks of rubble still on the ground from the Venetian explosion – Elgin had permission to excavate this area but not to touch the walls of the temple. © National Galleries of Scotland / Antonia Reeve

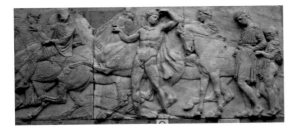
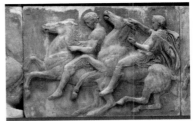

Two panels showing the Panathenaic procession proceeding easterly for 564 ft of the frieze. © Erin Leach

Movement on the monument – horses and riders left on the Parthenon by Elgin's workmen, now in the New Acropolis Museum.
© Acropolis Museum, photo by Socratis Mavrommatis

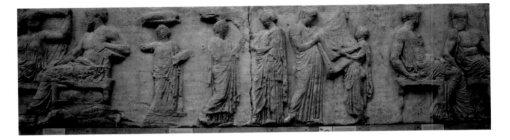

Presenting the peplos – a new robe for the goddess. © Erin Leach

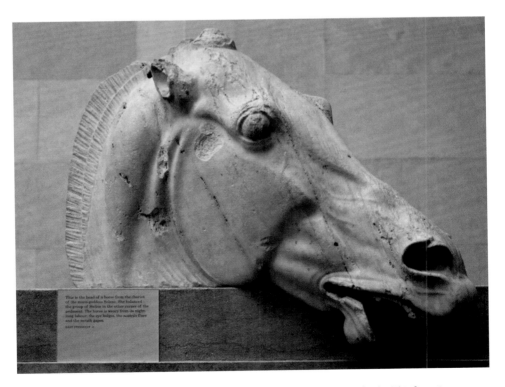

The horse of moon goddess Selene, exhausted after pulling her chariot across the night sky. This favourite of visitors to the British Museum would be better appreciated alongside Selene and her charioteer, who are in the New Acropolis Museum. © Erin Leach

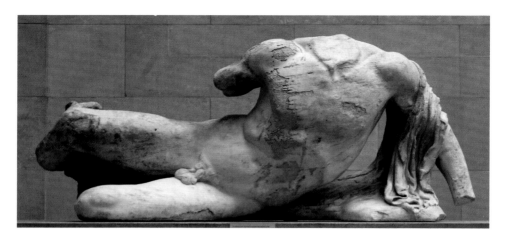

The river god Ilissos, with Putinesque chest, was dispatched from the Duveen Gallery for 'cultural diplomacy' with Russia in 2014. © Erin Leach

Inspecting the Marbles in the New Acropolis Museum: Amal Clooney with museum president Professor Pandermalis (*right*) and Greek culture minister Mr Tasoulas (*left*). © Yorgos Karahalis / Getty Images

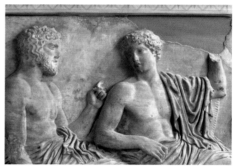

The gods sit and watch the procession on the east frieze – Poseidon and Apollo. © age fotostock / Alamy Stock Photo

Melina Mercouri telling the world in 1982 that the Marbles must come home. She was Greek culture minister and Oscar winner for *Never on Sunday*. 'Never on any day,' replied Margaret Thatcher.

© Afoi Anagnostopouloi

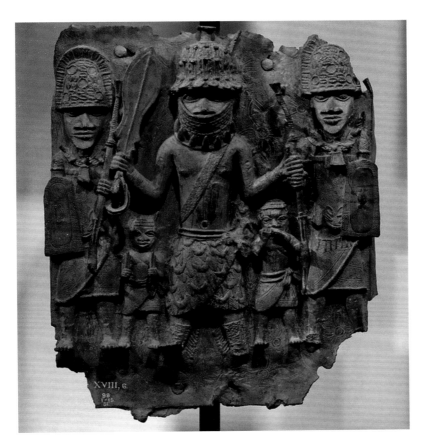

Some of the Benin Bronzes, looted by the British Army on a 'punishment raid' (which was really a raid for territory and profit). These are displayed in the British Museum. © Erin Leach

The British Army enters the citadel of Maqdala (1867) to be met by the body of King Theodore, who committed suicide with the pistol that was a gift from Queen Victoria – the only object that was not looted.
© Universal History Archive / Getty Images

The golden crown of Coptic Christian King Theodore. Although he is still revered in Ethiopia, the British government and V&A refuse entreaties to return his crown, which was looted by the British Army in the punishment raid of 1867.
© Victoria and Albert Museum, London

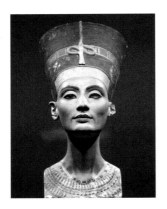

LEFT 'The beautiful one has come' – to the wrong address. Nefertiti, Queen of Egypt, in Germany. © Oliver Lang / DDP / AFP / Getty Images

BELOW Carrying the spirit of a heroic ancestor, Hoa Hakananai'a was taken from Easter Island by the British Navy and presented to Queen Victoria, who quickly had it removed to the British Museum, where it now affords a favourite selfie spot. © Erin Leach

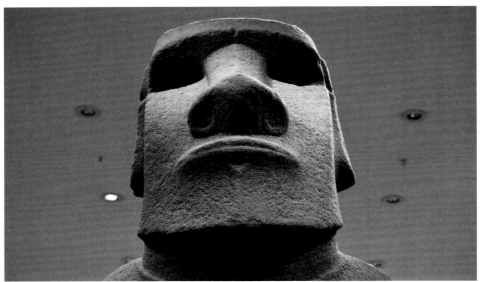

The decapitation of culture: a young Greek athlete 'discovered' by Germans in Pergamon in 1879 and removed to Berlin, last seen here in the Metropolitan Museum of Art, New York, in 2019. © Hailey Hovsepian

Michelangelo's David, which looks the same in the Cast Courts here in the V&A in Kensington as it does in Florence.

© Victoria and Albert Museum, London

Apollo, god of truth, art and poetry.

© Acropolis Museum, photo by Socratis Mavrommatis

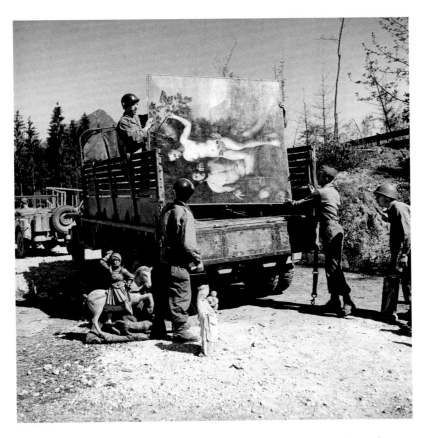

Allied 'Monuments Men' in a race to find Hitler and Göring's heists and return them. They competed with Stalin's 'Trophy Brigades', who kept whatever art they could lay their hands on – much of which is still held in Russia. © William Vandivert / The LIFE Picture Collection / Getty Images

Pet plunder – the Empress of China's Pekinese, dognapped by Lord Elgin Jr from the Old Summer Palace in Beijing before he burned it down.

Royal Collection Trust / © Her Majesty Queen Elizabeth II 2019

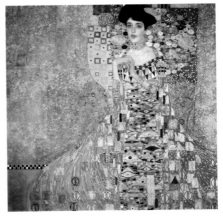

Klimt, *Portrait of Adele Bloch-Bauer I*. The Belvedere Nazis changed its name to *Lady in Gold* to hide the fact that Adele was Jewish. Austria had originally lied about her provenance, but, thanks to the US Supreme Court, she was eventually removed and now glitters in New York.

© incamerastock / Alamy Stock Photo

Members of the Tasmanian Aboriginal Centre happily hold the remains of their ancestors, covered with the flag of Australia's indigenous peoples, retrieved from the Natural History Museum after a legal battle. © Mark Stephens

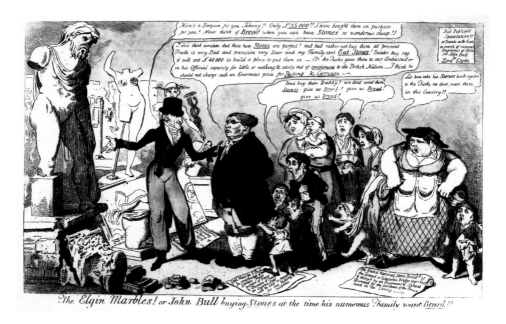

Elgin as a shyster, offering John Bull stones for a large amount of money after obtaining them for free. Bull's children, meanwhile, want bread. © Granger Historical Picture Archive / Alamy Stock Photo

metope, noticed the *Disdar* dropping a tear and crying 'Never again' as the object brought down with a crash the adjoining masonry and marble. But this wretched official accepted the bribes, accepted Hunt's deliberately distorted interpretation of the order and asked that Elgin protect him at the Sublime Porte. There is elliptical correspondence between Elgin and Lusieri which indicates that Elgin was able to obtain letters from a vizier at the Porte giving comfort to both corrupt officials, and these letters were delivered to them by Lusieri in October 1802 'in order to encourage them'[42] and to calm their fears of punishment if the Porte discovered their misconduct. These letters have never been produced, although British Museum publications speculate without the slightest evidence that they somehow retrospectively validate Elgin's breach of the terms of his licence. This is nonsense – if the letters had any legal import, Elgin would surely have kept a copy and revealed them to the select committee when they questioned him closely about his right to take the sculptures.[43] The only fact that can be deduced from this episode is that the officials felt guilty – either for taking bribes or permitting the spoliation, or both, and had begged Elgin, through Lusieri, to give them some protection. Very recently, a letter has come to light which seems likely to have been that delivered to the *Voivode*: it is from the Grand Vizier, but does no more than thank him for his hospitality to Elgin on the latter's visit to Athens in 1802, and asks him to continue to support the team's work – the only aspect mentioned is Lusieri's drawing of the monument. This was no more than a government compliment to an official about whom a favoured ambassador had put in a good word – no doubt it gave some comfort to the *Voivode*, but it cannot conceivably be regarded as a retrospective approval of action that had not been notified to the Porte.[44]

The stripping of the Parthenon walls by Elgin's team was blatantly in excess of the permission in what he and Hunt – dishonestly or mistakenly – called a *firman* – i.e. the letter from the Porte to the governor of Athens. Hunt's actions, bullying and bribing Turkish officials, were actions that Elgin knew about and quite ecstatically approved ('beyond our most ardent hopes'). Not even the British Museum propagandists can excuse Elgin on this score: B. F. Cook (formerly keeper of the Greek collection at the museum), in a book published by the museum itself, admits that 'it may be questioned whether the *Firman* actually authorised even the partial dismantling of buildings in order to remove the sculptures'.[45] Plainly it did not, and Hunt admitted as much to the select committee in 1816 when he said, euphemistically, that the governor had been 'induced' to 'extend the precise permissions of the *Firman*'.[46]

It is sometimes argued by Elgin apologists that his '*firman*' was ambiguous. It was not. The language, as translated from the Italian, makes it crystal clear that the direction to the governor was to allow Elgin's workmen only to measure and mould, and pick up or dig for 'stones' – pieces of marble – that had already fallen to the ground. The context negates any suggestion that 'stones' could mean marbles affixed to the temple, and the '*firman*' itself urges the local officials in Athens, to whom it is addressed, to give this limited permission to Elgin's agents, 'particularly as there is no harm in the said figures and edifices being thus viewed, contemplated and designed'. That was precisely what the letter intended: that his agents would view, contemplate and design (for their moulds) – rather than cause terminal harm by detaching and stealing the Marbles.

As for the claim that the Turks somehow 'condoned' Elgin's behaviour by allowing them to be exported, this too is nonsense. After being pulled

down from the Parthenon walls, the large pediment pieces and the metopes had their backs sawn off to reduce their size and weight and were then put in crates which were delivered to the yard of the British consul to await shipment. Shipment of the Marbles was effected in warships provided by the British navy or in boats like the *Mentor* arranged by Elgin, as British ambassador; so no questions were asked and no approval was necessary at a time when the relationship with the Porte was excellent. It worsened between 1807 and 1809, as a result of British support for Russia in hostilities against the Ottomans, and the last shipment, of some metopes and frieze panels, was held up. Elgin proposed further bribes to the *Voivode*[47] and enlisted the help of his successor, Robert Adair, who was told that Elgin's activities had never been approved. Extensive bribery was necessary – one Ottoman official required from Elgin 'two pistols worked with diamonds',[48] while Adair had to give further expensive presents to Turkish officials (including to Elgin's friend the Acting Grand Vizier) before permission was finally given for embarkation on the *Hydra* in April 1810. There was nothing in writing and no more than diplomacy and bribery attending this final act in the saga – once again, it is impossible to view the departure of the last spoils as any sort of 'condonation' of Elgin's behaviour, or of the misconduct of the *Voivode* in allowing his workmen to detach the Marbles in the first place. The recently discovered direction from the Porte regarding the loading of the ship refers only to Elgin having packed 'broken marbles and vases' in crates which could now be transported, indicating that the British had deliberately mislabelled the crates. In any event, there is no hint of any retrospective approval to strip the Parthenon.[49] In a circumstance of supreme irony, the *Hydra* sailed for Malta with the Marbles and an English passenger – Lord Byron – who became Elgin's most vituperative critic.

ELGIN'S MOTIVATION

Elgin's final toll was to dispossess the Parthenon of fifty slabs and two half-slabs of the frieze, and fifteen metopes, as well as various sculptures from other buildings on the Acropolis – all, as Hunt later said, that was worth taking. Under his orders, serious damage was done to the building by sawing through the frieze slabs, removing the cornice so as to detach the metopes and breaking the entablature on which they rested.[50] The words 'vandalism' and 'looting' are appropriate descriptions of Elgin's actions. He destroyed the temple, by taking all of its treasures that his agents thought were worth taking and were capable of being taken. Although he had not come to the East with pillage in mind, the circumstances allowed him the opportunity to pillage and he took that opportunity. He knew he was doing wrong, but he knew also that he would get away with that wrongdoing, because as British ambassador he had favoured status and immunity from any legal consequence. He could not resist the temptation to take what was not his to take, and did not scruple to take it by bribing its custodians. The Reverend Hunt told the select committee that he could 'not even conjecture the amount' of these bribes, but in addition to 'brilliant cut glass lustres and some horses and clothing and telescopes, firearms and other articles of English manufacture' such as gold watches and snuff boxes, there were cash payments for every piece of sculpture, estimated at £45 to £65 (many thousands in todays money).[51]

By the time he was examined about his motives by the parliamentary select committee, fifteen years later in 1816, Elgin insisted that they were pure. He had intended merely to have the sculptures drawn and moulded (which was true), until he came to Athens and realised that they were in peril of 'imminent and unavoidable destruction … had

they been left many years longer the prey of mischievous Turks, who mutilated them for wanton amusement or for the purpose of selling them piecemeal to occasional travellers'.[52] This was a lie, crafted to play to racist views in England about 'terrible Turks', although it was, in fact, they who had prevented the French ambassador, at the height of his own influence, from behaving like Elgin. The proof of Elgin's deceit is the fact that he never visited Athens at all until June 1802. The fatal first removals of the metopes had been in July the previous year, and the removal of much of the frieze had been accomplished before he arrived. His claim to have acted to save the sculptures only after seeing them in 'imminent and unavoidable' peril was, therefore, demonstrably false. It has, however, been advanced by the British Museum in all of its publications, on the basis that the end justifies the means – although Elgin may have 'exceeded' his licence, he did so to save the statues from destruction. Had he not acted to 'rescue' them, according to the museum, they would have been lost to the world for ever. 'No Elgin, no Marbles.'[53]

On analysis, the proposition that Elgin acted as a selfless saviour is clearly untrue, and the claim that without him the Marbles would have been lost to posterity is highly dubious. There can be no justification for Elgin's conduct, and no credible assertion that he obtained any property right in the removed sculptures on the basis of necessity or some kindred doctrine operative under English law. He paid nothing for them (other than in bribes) and never even offered to pay: he had no contract or any other agreement permitting him to treat them as his own possessions. In any event the applicable law on this point (and on any other question affecting title) would have been the law of the Ottoman Empire, as the *lex situs* (the law of the place) of the Marbles

at the relevant time. The British Museum has never shown that Elgin's removal of the abstracted Marbles was justified as an act of rescue under Ottoman law, or that such removal gave him title in the capacity of an 'agent of necessity'. Given that the alleged rescue would have resulted in the permanent dispossession of the party for whose benefit the 'rescue' was purportedly performed, whether the occupying Ottomans or the occupied Greeks, such an argument would be impossible to sustain.

Elgin's statement to the select committee in 1816, in which he claimed to have 'proceeded to remove as much of the sculptures as I conveniently could' when some Turkish soldiers told him that they would pound the marble to make mortar, was obviously false, because he delightedly authorised most of the removals before he ever set foot in Athens and before he spoke (if he ever did) to Turkish soldiers stationed there. His intention was to exploit the opportunity that Hunt had opened up by his bribery of the *Voivode*, and his wilful misinterpretation of the letter he called a '*firman*', to seize virtually free of charge (other than the munificent bribes to keep the officials sweet) as many priceless antiquities as he conveniently could.

It follows that the museum's narrative of Elgin as a man motivated by concern to save the Marbles for posterity is a distortion of the truth. Its claim is that 'Elgin's initial intention was to improve the arts of his country by having drawings and moulds made. He revised his plans when confronted by the continued destruction of the sculptures.'[54]

But Elgin was not 'confronted' by anything. His first visit was in mid-1802, by which time his agents had taken many of the Marbles. He only 'revised his plans' (or, rather, completely changed them) in August 1801 when he realised he could get away with a major act of

despoliation, after Hunt reported that he had taken advantage of a corrupt and frightened governor to remove a metope, and with bribes might remove other sculptures and transport them to Britain without sanction. There was no 'continued destruction' by the Ottomans. There is no evidence of the concerns he later claimed to have about the safety of the sculptures – there is no record, for example, of him even raising this so-called concern with the authorities with whom he was in regular contact at the Sublime Porte, or with MPs or Foreign Office officials, and the issue, he had to admit, was never mentioned in his dispatches.

When Elgin arrived in Athens for the first time in 1802, Hunt arranged for his and his wife's names to be carved on a column of the Parthenon: a small act of vandalism that betrays the egotism of the man and of his missionary Reverend Hunt, his eager instrument in the whole affair. Elgin's letters show no understanding of the fact that he was despoiling a temple and depriving the Greek people of their national treasure. The Marbles, suddenly, were his for the taking and he took them, knowing that he had no legal authority but that possession would be, in his case, nine-tenths of the law. And what of the Greek citizens of Athens, who lost their heritage and their main tourist attraction? Elgin, in all his letters and dispatches, never mentions them, although John Morritt, a few years earlier, had found them proud of the Parthenon and reluctant to countenance any removal, even of stones from the ground. Only once did Elgin offer them anything. That was in 1810, when he was having difficulty removing the last crate and it was suggested he might leave something for Athens, which needed a town clock. In due course, he sent a clock, but left the Albanians to pay for a clock tower.

AN AMBASSADOR'S CONFLICT
OF INTEREST

There was another dastardly aspect of Elgin's behaviour, which stemmed from the fiduciary duties which he owed his country as British ambassador to the Sublime Porte. He had, on his appointment, canvassed the Foreign Secretary and even the Prime Minister about his Parthenon project but they had declined his invitation to involve the government. Yet he used his influence as British ambassador to obtain the letter from the Acting Grand Vizier and then allowed it to be misused so as to facilitate the theft of cultural property which, as occupiers, the Turkish officials had a duty to protect. What must have factored into his thinking, in deciding to steal the Marbles, was not only his advantage in receiving Ottoman gratitude for British actions in Egypt, but his own diplomatic immunity: as ambassador he was safe from arrest or reprisals throughout his mission. These considerations came back to haunt him during the 1816 debates. There, Lord Ossulston raised the question of

> whether an ambassador, residing in the territories of a foreign power, should have the right of appropriating to himself, and deriving benefits from objects belonging to that power. It was not the respect paid to Lord Elgin, but to the power and greatness of the country which he represented, that had given him the means of procuring these chefs-d'oeuvres of ancient sculpture.[55]

Elgin's abuse of his diplomatic office affected many MPs who spoke in the debates: 'If ambassadors were encouraged to make these speculations, many might return as merchants,'[56] commented one, while another thought it 'a matter of public duty not to hold out a precedent

to ambassadors to avail themselves of their situation to obtain such property, and then to convert it to their own purposes'.⁵⁷ It was a prescient warning: Henry Salt, the British consul general in Egypt, was already emulating Elgin in trading in antiquities: he sold the colossal bust of Rameses II to the British Museum in 1817.

One leading lawyer – the MP Sergeant Best ('Sergeant' being a rank of barristers from which judges were recruited, the equivalent of 'top QC') – said that the preservation of national honour was more important than the improvement of national taste. Elgin had 'obtained the *firman* [everyone took Elgin's word that he had a *firman*] out of favour and had used it contrary to the intention with which it was granted'. Best derided Elgin's legal argument, pointing out that the *firman* gave no power to pull down and remove, and that neither Hunt nor Elgin had claimed that it did. 'The *firman* could do nothing without bribery', Best exclaimed, and listed some of the bribes that had been used 'to corrupt the fidelity of a subject of another state – the servant of a government in alliance with our own, and under obligations to us … these Marbles had been brought to this country in breach of good faith.'⁵⁸

These sentiments were widely shared in the British establishment of the time, and most MPs who spoke in the debates were critical of Elgin's behaviour, on moral and on legal grounds, but thought that since the Marbles were now in London, their theft was a *fait accompli* and they should make the best of it by obtaining them from Elgin at a bargain price. The vote was by 82–30 in favour. Most MPs, despite reservations, were prepared to support the transfer because the Marbles were present in England (they had already been displayed at Burlington House) and although they were priceless, the actual price offered to Elgin was sufficiently low that he could not be said to have benefited

financially, given that it amounted to less than half of the £75,000 he had spent to steal and transport them.

By purchasing the Marbles in 1816 with knowledge of Elgin's behaviour, the British government incurred responsibility in international law for his conduct. Elgin had used his role as ambassador to obtain the alleged *firman* in July 1801 as a diplomatic benefit of British military success in Egypt against Napoleon. The Italian copy made reference only to Lord Elgin as ambassador ('our sincere Friend his Excellency Lord Elgin, Ambassador Extraordinary from the Court of England'), not in his private capacity, and the permission granted by the signatory, the Acting Grand Vizier, relating only to moulding and to picking up pieces in the rubble, was expressed to be in conformity with 'what is due to the friendship, sincerity, alliance and good will subsisting *ab antiquo* between the Sublime and ever durable Ottoman Court and that of England'. Moreover, Elgin ordered that shipments of the sculptures were to be sent to him 'care of the Foreign Office in London',[59] a number of the shipments that left the port of Piraeus for Britain were taken or accompanied by naval vessels,[60] and the permission for the final shipment of marbles to leave Piraeus in February 1810 was obtained by Sir Robert Adair, who had to pay copious bribes, presumably at the expense of the British taxpayer.[61]

Under international law, the conduct of an ambassador engages the responsibility of a state.[62] This can be the case even when that conduct is outside his or her ambassadorial duties.[63] While Lord Elgin's own personal motive may have been that of private acquisition (or, as he claimed, bettering the situation of the fine arts in Britain), he used his ambassadorial influence and reputation in order to obtain limited permission from the Ottoman authorities, who had given it precisely because of

the favour in which the 'Court of England' had come to be held. Even the House of Commons Select Committee noted that he had used his standing as ambassador improperly in order to obtain the concession.[64]

As for Ottoman responsibility, they had no authority to alienate or relinquish title to those public monuments on their territory. Public buildings and religious monuments (such as the Acropolis monuments and any attached sculptures) benefit from a strong presumption against state divestment.[65] In any event, Greece in 1801 was an occupied nation and should have benefited from the legal protection offered to occupied nations, including protection of its religious monuments, which the Turks, as John Morritt MP explained, had always respected. As we have seen, the only licence Elgin could ever produce was the Italian translation of the Acting Grand Vizier's response to Hunt's request, which directed the *Voivode* to allow drawing, moulding and excavating, but not activity that caused 'harm' to the building – such as stripping it of its fixtures. Insofar as the local governors acquiesced in the looting, that acquiescence was unlawfully obtained by extravagant bribes, and even if the two governors who took them were never prosecuted, this does not affect the liability of Britain for lawless plundering by its ambassador. In British commercial law, pioneered shortly before this time by Lord Mansfield, any transaction procured by bribery was null and void.

NO ELGIN, NO MARBLES?

Is the catch-cry 'No Elgin, no Marbles' true? It is the British Museum's contention that had the Marbles been left on the Parthenon, where they had stood for 2,300 years, they would have been destroyed over the next thirty years. This could not have happened as a result of Turkish susceptibility to bribes, which (except for Elgin's lavish bribes to the

governors) were hitherto accepted only for small pieces dug up or lying in the rubble. The French might have made another effort when their relations with the Sublime Porte improved, but there is no reason to think they would have advanced further than their effort in 1780. As the Greek War of Independence gathered momentum after 1820, there might have been some danger to the Marbles from the fact that they were located in a military zone of strategic importance. But there is no need to speculate: there was in fact some minor damage to the Parthenon walls during the Greek army's siege of the Acropolis in 1821–22, and again when the Turks in turn besieged it in 1827, but in neither case were the remaining Marbles affected. The sculptures which Elgin had left on the walls and pediment all survived – in some measure because by this time the Greek commanders were well aware of the importance of protecting the Parthenon and orders were given to the artillery in 1822 to avoid aiming at its columns. Indeed, it was towards the end of this siege that the Greek army learned that Turkish soldiers were melting down lead clamps from the Parthenon to make bullets. One of the Greek generals allegedly offered to send a quantity of bullets to the Turks, if they agreed to stop interfering with the Parthenon.[66]

There is little doubt that the Marbles, if left in place, would have survived the vicissitudes of the war and the petty corruption of the Turks long enough to fall into the safe custody of the Greek Archaeological Service, in whose hands the Parthenon was placed in 1835. The British Museum's claim that Elgin 'saved' or 'salvaged' or 'rescued' the sculptures (that is, 'No Elgin, no Marbles') is simply propaganda. The overwhelming likelihood is that, without Elgin, the Marbles would still have been on the Parthenon when Greece won its independence, and would now be on display in the New Acropolis Museum.

CHAPTER FOUR

IN THE KEEPING OF THE BRITISH MUSEUM

In myths and Hollywood movies, there is doom in store for every tomb or temple raider from a curse or from Nemesis, goddess of revenge. The superstition certainly fits the fate of the Seventh Earl of Elgin, whom the gods (together with his creditors, his wife and Napoleon) drove slowly mad. He lost his liberty (foolishly returning through France, he was held under house arrest for three years) and then his wife had an affair with his best friend so he had to divorce her, expensively and publicly, in 1808. He lost the lower part of his nose, probably from syphilis. He lost some sculptures in transit, and many of them spent a year at the bottom of the sea before they could be salvaged from the wreck of the *Mentor*, the boat acquired to convey them to London, where street urchins were singing a ditty probably composed by Byron:

> Noseless himself, he brings here noseless blocks
> To show what time has done and what the pox.

He even lost his dreams of surrounding himself at Broomhall with moulds of the great works of Phidias – he could not afford its upkeep and had to discharge most of his servants. His creditors pressed, and

he begged the British government to buy his only notable asset – the Parthenon Marbles – which they did in 1816, for less than half his asking price. He lost his Scottish title (it was an elected peerage and he was voted out) and was denied the English peerage that he craved and which he had hoped would be vouchsafed for his patronage of classic art. He died a broken man in France in 1841, having made one contribution to the French language: the word *elginisme*, meaning the plunder of cultural treasure. Worst of all had been the opprobrium, in high society and low, when he returned to London. The Hellenic movement was by now campaigning for humanitarian intervention to free the Greeks, and Lord Byron led the demands for poetic justice on this modern Pict (an ancient Scot), who plundered and de-marbled the temple. Childe Harold, on his pilgrimage, reflects:

> But most the modern Pict's ignoble boast
> To rive what Goth, and Turk, and Time hath spar'd:
> Cold as the crags upon his native coast,
> His mind as barren and his heart as hard
> Is he whose head conceiv'd, whose hand prepared,
> Aught to displace Athena's poor remains.[67]

Elgin had to devise a counter-narrative as the prelude to selling the Marbles to save himself from bankruptcy, and this would require him to demonstrate that he had both good title and good faith. In 1810, with the help of a friend, he published anonymously *Memorandum on the Subject of the Earl of Elgin's Pursuits in Greece*, which presented him as a philanthropist who had acted in order to save the Marbles from the corrupt Turks and the greedy French. The following year he wrote to

the Prime Minister and to the Paymaster General offering 'his' sculptures for sale, at a price of about £70,000, to which should be added (he hinted heavily) his long-desired English peerage. It came as a shock to be told that the government would offer only £30,000, without the peerage.

THE SELECT COMMITTEE

In 1816, close to financial ruin, Elgin petitioned Parliament, which agreed to set up a select committee to advise on whether the Marbles should be acquired by the government, and if so, on the appropriate terms. The committee heard briefly from Elgin and the Reverend Hunt, and from a number of witnesses as to artistic worth, and reported (to Elgin's great disappointment) that the Marbles should be obtained for only £35,000, less than half the £75,000 he had spent acquiring and transporting them (the latter would amount to £9 million today). The report was debated by Parliament on 7 June 1816 and its recommendation was adopted, namely to acquire possession of the Marbles and vest them by statute in the trustees and their successors, in perpetuity, under the description (insisted upon by Elgin) of 'the Elgin collection', as if they were rocks he had collected on the beach, and might therefore be said to own. However, the committee report (contrary to what Elgin's defenders often claim) did not make any finding that Elgin had good claim to ownership. It was for the very reason that his title was so questionable that it was necessary to validate it by the Act of Parliament, which bestowed it by statute on the museum trustees.

The House of Commons Select Committee met in February and March 1816. Its task was to examine 'the authority by which this collection was acquired and the circumstances under which that authority was

granted' and then to report on its artistic merit and monetary value.[68] Elgin was its first witness, and the first question, naturally enough, was by what authority he removed the Marbles. It was a question repeated in different ways for the next hour, because it soon became apparent that Elgin could produce no written authority at all, and no sensible answer. There were general warrants, he said, that were still in Athens, but nothing that resembled a permission specifically to remove the statues from the temple. The committee seemed incredulous that a man seeking to sell his collection for £75,000 could not have kept a copy of any official document that entitled him to take them – he merely said there had been '*firmans*' that he did not have in his possession which entitled him to remove the Marbles. He had never mentioned his enterprise in his dispatches to the Foreign Office, and although he may have mentioned it often in conversation with Ottoman officials, he could not recall one single example. 'Did you not keep, for your own satisfaction, any copy of a permission?' he was asked. 'No, I never did,' was his reply. As the questioning continued, he resorted to lies about the *firmans* and how they had given him a general right to remove the Marbles from the building, and said that goodwill towards Britain at the time had allowed him to do pretty much what he wanted – he had removed the Marbles in plain view, to save them from Turks who did not care. He could not remember the terms of his permission, or what he had applied to do to elicit it – he must have made a 'quite general' application for it.[69] This evidence was, of course, false: Hunt had on his behalf made a specific application to draw, mould and excavate, but not to remove sculptures from the building.

The committee moved on to consider the artistic merit of his collection, but Elgin must have been disquieted – he had been unable to validate his title, and the committee seemed (understandably) sceptical.

There was popular feeling against the purchase – George Cruikshank expressed it in his famous cartoon 'The Elgin Marbles! Or John Bull buying Stones at the time his numerous family want bread!' 'My family can't eat stones!' complains the British everyman as he contemplates the sculptures and wonders why Elgin, having taken the Marbles for free from the Turks, wants 'such an enormous price for package and carriage'. His children cry for bread while the much-beset Mrs Bull urges him to give his 'stones' back to the Turks.

It was no doubt at Elgin's initiative that Philip Hunt was hunted down – providentially, he was in London, but without his papers, which were at his parsonage in Bedford. He was rushed before the committee as its last witness, by which time the committee had heard from a number of distinguished experts as to the great artistic value of the Marbles and the benefit of keeping them in England. Its members seem to have made up their minds that the Marbles were worthy of acquisition, and so the examination of Hunt was perfunctory, and there was no suggestion of adjourning to have the '*firman*' brought from Bedford, just sixty miles away. When asked whether it gave permission to remove sculptures from the walls of the temple, Hunt said carefully, 'That was the interpretation which the *Voivode* of Athens was induced to allow it to bear.' Hunt could not recall all the inducements given to the *Voivode*, although they included 'brilliant cut glass lustres, firearms and other articles of English manufacture'. As for the total of the bribes, Hunt was unable 'even to conjecture the amount'.[70]

The committee's proceedings were not adversarial: there was no opposing party, no cross-examination of Elgin and Hunt, no evidence from the governors of Athens or the officials of the Sublime Porte, no opinion from the law officers as to the legality or propriety of Elgin's

behaviour. Incredibly, the select committee did not ask for what everybody called 'the *firman*'. Hunt said that the original had disappeared but he had a copy, in Italian, at his home at Bedford – he was not asked to retrieve it for examination, although he later sent it to the committee with a translation in English. The failure to make any enquiry of the Ottomans makes the proceedings a travesty, so far as Elgin's authority was concerned. He lied about his motive to save the Marbles ('the prey of mischievous Turks') from 'imminent and unavoidable destruction'.

When asked whether there 'was any opposition shown by any class of the natives', Hunt confidently but deceitfully replied, 'None,' despite admissions in letters from his colleague Giovanni Battista Lusieri that 'there were murmurs' from the Greeks and the Turks as Hunt demanded various sculptures.[71] There is evidence of the *Disdar*'s distress and of the shock suffered by tourists as they watched frieze panels being winched off the building. No protest was recorded from the Greek Orthodox archbishop, spokesman for the Christian majority in Athens, and his views were not sought by the select committee.

The committee had no interest in examining the mythical '*firman*':[72]

Your Committee had no opportunity of learning from Lord Elgin himself their [the '*firmans*'] exact tenor or of ascertaining in what terms they noticed, or allowed the displacing, or the carrying away of the Marbles. But Dr Hunt, who accompanied Lord Elgin as Chaplain to the embassy, has preserved and now has in his possession a translation of the second Firman ... but as he has had it not with him in London, to produce before your Committee, he stated the substance, according to his recollection...[73]

The fact that the select committee could not even be bothered to ask Hunt to produce the only original document (albeit in an Italian translation) from his home outside London shows how, by the end of the evidence about value, the Committee had given up on its initial demand for proof of Elgin's title. Elgin had, in his letter to the Prime Minister in 1811, admitted that his successor as British ambassador, Sir Robert Adair, had told him that 'the Porte denied that the persons who had sold the Marbles to me had any right to dispose of them', but Adair was not called to give evidence and Hunt was not called upon to produce the letter in Italian that he described as a translation of the 'firman' for examination of its contents. (The English translation he sent them was annexed without comment to their report.) The evidence the committee received from its distinguished array of experts established that the Marbles stood at the pinnacle of classical achievement, and that it would be in the national interest to purchase them. The weakness in Elgin's title could be overlooked, and it was. The committee made no finding that he had any legal right to sell them, but a statute could cure any problem by vesting title for ever in the trustees of the British Museum. It recommended, to Elgin's great disappointment, that £35,000 was 'a reasonable and sufficient price', and sought to console him by recommending his appointment (and, in due course, that of his heirs) to the 'distinction' of becoming trustees of the British Museum. It said nothing about an English peerage.[74]

The weakness in Elgin's title was clear from such evidence as the committee bothered to gather. The firman that Hunt belatedly sent to them was merely a letter from a Porte official and did not authorise the ripping down and export of the Marbles, and Elgin had abused his

position as ambassador to enrich himself by taking inherent parts of the temple. Many of the MPs in the subsequent debate in the House who voted to pay £35,000 made clear that they condemned his conduct but were prepared to take advantage of it so long as he did not make a profit out of the transaction, and at £35,000 that objective would be achieved.

There was, in the House of Commons debate, no thought for the people of Athens or the nascent Greek independence movement, although one prescient MP, Hugh Hammersley, did propose an amendment whereby

> Great Britain holds these marbles only in trust till they are demanded by the present, or any future, possessors of the city of Athens; and upon such demand, engages, without question or negotiation, to restore them, as far as can be effected, to the places from whence they were taken, and that they shall be in the meantime carefully preserved in the British Museum.[75]

Hammersley's motion was too hypothetical to be put to the vote, but it reflected a view among some MPs who voted in favour of the acquisition. It was a bargain for the government (the experts had valued the Marbles more highly) and at the price paid Elgin would be denied any profit, so it would not be a precedent for other British ambassadors to abuse their office for private gain. Elgin himself was distressed at the offer, but so were his finances. Ironically, the government's money never reached his grasping hands, as it was intercepted by his creditors.

The Marbles, having been thus acquired by the government, were transferred by Act of Parliament on 1 July 1816 to the trustees of the British Museum, and described at Elgin's request (offensively to the

Greeks) as 'the Elgin Collection' and hence 'the Elgin Marbles'. The Act purported to pass to the trustees the title that the government had acquired from Lord Elgin. However, Elgin's title – i.e. his lack of it – was vulnerable to the general principle of private international law, that 'the proprietary effect of a particular assignment of movables is governed exclusively by the law of the country where they are situated at the time of the assignment'.[76] So far as the purported 'transfer' to Elgin – without consideration (i.e. purchase price, paid in money or in kind), undocumented, and procured by bribes – is concerned, the applicable law was therefore that in force in Athens in 1801–03. Sharia law in Greece under Ottoman occupation would have required express permission from the Sultan by way of a *firman* for removal of the Marbles from the Parthenon walls, and Elgin did not have it. All he could produce, through Hunt, was a letter to the governor, which did not permit detachment of the Marbles or 'harm' to the walls. It would follow, in international law, that the Marbles never became a lawful part of Elgin's property. In English domestic law, however, they were vested by the 1816 statute in the trustees and their ownership is unchallengeable in English courts.

LORD DUVEEN AND THE CLEANING SCANDAL

The sculptures were exhibited in 'The Elgin Room' of the museum until 1939. It was dingy and somewhat cramped, but the metopes with their 'brown gold patina' were at least displayed in their original honey-coloured warmth. They were gently washed, from time to time, to remove the soot and grime that settled on them in central London. But in the late 1930s they were improperly and incompetently 'whitened' by use of copper rods and wire brushes and lavish application of the

scouring agent carborundum. Original surfaces were cut away, large
sections of surface were scraped off; a worker sat in a side room for
months applying a hammer and chisel to remove the patina from the
figures of the frieze to make them 'whiter than white'. A secret internal
inquiry concluded: 'The damage that has been caused is obvious and
cannot be exaggerated.'[77]

This was a scandal and should have been a public scandal, but the
trustees were determined to hush it up. As one of them, the Archbishop
of Canterbury, wrote to the museum's director:

> I had the opportunity of a short talk with the Lord Chancellor this
> afternoon and he was of the opinion that no such express publication
> of what has happened to the Elgin Marbles should be published ...
> Certainly the last people to whom I think any statement should be
> voluntarily sent would be the Greek Government![78]

That was because the museum's case for holding on to the Marbles
was premised on the argument that they would be better protected in
the Elgin Room than atop the Parthenon, in the rising traffic fumes of
Athens, or in a museum run by incompetent Greeks. The truth, on the
contrary, was that while in the custody of the museum, an attempt was
made over two years, 1937–39, to change their colour, and that some had
been permanently damaged by methods that no competent custodian
would dream of using. Although the press got wind of the problem in
1939, it was artfully covered up: two workers were made scapegoats and
the museum misleadingly presented the episode, for half a century, as
a minor matter. As late as 1999, museum officials instructed the then

Culture Secretary, Chris Smith, to delude Parliament by stating that 'the Parthenon sculptures had been kept in very good condition – very good care has been taken of them'.[79] That was untrue.

How did this disaster – which controverted the museum's claim to be a better guardian of the Parthenon heritage than any institution in Greece – come to pass? It was the consequence of the trustees abdicating their responsibility and allowing the Marbles to fall under the influence of Sir Joseph – later Lord – Duveen, in whose donated gallery they repose today. He had made a fortune as a fraudulent art dealer, buying paintings in Europe and enhancing and misattributing them for subsequent sale to naïve American billionaires.[80] His unsavoury reputation was well known to the trustees. He suborned the art expert Bernard Berenson, who sometimes yielded to his pressure to give false attributions to the paintings that Duveen would knowingly sell at extravagant prices on the pretext that they were old masters.[81] He objected to paying tax on his profits and had been convicted in America of tax evasion as early as 1910. He was frequently in the courts, as a defendant when his victims realised they had been gulled,[82] or as a plaintiff, suing victims for defamation when they revealed his frauds. After the First World War he came to England, where he was protected by plaintiff-friendly libel laws (although they did not stop the gossip), and his money, artfully directed to political parties and royalty, soon secured him his knighthood and later his peerage.[83] He decided to refurbish his reputation by association with the Elgin Marbles, so he donated a large gallery in which to house them.

Duveen made no secret of his determination to alter the Marbles by having them cleaned until they were 'whiter than white'. He may have been ignorant of the fact that the frieze was originally brightly

coloured, although his biographers think that he was out for his own reputational dazzle. He is recorded to have said, 'Wait until you see them with their London grime removed and in their first purity. They will be luminous!'[84] Museum experts knew that this would be an historical and archaeological distortion and that the surface of ancient artefacts should not be tampered with. Nonetheless they went along with Duveen's demands for the brightest of lighting in the gallery and the removal – by wire brushes – of some of the patinas. Duveen's foreman ordered museum employees to scour the Marbles and actually to chisel away some of their precious details so they would shine more brightly. Sir Jacob Epstein, in a letter to *The Times* in 1939, fulminated that 'the ignorant and disfiguring scraping had ruined these priceless objects'.[85]

It is difficult not to attribute blame – or at least reckless indifference – to the trustees for the damage which ensued at Duveen's direction. The inquiry found as a fact that the 'foreman employed by Lord Duveen in connection with the new Parthenon Gallery had expressed Lord Duveen's desire that the sculptures should be made as clean and white as possible'.[86] The foreman had gone around pointing out that 'one of the slabs chosen for Lord Duveen to show in his new gallery was not white enough' and he ordered workmen to 'brighten it up … the sculptures should be made as clean and as white as possible for Lord Duveen'.[87]

It is quite obvious that the trustees and the museum's director, in return for Duveen's donation of 'his' gallery, allowed him to treat the Marbles as his own property and to damage and distort them until their altered state became obvious. Duveen's foreman had of course paid money to the three museum employees who did the damage, as an inducement to scour and scrape in a manner that went far beyond the museum's own cleaning protocols. The inquiry reports were kept secret

for half a century, while the museum pretended that little or no damage had been done: a workman had merely used 'unauthorised' techniques. Only when William St Clair exposed the scandal in 1998 did the museum 'come clean' and publish the reports as annexes to a paper by its employee Ian Jenkins. What is remarkable about all museum-published books is that they attribute no blame at all to Duveen, whom they always – even today – present as an unblemished philanthropist, much as they present Elgin himself. The 'Elgin Marbles', which came courtesy of massive bribery, have been proudly displayed in the Duveen Gallery since 1962, so they will glorify the image of a man who, as Bernard Berenson said, 'stood at the centre of a vast circular nexus of corruption that reached from the lowliest employee of the British Museum, right up to the King'.[88]

The display itself is deliberately distorting – as Mary Beard explains, 'it has been designed to disguise the fact that large sections of the frieze are in Athens ... Overall the effect (and the intention) of the gallery design is to efface what remains in Athens ... The Duveen effect is to squeeze that memory out.'[89] In the Duveen Gallery, the visitor cannot possibly re-capture the glory of the Parthenon, or gain any perspective or coherence in its frieze. In this 'something for everyone' museum, the Marbles are deracinated and diminished.

TO RUSSIA WITHOUT LOVE

Although the trustees will not trust Greece with a 'loan' of the Parthenon sculptures in their possession unless it acknowledges Elgin's good title, they are content to allow the director to play with their Marbles to serve 'cultural diplomacy' – which was Neil MacGregor's idea of the museum promoting human rights, by lending its treasures to countries

where rights are notably lacking. In pursuit of this proclaimed objective, the river god Ilissos, pilfered by Elgin from the Parthenon pediment, travelled to a museum in Russia in 2014, at a time when that country was being subjected to sanctions on account of its invasion of Ukraine. President Putin welcomed the god, which he personally inspected at the Hermitage Museum in St Petersburg (where he had recently closed down the British Council office), but thereafter sent more troops into Ukraine. Far from discouraging rogue states, 'cultural diplomacy' can serve to encourage them: when the museum lent the Cyrus Cylinder to Iran in 2010, President Ahmadinejad exploited the exhibition for propaganda purposes, staging at its opening a pageant in which Cyrus wore the uniform of Basij militia, the government's death squad. Sending Marbles, piecemeal, for exhibition in pariah states is hardly an act of which Pericles would have approved.

The delivery to Russia did, however, raise interesting legal issues, because the loan required an export licence, and the granting and withholding of such licences is clearly a matter of government concern and capacity to intervene, since the requirement is compulsory: museums and galleries must apply for export licences, even for a temporary loan, and government guidance points out that 'the Minister may withdraw or modify a licence at any time'. *The Times*, which was permitted to break the story exclusively and 'spun' it as a coup by MacGregor, did not enquire whether export licences were applied for, or, on the assumption that they were granted, why a government agency had permitted the loan at a time when it was imposing other sanctions on Russia.

This whole episode belies the UK government's repeated claim that it has no power over the actions of the 'independent trustees'. It did have power to permit or refuse the export of the river god through its agent,

Arts Council England. It could influence the trustees to enter into the non-binding mediation over the future of the Marbles that UNESCO has sought. The very fact that the Prime Minister, as head of the government, has the power to appoint a majority of the trustees indicates that these appointees might be expected at least to consider the government's view of the national interest. There is no indication, from the minutes of their meetings at the time, that they did.

The trustees maintain, in their publications, the position that they will not 'debate' the future of the Marbles, let alone 'mediate' over that future. The museum bookshop, near the Duveen Gallery, offers visitors an array of books on the Parthenon sculptures, carefully excluding the leading work by William St Clair, *Lord Elgin and the Marbles*, which exposed the Duveen cleaning scandal, and Jeanette Greenfield's critical and authoritative *The Return of Cultural Treasures*. It refuses to sell the best-written (and least expensive) popular book about the Marbles debate, a brilliant polemic by Christopher Hitchens,[90] and will certainly decline to stock this book. Petty censorship demonstrates intellectual cowardice: this institution does not believe, *pace* John Keats, that truth is beautiful. But it does come out: Neil MacGregor, as he was posing for *The Times* photographers beside Ilissos on its temporary plinth in St Petersburg, incautiously confessed, 'It looks much better [here] than it does in London.'[91] If the river god looks much better at the Hermitage, how very much better would he look, alongside the other statues captured by Elgin, when reunited with his counterparts in the New Acropolis Museum?

ELGINISATION

Possession (at least in English law) of the Marbles allows the trustees (in reality, the museum director) to do anything they like with them,

other than to de-accession them by restoring them to the New Acrop-olis Museum. In 2015, with sponsorship from a Swiss bank, the Phidias sculpture of Dionysius, ripped from the east pediment, was once more severed from its context and displayed alongside Ilissos, just back from Russia, and nudes from the school of Michelangelo. This temporary exhibition – 'The Body in Greek Art' – enabled the museum to extol the separated Marbles as 'for 200 years the property of Britain' and to extract an entrance fee from voyeurs keen to see 150 classic nudes and, thereby (so exclaimed MacGregor), 'to explore what it means to be human'.[92]

In 2017, the museum took some more marbles and wheeled them over to an exhibition hall to juxtapose them with works by the French sculptor whose name was the attraction – 'Rodin and the Art of Ancient Greece'. Rodin had visited the museum, but there was no other obvious connection, unless it was to make visitors wonder who was the better sculptor. Although it did enable the museum's chief Parthenologist, Ian Jenkins, to boast about 'the Elginisation of the Parthenon sculptures from architecture into art',[93] a claim both ridiculous (they have always been both) and slightly worrying – 'Elginisation' apparently being the new word to celebrate their conversion to British nationality, after 200 years' residence. They were absent from the Duveen Gallery for some months, although the removal enabled the museum, where entrance is traditionally free of charge, to make some money from Elgin's loot by requiring payment from visitors to the exhibition.

Although the British government and the British Museum have rejected all UNESCO requests to mediate over the future of the Mar-bles, an opportunity to put that future on the negotiating table came with Brexit.[94] Since the Parthenon had been declared by the European

Union in 2007 as the most important cultural monument on the continent, it might have been thought that Article 3 of the EU Treaty, which imposes a duty on the EU to enhance Europe's cultural heritage, and Article 167, which requires that all EU negotiations must 'take into account' the objective of 'conserving and safeguarding cultural heritage of European significance', would make the surrender of Elgin's ill-gotten gains a part of any Brexit deal with Britain. The issue was raised in the Greek Parliament, but the Brussels bureaucrats who pretend an interest in culture declined to take the opportunity to offer the UK a discount on its departure bill, or any other concession, as part of a deal. Nor did the UK show any inclination to dispose of the Marbles, despite opinion polls which say that the majority of its people favour their return. As it was in the process of leaving Europe, it was not prepared – even for a major concession – to leave Europe with the Parthenon Marbles.

And so, after just two centuries, the 'Elgin' half of the Marbles are to be treated as if they are no longer Greek: these immortal symbols of ancient democratic society have been 'Elginised' at the British Museum and incorporated into British culture, as if through long residence here they have acquired UK citizenship. James Cuno actually makes this argument: he says they may now be 'claimed as symbols of and vitally important to the cultural values of modern Britain'.[95] But the mere fact that they have been exhibited for a long time in London gives them no place in 'the cultural values of modern Britain' other than a reminder that this nation does not value the culture of other countries and is resistant to providing restorative justice for illegal (and, in other cases, bloody) spoliation. The Marbles, even those taken in Elgin's heist, are irrevocably the proudest part of the history of Greece, and indeed of the

world, and it is in the interests of the world (which 'universal museum' propagandists like Cuno purport to champion) that they should be reunited in Athens.

CHAPTER FIVE

THE CASE FOR RE-UNIFICATION

The Greek demand for the Marbles is the most famous and long-standing request for the restoration of cultural heritage.[96] The British Museum has repeatedly recognised that ownership of the sculptures has been 'long disputed by the Greek Government'[97] and the Foreign Office accepts that the return of the Marbles has been a 'perennial question' for the UK.[98]

It is particularly striking that UK officials for some years accepted that the arguments advanced by Greece in favour of return were compelling. At various times parliamentarians and government officials were themselves so convinced that the Marbles should be returned that the impetus for re-considering the issue of restitution often came from within the British state. The experts on Greece within the Foreign Office repeatedly gave official advice stating that the Marbles should be returned[99] and that they fell into a narrow category of works of art 'which should remain in the [Greek] national heritage'.[100] However, after Greece's claim, forcibly made by its previous culture minister, Melina Mercouri, received official international endorsement through a UNESCO declaration in the 1980s, the UK government under Margaret Thatcher made a U-turn and its approach thereafter became one

of categorical rejection of any possibility of repatriation of the Marbles to Athens.

DEMANDS FOR THE MARBLES AFTER GREEK INDEPENDENCE

The achievement of independence, in 1828–32, created a Greek state with the international standing needed to advance its claim for return with the British authorities. The first guide to the antiquities of Athens published in free Greece, by Kyriakos S. Pittakis (a prominent classical archaeologist who was to be appointed to the executive post of general keeper of antiquities),[101] stated that 'in the state of independence we are entering we will have the right to reclaim from the English nation the masterpieces of our ancestors to put them back in the place the divine Phidias chose for them'.[102]

Calls for the repatriation of the Marbles to Greece by its government commenced as early as 1833. That same year, the realisation of the full extent of the damage caused by Lord Elgin's looting prompted the adoption of legislation in Greece for the protection of cultural heritage,[103] and the establishment of a new body, the Secretariat (or Ministry) for Ecclesiastical Affairs and Public Education. This new government agency was mandated to support the excavation of lost masterpieces of art, look after those already existing and 'exercise vigilance to ensure that they are not taken abroad' – the Marbles debacle had made the preservation of Greece's cultural heritage a matter of national priority.[104]

The King of Greece ordered the Greek ambassador in London to put forward the first formal claim for restoration in 1836. The Greek delegation were told to

make it clear that the legality of Lord Elgin's act was abundantly doubtful ... even if he had a *Firman* from the Sublime Porte, the act of removing all works of art that are closely associated with the ancient glory of Greece could have been disputed in the name of human rights and it would be sad for antiquity-lovers and not at all to the credit of the British people if this restoration remained incomplete owing to looting committed in the name of Britain by the late Earl of Elgin.[105]

The Greek diplomats were rebuffed by the Foreign Secretary, Lord Palmerston,[106] as they have been ever since.

Another official claim was pursued in 1844 by the Greek conservator of antiquities, and in 1846 the British government, as if to acknowledge the shameful detention of the Marbles, presented the King of Greece with 'a complete set of casts from the Marbles of the Parthenon in the Elgin Collection', which 'the Trustees of the British Museum ha[d] prepared as a present to the Greek nation ... free of all expense'. This 'free of all expense' present was an inadequate and insulting substitute – a gift not made from generosity, but to cover the shame of wrongful acquisition. If the Marbles do come back to Greece, however, the casts (which are displayed in the New Acropolis Museum) could be returned to replace them.

Many influential intellectuals took up the Philhellene cause initially promoted by Byron. The British magazine *Nineteenth Century* published a debate on the topic in 1890–91, with an article by the editor, Frederic Harrison – a prominent Oxford academic, historian and jurist – entitled 'Give back the Elgin Marbles' setting out the case for return in terms that are still relevant today:

The Parthenon Marbles are to the Greek nation a thousand times more dear and more important than they can ever be to the English nation, which simply bought them. And what are the seventy-four years that these dismembered fragments have been in Bloomsbury when compared to the 2,240 years wherein they stood on the Acropolis? ... Athens is now a far more central archaeological school than London. Of course the sneer is ready, 'Are you going to send all statues back to the spot they were found?' This is all nonsense. The Elgin marbles stand upon a footing entirely different from all other statues. They are not statues: they are integral parts of a unique building, the most famous in the world...[107]

Calls for the restoration of the Marbles to Athens continued in the twentieth century, when parts of the UK government began not only to acknowledge the Greek claim but to accept that it was justified. In 1924, the Foreign Office advised the government that the Marbles should be returned to Greece. Harold Nicolson – then working in the Near Eastern Department – actually urged that Britain take 'the opportunity to put right an ancient wrong'.

This advice was expanded and repeated during the Second World War, when the Foreign Office commissioned an expert opinion which recognised in the clearest terms that 'everything point[ed] to a decision in principle to return the Elgin Marbles to Greece'.[108] During consultations, even the British Museum accepted that

the Greeks regard [Lord Elgin's actions] as a spoliation of their national heritage under Turkish tyranny ... The point is that the Acropolis of Athens is the greatest national monument of Greece, and

that the buildings to which the Marbles belonged are still standing or have been rebuilt. The return of the Marbles would … gratify Greek sentiment.[109]

At a time when Greece was the only European ally still fighting the Nazis, Britain was understandably sympathetic, but lost interest when Greece itself descended into civil war. Afterwards, however, further claims for return of the Marbles were made directly by the Municipality of Athens and the Academy of Athens, and the Archaeological Society. In 1961, the British Foreign Office was asked to state its position on the question and it continued to recognise the merits of Greece's claim. The head of the relevant department at the Foreign Office stressed that the Marbles had

> a close association with the history and national life of Greece and that they fall into a small and narrowly restricted category of works of art which should remain in the [Greek] national heritage … It seems to us … that the Elgin Marbles represent a special case to which special arguments apply and which would not necessarily constitute a precedent if it were decided to return them to Greece.[110]

This statement expressly recognises that the 'floodgates' argument – later repeated *ad nauseam* by the UK as a reason for rejecting the demand for return of the Marbles – is ill-founded.[111] Nonetheless, Prime Minister Macmillan did not pursue the matter,[112] and further requests by the Greek ambassador were ignored.

Between the years 1967 and 1974, there was what Christopher Hitchens describes as an 'unspoken moratorium' over the campaign to return

the Marbles when a military junta took control of Greece. It imposed heavy censorship, imprisoned many scholars and intellectuals and banned the music of Xenakis. Supporters of restitution outside the country ceased all demands on the British Museum and government, as if they all recognised that no cultural favours should be bestowed on fascists. This will become an important exception to any international rule requiring restitution of cultural treasures: not only must they be secure from war and theft but they should not readily be returned to a state that denies basic human rights to its people. On the fall of the Greek colonels in 1974, the Parthenon Marbles took on a new role as the symbol of the country's renewed democracy, and agitation for their return recommenced after Greece joined the European Community in 1981. Up to that point, with the exception of the short fascist period, there had for 150 years been official and unofficial requests for return – a fact that confounds ignorant objections, notably by John Henry Merryman (see page 126), that since Greece had not complained until 1982, it was time-barred from bringing an international legal action for their return.

In that year, culture minister Melina Mercouri, an Oscar-winning actress, launched an international campaign, saying: 'The Parthenon Marbles ... are our pride. They are our sacrifices. They are our noblest symbol of excellence. They are a tribute to the democratic philosophy. They are our aspirations and our name. They are the essence of Greekness.'[113]

Her campaign began well, gathering majority support at UNESCO's World Conference on Cultural Politics for a recommendation which stated:

Considering that the removal of the so-called Elgin marbles from their place in the Parthenon has disfigured a unique monument which is a symbol of eternal significance for the Greek people and the whole world,

Considering it right and just that those marbles should be returned
to Greece, the country in which they were created, for reincorpora-
tion in the architectural structure of which they formed part,

[The conference] Recommends that Member States view the
return of the Parthenon marbles as an instance of the application
of the principle that elements abstracted from national monuments
should be returned to those monuments.[114]

But the high profile of Ms Mercouri irritated a woman of higher
profile: Mrs Thatcher. The emollient stance of the Foreign Office was
replaced by the Prime Minister's intransigence, and her arts minister,
Paul Channon, announced her government's response: '[The Marbles]
should remain in the British Museum.'[115] He added (and this became
the UK government's refrain ever afterwards) that it could not interfere
in the affairs of a private establishment like the British Museum.[116]
This was, and still is, disingenuous: the government can interfere, as
we shall see, with a simple amendment to the British Museum Act or
with specific legislation, or simply by appointing trustees who favour
repatriation.

This British strategy of evasiveness continued in responses to Greek
requests in 1983 and 1984, pointing to the British Museum as the only
body competent to decide the Marbles' destiny.[117] The museum's trus-
tees avoided addressing the issue by claiming that their hands were tied
by the de-accession prohibition in the British Museum Act (not that
they have ever suggested an amendment to the statute or shown any
willingness to consider Greek requests for a long-term loan).

In September 1984, Greece again formally requested the return of
the Marbles through a newly available UNESCO written procedure

for seeking the return of cultural treasures.[118] Of course Britain formally rejected the Greek request, on the disingenuous basis that the trustees of the British Museum were prohibited by law from disposing of any sculptures in their collection by returning them to their countries of origin.[119] When Greece notified UNESCO of its intention to build a new museum in Athens to house all the remaining Parthenon Marbles on their return, the organisation decided to delay Greek demands until the museum was completed.

Meanwhile, the British public continued to debate the issue and by 1998 a MORI opinion poll found that a substantial majority of the population in the UK was in favour of returning the Marbles to Greece, as was a clear majority of Tory and Labour MPs.[120] Other UK polls conducted since then have yielded similar results.[121]

At last, Parliament took a hand. The House of Commons' Digital, Culture, Media and Sport Select Committee held an inquiry in 1999–2000 on 'Cultural Property: Return and Illicit Trade'. Because this seemed to offer an amicable way for the UK to decide, on the merits of the argument, the Greek government co-operated and submitted a memorandum re-iterating its position in favour of re-unification, supported by submissions from many organisations and individual experts.[122] However, the committee's report dodged the central issue, although it noted the trustees' lack of power to alienate property held by the museum, and recommended that primary legislation be introduced to deal with 'special cases' when de-accession should be expressly permitted.[123] Despite the mass of evidence overwhelmingly in favour of re-unification, this committee failed to answer the crucial question of whether the Marbles were a 'special case'. Its recommendation to end the absolute prohibition on de-accession has been ignored.

Still, the Greek government persisted in its efforts to leave no stone unturned to obtain the return of its stones through diplomatic channels. Between 1982 and 2005, UNESCO's Intergovernmental Committee for Promoting the Return of Cultural Property to its Countries of Origin or its Restitution in case of Illicit Appropriation adopted eight resolutions on the Marbles (in 1983, 1989, 1991, 1994, 1997, 1999, 2003 and 2005) calling on the UK government to negotiate, but all were refused.[124] The UNESCO committee has since then issued further resolutions favouring return of the Marbles in 2007, 2009, 2010, 2011, 2012 and 2014.[125]

THE UK REFUSES UNESCO MEDIATION

Finally, in desperation over an issue that had consumed much of its time, money and supply of paper, UNESCO asked the UK to enter into mediation with Greece. On 26 March 2015, the trustees of the British Museum and the UK government replied: their letters were separately addressed to UNESCO, but their positions in rejecting mediation were identical – thus exposing the nonsense parroted for the previous thirty years about the museum's independence from government. The museum minutes for 2015 reveal no discussion of the UNESCO request, which suggests that the trustees failed to consider it properly and independently. The government's position was expressed thus:

> The Parthenon sculptures in the British Museum were legally acquired by Lord Elgin under the laws pertaining at the time and the Trustees of the British Museum have had clear legal title to the sculptures since 1816. Neither the British Government nor the British Museum are aware of any new arguments to the contrary since 1985, when a formal

Greek request for the return of the sculptures was turned down by the British Government.[126] We have seen nothing to suggest that Greece's purpose in seeking mediation on this issue is anything other than to achieve the permanent transfer of the Parthenon sculptures now in the British Museum to Greece and on terms that would deny the British Museum's right of ownership, either in law or as a practical reality. Given our equally clear position, this leads us to conclude that mediation would not carry this debate substantially forward.

In addition to the matter of clear legal title, a further relevant factor is that the Trustees of the British Museum are prevented by law from de-accessioning objects in the Museum's collections unless they are duplicates or unfit for retention.[127]

The UK position is that it will not mediate, and that no political or diplomatic solution to the Marbles issue is worth exploring. It is a position based on the false claim that Elgin acquired legal title in the Marbles, and the incredible claim that the government was unaware of any new argument since 1985 – everyone knew about the New Acropolis Museum, built expressly to receive all the Marbles, which opened in 2009.

This refusal was the culmination of almost two centuries of efforts by Greece to engage the British government and the British Museum in meaningful discussions concerning the return of the Marbles to their original and natural location. The message could not be clearer: the trustees of the British Museum, in tandem with the Conservative government, will always oppose any re-unification of the sculptures at Athens. Although the trustees have their hands tied by the terms of the 1963 Act, they have never suggested that the ban on de-accession

should be removed (other than once, in respect of Nazi loot). The recent statements rejecting UNESCO mediation make clear that the trustees believe that these 'Elginised', i.e. now 'British', Marbles must never be returned to Greece. If the museum prevails, the world will never again see all the surviving pieces together in the place where they were created. If asked, 'Do you oppose for all time the collective presence of the sculptures at Athens, however ardently the people of the world would like to see them reunited?', the trustees would answer 'Yes'. In this manner does the museum show its disrespect for the integrity of monuments and for the study of architectural elements in their original setting. Its refusal to enter into mediation or any manner of independent adjudication probably indicates an awareness of the weakness of their case but is an insult to the developed policy within Europe and elsewhere in favour of the consent-based amicable resolution of cultural property disputes (and disputes generally).[128]

The arguments against re-unification have chopped and changed since that first debate in 1816: they have ranged from pettifogging (de-accession is against the law) to pragmatic (de-accession would be bad for British tourism) to idealistic – the allegedly noble cause of the 'encyclopaedic' museum. For seven years, from 1967 to 1974, the argument against returning the Marbles to a fascist dictatorship was conclusive but is now heard no more. Another that has faded, although persuasive in its time, was that the sculptures could not be restored to the building itself, to endure the smog and traffic fumes arising from the city of Athens – a point accepted by the Greek archaeologists who themselves removed the surviving Marbles to the shelter of the old Acropolis Museum. Although it stood on the edge of the citadel, it was a dilapidated and crumbling building, but it has since been replaced

by the splendid new museum with a top floor devoted to their display, within view of the Parthenon – the optimim environment for an integrated exhibition of all the Marbles. Although the British Museum's curators of Elgin's loot are devoted, their curatorial skills cannot compare with the Greek archaeologists and historians employed in Athens – by a museum that can attract all the leading experts. If the question is (as it should be) where the Marbles can, if reunited, best be curated and cared for and appreciated by the international public, the answer must be in Athens, at the New Acropolis Museum.

THE CASE FOR THE MUSEUM, REFUTED

However, other arguments have been advanced for retaining the *status quo ante*. The parliamentary select committee in 2001 summarised (without evaluating) six propositions then put forward by the museum, and there are a few further arguments that can be found in the extensive literature on the subject (more than 100 books and chapters in books, together with hundreds of monographs, papers and articles both learned and unlearned). The UK propositions are as follows:

Proposition 1: The Elgin Marbles are properly
and legally held by the British Museum
This is designed to avoid the all-important questions of the legitimacy and propriety of Elgin's taking of the Parthenon Marbles by diverting to the trivial and uncontroversial question of their legal status in the UK as artefacts placed by statute in the possession of the museum. That question was settled by Act of Parliament in 1816, whereby the property that it described as 'the Elgin Collection' was vested in the trustees of the British Museum. That property – it referred to 'ancient marbles and

sculptures' which had been 'collected' or 'assembled' by him – thereupon passed in British law to the trustees, irrespective of whether Elgin himself had good title or bad title or no title at all. Parliament, by passing statutes, creates law which cannot be gainsaid by domestic – that is, English – courts. Thus it follows that Greece could not bring a successful claim in English courts for return of its property – they are bound to apply the law of England, which is that the trustees are owners, whether rightful or not.[129] Of course (and it may be, crucially), this would not stop an international court from looking at the true facts set out in Chapter Three of this book and concluding that Elgin had no better a title than a thief, and that Parliament had knowledge of this fact (the select committee reported that he had 'exceeded' his licence and did not make a finding that he had property in the Marbles), therefore the museum trustees cannot prevail against an action on behalf of the true owner, the state of Greece.

The international law issue will be discussed in Chapter Six: for the present, the museum's proposition about its 'legal' ownership is only true in this technical sense. And its claim that Elgin 'acted properly' may be dismissed out of hand. It well knew – all MPs and trustees at the time knew – of Elgin's serious conflict of interest, and how he had abused his ambassadorial position in the hope of private gain and public glory. That was the very reason he was paid less than half his expenses, and one good reason why his much-coveted English peerage was refused.

The illegality of Elgin's taking of the Marbles is set out in Chapter Three. His letter of authority (repeatedly but wrongly identified as a 'firman') specifically directed the governor of Athens to allow only the making of moulds and collection of 'stones' from the rubble

– implicitly, it prohibited the stripping of the decorations from the structure itself, and both Elgin and Hunt admitted their lack of authorisation. Their success was achieved – as Hunt admitted – by extensive bribery of two corrupt Turkish governors, paid to turn a blind eye. The museum cannot pretend that this conduct was somehow retrospectively approved by the 1816 Act, nor was it approved (as some of its supporters have suggested) by the Ottomans raising no objection to the transport ships (some of them British warships) leaving Piraeus with the monuments on board. As for the suggestion, made in some British Museum publications, that Elgin obtained 'letters' from the government retrospectively approving the criminal behaviour of the two officials, these have never been produced and are only briefly mentioned in one letter from Giovanni Battista Lusieri, Elgin's Italian overseer. When one such letter was recently found in the archive, it merely thanked the *Voivode* for his hospitality to Elgin on his visit to Athens and urged continuing support of Lusieri's project of drawing the Marbles, not of removing them.

The museum's argument gives rise to one logical absurdity. If Elgin's title to the Marbles was good, why was an Act of Parliament necessary to vest them in the trustees? They were entitled to receive objects by gift, or to purchase them, and no statute was needed to convey or confirm their title. Once the amount of the payment had been agreed, Elgin could simply have donated the Marbles to the museum in return.

The inference must be that Parliament passed the Act because the select committee had not made a finding that Elgin had a good title, and it was necessary to repair any defect by transmitting to the trustees a title by statute which could not in consequence be challenged. There

is ample evidence in the debate that MPs knew of the defects in Elgin's title, and presumably intended to pass a law that would cure them, as well as to approve the payment of £35,000. The Act was a device to preclude any investigation into those defects at the instigation of other interested parties – such as the Ottoman Empire, the city of Athens or the people of Greece. It was, in effect, a laundering device – the first 'whitewashing' of the Parthenon sculptures.

No international tribunal should accept a title acquired under such dubious conditions. Any such tribunal must take account of the current state of international law,[130] the growing influence of international law on domestic law,[131] and the British Museum's professional undertaking to keep abreast with developments in the law. These last-mentioned developments must include developments in international human rights law and customary international law, both of which can affect the integrity and direction of museum collections and collecting practice (see Chapter Six). In other words, legal developments are not confined to developments in English domestic law. A state cannot under international law legitimise the unlawful acts of its citizens in foreign countries by its own retrospective legislation, any more than the Nazis could pass laws vesting title in expropriated artworks in their own museums or Napoleon could legitimise his art thefts in Italy by donating them to the Louvre. An international court should withhold force and credit from a law passed in 1816 which purported to legitimise the unauthorised looting of a temple belonging to another country.

It follows that the British Museum's first proposition is otiose. It lawfully holds the Parthenon Marbles, under the alias of the 'Elgin Collection', because of a statute passed by an English parliament, but

for no other legal reason. The passage of this statute was to enable the purchase of cultural treasures that had been unlawfully and improperly acquired and should now be returned. This cannot be ordered by an English court, but may be made subject to an order (or at least an 'advisory opinion') by the International Court of Justice, the European Court of Human Rights or an *ad hoc* arbitral tribunal. The Marbles may also be returned, without court action, by the British government if it repeals the rule against de-accession (either generally or specifically in respect to the Marbles), and, if necessary, appoints trustees who are in favour of restitution.

Proposition 2: The Marbles 'are displayed there in the British Museum in the unique context which permits the intellectual and visual comparison of the art of great civilisations'

This is the 'encyclopaedic' or 'universal' museum argument which figured most prominently in the museum's refusal even to discuss any future for the Marbles other than in the Duveen Gallery (or anywhere, if the trustees are so inclined, other than in Greece). Its fallacy is obvious: the museum does contain artwork from different civilisations but makes little attempt to compare them with the Parthenon Sculptures, because for the most part they are incomparable. It does not offer 'intellectual and visual comparison' except when it brings in some Rodin sculptures for juxtaposition with marbles torn from their context. The 'art of great civilisations' on display is for the most part so removed from classical Greece as to defy comparison: colourful headdresses from Africa, tribal decorations from the South Pacific, Egyptian tombs and mummies – what have these to do with the work of Pericles and Phidias? The Parthenon is a non-pareil, to be visually and intellectually

appreciated as it was designed – with the unity described in Chapter Two. It is understood by being restored to that unity, not by comparison with totem poles, fish traps, armour, funerary offerings and mummies from other times and places.

For all the museum's efforts to theorise about its right to these Marbles to enable it to offer a 'universalist experience', its argument comes apart when it tries to explain that experience. And it does, in a publication by the senior curator of its Greek collection, Ian Jenkins.

He begins by lauding 'the cosmopolitanism of the "something for everyone" museum, predicated on a pluralist idea of history where the making and understanding of one culture informs and is informed by knowledge of others'.[132] This 'something for everyone' approach is then illustrated by juxtaposing that section of the frieze which shows boys bringing a lowing heifer to sacrifice, with a recent photograph labelled 'Masai youths restraining a bolting cow'. The frieze sculpture of horsemen preparing their steeds for the cavalcade is juxtaposed with a picture of an English fox-hunt meeting outside a Georgian mansion. Pictures of Assyrian torture then appear, with the explanation: 'This kind of documentary cruelty was avoided in Greek temple sculpture.'[133] These are the given examples of the 'something for everyone' museum, where 'one culture is informed by knowledge of others'. This is nonsense. Fox hunting, Masai herding and Assyrian torture impart no 'knowledge' of any kind about the Marbles. These comparisons are wholly inapposite. They in no way afford either an 'intellectual' or a 'visual' comparison 'of the art of great civilisations'.

The 'encyclopaedic museum' concept has been criticised in Chapter One.[134] It may provide a few 'gee-whiz' moments for the conga-line of school children pressing their noses to the glass encasing the fragments

of long-lost civilisations, but a treasure as momentous as the Parthenon Marbles needs a museum all to itself for true appreciation. In Athens they would be exhibited in a specially designed space, highly praised for its conception and execution, containing most of the other remaining pieces from the Acropolis and within vision of the Parthenon itself. That is the most appropriate and most compelling context in which to see the sculpture, not on the grey walls in the Duveen Gallery, to be seen for a few minutes by tourists who have just viewed the Rosetta Stone and are keen to move on to see the Egyptian mummies.

Proposition 3: 'The Marbles are now irrevocably established as museum pieces and their return to the structure of the Parthenon to which they originally belonged is not envisaged'

This is not an argument against re-unification. It is obvious to everyone that the Marbles cannot be stuck back on the Parthenon. The question is whether the 'Elgin' Marbles belong in a gallery in the most congested and petrol-fume-ridden part of London, or with the rest of the surviving Marbles in a gallery beneath the Parthenon. However, under this head comes, *sotto voce*, the argument for 'Elginisation' – the idea that the Marbles have been in the museum for 200 years ('longer even than there has been a modern state of Greece') and in their whitened and scrubbed form, highlighted in the Duveen Gallery or wherever else the trustees may separate them for individual exhibition, they have somehow transmogrified into a form of British art, or at least (as James Cuno puts it) may be 'claimed as symbols of and vitally important to the cultural values of modern Britain'.[135] This claim is breathtaking but seems to be how museum officials actually feel when they speak of

'Elginisation' – they are giving visitors an experience in the Duveen Gallery which is quintessentially British, like the tea and scones served in the restaurant upstairs. What is missing, in this reductionist view of the Marbles, is any sense of their meaning to the democratic world – wherever peoples may live in democracies, this is the start of their kind of society. The real question is where they can best be seen, and however lovingly they have been cared for by British foster parents, there can be no place like their Acropolis home.

Proposition 4: 'The Marbles are freely accessible in the British Museum to over five million visitors a year, three quarters of whom are from abroad'
The sculptures would of course be equally accessible in Athens, which has five million tourists each year, and in a far more authentic context. If the Marbles were returned, the proportion of foreign visitors in the New Acropolis Museum could well exceed three quarters of all entrants once the massive initial attendance from the Greek public had subsided. It has been estimated that less than 40 per cent of the visitors to the British Museum visit the Duveen Gallery, where the sculptures are held (the Rosetta Stone has the most visitors), and there is no evidence that tourists would not visit the museum if the original sculptures were not among its many exhibits, replaced by plaster casts. At the Acropolis Museum, of course, 100 per cent of its visitors see the Marbles, while those visitors to the British Museum who do walk through the Duveen Gallery do not, for the most part, linger long – there are other treasures to see before closing time and although entrance to the building is free it will cost them to go into a 'special exhibition' space if individual marbles are on display. In any event this argument says nothing about the quality of the tourist experience, so much more informative

and overwhelming were the Marbles to be experienced together in an Athens museum devoted to their study.

Proposition 5: 'Removal of the Marbles to Athens would encourage similar claims for other objects from other countries which would undermine the comparative principle at the heart of the British Museum's purpose'

The 'comparative principle' is not a 'principle' and does not reflect the way many visitors experience the museum. Schoolchildren, for example, are taken for their studies only to the relevant gallery or galleries; visitors may feel awe or excitement in several galleries, but not because they are 'comparing' them. In any event, the pleasure of comparison should yield to justice and to the imperatives of cultural and institutional integrity. Claims from other countries for other exhibits must always be addressed on their merits, even though none will be for objects as important internationally and as precious as the Marbles. The British Museum owes in any event an ethical responsibility to involve and respect the interests of 'originating communities'. The Code of Ethics for UK museums urges them to 'deal sensitively and promptly with requests for repatriation both within the UK and abroad', not to discourage them or to reject them on some 'comparative principle'.

This objection has regularly been raised, especially by British politicians: repatriation of the Marbles would 'empty the British Museum' by leading to an avalanche of claims for other cultural treasures. Advocates for the Marbles at first went out of their way to deny this, pointing out that the Parthenon sculptures differ from other museum objects in that they emanate from a unique and surviving monument, and their return to Athens would carry negligible weight as a 'precedent' for other acts of return. As Frederic Harrison said in 1890, the Parthenon sculptures 'stand upon a

footing entirely different from all other statues. They are not statues: they are integral parts of a unique building, the most famous in the world...'[136] And, as the Foreign Office has acknowledged, the Marbles 'represent a special case to which special arguments apply and which would not necessarily constitute a precedent if it were decided to return them to Greece'.[137]

But now the debate has changed, and it is time to abandon this exclusivist defence in favour of admitting that restitution of the Marbles might well encourage further claims, although (because the Marbles are unique) not necessarily successful ones. As a first and best claim, the case for the return of the Marbles is built upon arguments some of which do apply to other cultural treasures, and their repatriation should be considered by the same criteria. The Benin Bronzes, for example, constitute art which is important to Africa, but not to the world in the way that the Marbles have international resonance. On the other hand, the barbaric manner of the taking of the Bronzes amounted to a war crime, which is morally more despicable than Elgin's theft and duplicity. The arguments that must be addressed, and the factors that must be weighed, considering restitution for the Parthenon Marbles can helpfully be applied in other restitution disputes. It is the best-case scenario because of their supreme importance, to the world as well as to Greece, and it is a re-unification, not only a restitution. However, the factors in favour may well be adopted in submissions supporting other claims – some of which, as will be contended in Chapter Seven, deserve to be successful.

Proposition 6: 'Removal of these and other objects from the British Museum could discourage potential donors from making gifts to the British Museum'
Wrongful actions by great institutions are not usually justified by mercenary motives: the Catholic Church could not excuse its cover-up of child

abuse on the grounds of its need to protect its reputation and donations. In any event, the hypothetical proposition may turn out to be entirely mistaken – restitution of the Parthenon Marbles would add to the integrity and lustre of the British Museum, and perhaps attract more donors, whereas a continuing refusal even to discuss return may alienate potential supporters, just as the National History Museum did at first by trying to experiment on, instead of returning, the Tasmanian Aboriginal remains. The loss of the original Marbles makes little difference to a museum with ninety other galleries, in which there is space only to display a small fraction of its 8 million acquisitions. There is no need for the Duveen Gallery to stand empty: it could then feature all the Marbles, in life-like colour on plaster casting. With a bit of imagination, it could present a sound and light show about the building of the Parthenon and the advent of democracy in ancient Athens, with virtual appearances by Pericles (perhaps voiced by his fan, the British Prime Minister) and Phidias and an excerpt from the National Theatre's *Antigone*. Whatever, the museum could certainly rise to the challenge of making substitute Marbles meaningful, and in nearby rooms it has authentic Greek temples and statues from the same period to satisfy its so-called comparative principle. The very act of restitution, if done willingly and in the right spirit, could only add to the museum's international fame and reputation.

Proposition 7 (circa 2018): The mysterious Raschid Aga
The arguments over the legality of Elgin's despoliation of the Parthenon have raged for two centuries, but the books and learned articles and statements from the British Museum and evidence to the parliamentary enquiries in 1816 and 2000 concentrated on the supposed '*firman*' – whether it was indeed a *firman* or just a letter to the *Voivode* from the

Acting Grand Vizier, and whether Elgin had exceeded its terms. The British Museum was losing the argument, as even its own supporters acknowledged that the letter to the governor of Athens gave no direction to allow Elgin to pull down the frieze and metopes attached to the Parthenon. There had been no permission to export the Marbles: most had been shipped without seeking any permission, until the last lot was delayed by worsening relations with Turkey, when permission was obtained by bribery and diplomacy. It is astonishing, therefore, that very recently there has appeared, on a wall at the entrance to the Duveen Gallery, a large notice that tells visitors a new and very different story to justify Elgin's behaviour. Having said erroneously that he had obtained a *firman* which allowed his men to work without disruption to remove 'any pieces of stone with inscription and figures' (it does not say that such pieces had to be found among the rocks and rubbish), it goes on: 'The letter was delivered by a senior Ottoman official, Mohammed Raschid Aga, who outranked all other officials in Athens and he agreed to the removal of sculptures from the Parthenon itself.'

This is, quite simply, false. Raschid Aga was a 'moubashir' – an Ottoman official based in Constantinople, not in Athens, who accompanied Reverend Hunt to Athens to deliver the letter from the Acting Grand Vizier to the *Voivode*, directing that Elgin's workmen should be given access to the Parthenon to draw, mould and excavate 'stones'. He is described somewhat dismissively by Hunt as 'a kind of *ad hoc* man' who had been assigned to him to see that the order was obeyed,[138] and he helped at the meeting with the *Voivode* by threatening the *Disdar*'s son if it was not. But that is the only reference to him in the voluminous correspondence about the Marbles, other than a brief mention the following year of him helping to get a bribe (a horse and a cape) to the *Voivode*.[139] There is no

suggestion that he was empowered to give any approval to the removal of the Marbles from the Parthenon itself (which required a *firman* from the Sultan), and it is inconceivable that any such approval, had it ever been given, would not have been invoked by Elgin and Hunt when they were quizzed on this very point by the select committee. It is also bizarre that Raschid Aga has not previously been mentioned in publications by the museum and its supporters in defence of Elgin, although he now appears to be the sole basis for the museum's assertion that Elgin acted with 'the full knowledge and permission of the Ottoman authorities'.[140] He had no permission, as the Ottomans confirmed to his successor, Sir Robert Adair, and it is perhaps a sign of desperation that the museum should now rely on this obscure and inconsequential official, who was not, as it alleges, the senior official based in Athens and who had no conveivable power to authorise the spoliation of the Parthenon.[*]

DE-ACCESSION

The first six propositions above were put forward by the British Museum as its submission to the parliamentary select committee in 1999, which made no judgement other than to recommend, in vain, the amendment of the rule which prohibits de-accession. Twenty years on, and after the opening in Athens of the New Acropolis Museum, these propositions are heard less frequently, and the only new one concerns the mysterious Raschid Aga. But there remains the old chestnut about the museum being prohibited by law from returning the sculptures because of the ban on de-accession, which is an argument about changing the law, not against reuniting the Marbles. This ban on de-accession arises because the 1816 Act vests 'The

[*] It may well be that resort to Raschid Aga came after the 'leak' of the Robertson, Palmer and Clooney report in 2015, which reflected arguments based on the so-called *firman*.

Elgin Collection' in the trustees, as a body corporate, and Section 3(4) of the 1963 British Museum Act lays down that 'objects vested in the Trustees as part of the collection of the Museum shall not be disposed of by them'. So the museum, while it may grant a loan of the Marbles, cannot de-access them from its collection, as the law stands. But that law can simply be amended, either by excluding the Marbles or (preferably) by giving the trustees a general discretion to de-access so they can also return, for example, the Benin Bronzes or other cultural property seized in colonial wars.

There are several examples of Parliament making such amendments, most recently in the case of the Constitution of Australia, passed by the Imperial British Parliament in 1901 and required by law to be held in the Public Records Office. It is a turgid document, devoid of literary merit or cultural significance (other than for lawyers), and there are thousands of printed copies available. Nonetheless, when the Australian government, after ninety years, saw it on loan in a travelling exhibition and asked to possess it, a simple amendment did the trick: 'The Copy of the Commonwealth of Australia Constitution Act 1900 which at the passing of this Act is on loan to the Commonwealth of Australia shall cease to be included in the public record to which the Public Records Act 1958 applies.' A similar simple formula could be used to allow the release of the 'Elgin' Marbles from the lock imposed on the trustees by the British Museum Act.

There have been two other examples. In 2004, Parliament passed the Human Tissues Act 2004, Section 47 of which entitles museums to return human remains still in their collections to tribal descendants and others with good claims of kinship – this amendment paved the way for Tasmanian Aboriginals to recover the skulls and bones of their ancestors from the Natural History Museum. Then there was the Holocaust (Return of Cultural Objects) Act of 2009, passed after public concern at a Court of

Appeal decision which stopped the trustees of the British Museum from de-accessing and returning to their original Jewish owners artworks stolen by the Gestapo.[141] The trustees in that one case had been on the side of the angels, accepting the right of victims of crimes against humanity to have the stolen property returned to their families. Nonetheless, the court ruled, as a matter of statutory construction, that the prohibition was absolute – what was in the British Museum had by law to stay in the British Museum, unless Parliament moved to amend Section 3(4) of the 1963 British Museum Act.[142]

There would be nothing unusual or difficult in such an amendment, although once it was passed there would still need to be a decision by the trustees to relinquish possession of the Marbles to the New Acropolis Museum. Presumably they would do what the government wanted (except in the case of Nazi loot, they always have), but if they proved truculent there would be a simple solution. Of the twenty-five trustees, one is appointed by the monarch and four are nominated by royal institutions, and five more by the trustees themselves, but the remaining fifteen – a clear majority – are appointed by the Prime Minister. So if the government wanted the Marbles returned, it could simply appoint trustees who favoured this course and who would themselves appoint five members who shared their view. In reality – as a matter of law – the familiar pretence of the British government when replying to Greek and UNESCO requests – 'It's not for us to decide, it's for the museum's independent trustees' – is disingenuous. It remains a fact that Britain has only altered its law against deaccession to return cultural property to two races – Jews and Australians.

John Henry Merryman

Academics who write articles in obscure law journals occasionally hit

on an argument that has a seminal influence on their subject of study – at least until it is refuted, sometimes many years later. A good – or bad – example is that of John Henry Merryman, who wrote a piece in the *Michigan Law Review* in 1985 which misled generations of journalists and scholars who were not lawyers into believing that Lord Elgin and the British Museum had an unassailable legal title to the Marbles. The normally savvy William St Clair, who wrote what is otherwise the best book on Lord Elgin and the Marbles, fell for his argument, as did Margaret Miles, a professor of art history who wrote *Art as Plunder* in 2008, and was strongly of the view that the Marbles 'really belong in Athens, reunited with the rest of the sculpture from the temple and exhibited near the temple itself' but added that 'the British have clear grounds for possessing them, as John Henry Merryman has argued persuasively'.[143] Even in 2018, *The Independent* newspaper cited Merryman as the legal authority for the museum's ownership. It is extraordinary that Merryman's flawed thinking has survived for so long.[144]

Merryman was for many years a professor in the Arts Department of Stanford University and a leading critic of the 'anti-market bias' of UNESCO and of what he dismissively termed 'the archaeologists' crusade' for repatriation of heritage. He was a collector himself and became a leading proponent (along with James Cuno and Neil MacGregor) of the case for 'universal museums' retaining stolen artefacts. These preferences may unconsciously have affected his thinking about the law, although he was writing at a time long before the New Acropolis Museum and many agreed with him that the lost Marbles should not be returned to suffer the traffic fumes and smog of Athens. (Not until 1993 were the Marbles left by Elgin on the temple taken down and placed indoors.) It is also fair to point out that Merryman agrees that

the so-called *firman* did not authorise Elgin's actions. How then could he conclude that 'as a matter of international law the removal was legal' when he was not an international lawyer?

His article was written in the wake of Melina Mercouri's demand for return in 1982, and his first big mistake was to think that this was 'the first official request by the Greek Government for return of the Parthenon sculptures'.[145] The first of many official requests for return was made by the government of Greece in 1833 (see page 102). 'Nor', Merryman continued, 'has Greece aggressively pursued its diplomatic remedies, since the 1983 request for return of the marbles is the first such diplomatic demand.'[146] No good lawyer could allow such ignorance of the facts to be the basis of a legal argument (see all the demands listed earlier in this chapter) – but it is the basis for Merryman's contention that Greek claims would be time-barred if brought before an international court. Fatally for his argument, there are no time-bars in international law.[147] There may be questions of estoppel or waiver if delay is unreasonable or has prejudiced the UK, but the record shows that Greece has been 'perennial' in making claims – although Merryman does not seem to have looked at the record. He suggests that the 1980 English Limitation Act, which bars claims after six years, would have effect in an international court, although as a matter of international law it would have no effect whatsoever.

Merryman's next mistake doubtless stems from his unfamiliarity with English law, and its positivist insistence on the supremacy of parliamentary legislation. 'The law of all civilised jurisdictions', he portentously declares, mandates that 'the right of the Crown to the Marbles was no better than Elgin's right to them.' But not, of course, when a statute – the 1816 Act – vested title to the Marbles in the British Museum. This basic point Merryman entirely overlooks, and he goes on to accuse the Greeks

of delaying for 155 years, between independence and Melina Mercouri's 1982 demand, in pursuing their legal remedies in an English court. 'In fact, Greece might have brought suit in an English court for return of the Marbles on the theory that they were illegally taken by Elgin,'[148] Merryman asserts, although in fact, any such action would be hopeless because of the unchallengeable title bestowed by statute on the trustees. So his conclusion – that the Greeks abandoned their claim in international law by failing to bring an action in England – is completely mistaken.

On what basis does Merryman think that Elgin ever acquired a good title, since he concedes that the '*firman*' did not justify his ripping down of the Marbles and that, 'accordingly, it would seem that Elgin did not acquire property rights in the Marbles'?[149] He invokes an American law that an act in excess of authority can be ratified by an act of acquiescence, and says that the Sultan issued a *firman* in 1803 to approve what the *Disdar* and the *Voivode* had done, and later (in 1810) ordered that the last shipment be allowed to leave for England. But this is factually incorrect – no *firman* was issued in 1803 or in 1810. As the evidence shows, in 1803 there is reference in Giovanni Battista Lusieri's correspondence to 'comfort letters' to the *Disdar* and the *Voivode*, but these turn out to be merely letters from a high official complimenting them on hosting Elgin's visit to Athens in 1802. So it cannot seriously be suggested that there is any document retrospectively ratifying Elgin's unauthorised despoliation of the temple.

As for the 1810 export, it was arranged by Robert Adair (Elgin's successor) through diplomacy once relations with Britain had improved, by bribes to Turkish officials and by mislabelling the crates to pretend that they held only 'broken marbles and vases'. This did not imply any legitimation of the looting years before, especially since the Ottomans specifically told Adair that Elgin had no right to take the Marbles.

If Elgin did not acquire property rights in the Marbles, then he was guilty of theft, as were the Reverend Philip Hunt and Lusieri: the two bribed officials were accomplices. Crimes cannot be 'ratified' as Merryman thinks, although criminals may not be prosecuted or else may be pardoned. There can be no suggestion that the Sultan pardoned Elgin or his accomplices, and Elgin would have had immunity from prosecution in any event, as the British ambassador. In English civil law, an excess of power may only be subsequently cured by specific and express ratification and will not absolve those who abused their power from the consequences. In any event, the despoliation (like the order to allow the last and falsely labelled crates to leave) was only achieved by extensive bribery, which Merryman overlooks: 'The fact that bribes occurred was hardly a significant consideration,' he says because American anti-bribery legislation came in much later. He must have been ignorant of Lord Mansfield, whose rulings, in the English courts before the time the Marbles were taken, decided that bribery would make any agreement void for illegality. Moreover, the most basic legal fact about a property-passing transaction is that it must be supported by 'consideration', in money or kind. It never occurred to Merryman to ask why this wealthy collector did not approach the Ottomans and simply ask to buy the Marbles. Elgin could easily have afforded to pay for them in 1801, with perhaps a gift to solace the people of Athens. This would have been the honest and appropriate way to proceed. Elgin never thought to make any such approach, for one very good reason: he well knew that the Sultan would never give approval. That is why, at the end of July 1801, Hunt and Lusieri commenced the destruction of the temple by 'inducing' the Turkish authorities with bribes and with claims that the letter from the Acting Grand Vizier could have a meaning that it could not possibly bear. At any point Elgin could

have offered to pay for the Marbles he was taking, but other than his belated offer to send a town clock, he was never willing to contemplate any kind of legitimate purchase or compensation. That refusal to deal honestly is what makes Elgin in law a thief, and none of the confused thinking of Professor Merryman can lead to any other conclusion.

Delay

Merryman's argument about delay is plainly mistaken, but the issue needs to be addressed in relation both to the return of the Marbles and to other antiquities looted in colonial wars. The International Council of Museums has emphasised that 'in no event shall the state which holds the cultural property in question, be able to invoke any statutes of limitation'.[150] The only suggestion that it should has come from a subcommittee of the International Law Association which once made a suggestion, never taken up, that 'cultural material that has reposed in the territory of a state for at least 250 years shall be exempt from return to its place of origin' – but this would still give Greece another thirty years to bring its action.[151] We have seen that Professor Merryman's argument is misconceived: English time limits may be effective in domestic law, but cannot limit rights in public international law. Nor should they. Cultural heritage is bound up with the identity of group traditions and practices, continued or venerated over centuries, and lost components of that heritage remain significant to collective life.

Another problem, as we have seen, with Professor Merryman's thinking is that it begins with an assumption that the first official Greek demand for return was not made until Melina Mercouri's efforts in the 1980s, ignoring all the official claims, demands, requests and diplomatic initiatives since 1833 – as a quick glance at Foreign Office records would

readily have established. The UK has been apprised of, and knows all too well, what it irritably calls the 'perennial' claims by Greece to ownership of the Marbles, and there has been no failure to act (other than during the seven years of fascist rule) or any waiver by Greece of a right to return. The point of no return was only reached when the UK and the museum trustees asserted a permanent refusal to surrender possession or to engage in mediation.

That was in 2015, and it put Greece on notice that diplomatic and political efforts to retrieve the Marbles, at least from UK Conservative governments, will be pointless. If the country contemplates international legal action to retrieve them, then it should take that action within a reasonable time from this refusal. Jurisprudential patience is finite and the UK government has tried before to non-suit Greece in an international arbitration by accusing it of delay, although its claim was rejected because, as with the Marbles, Greece had made 'repeated representations at intervals which could not be regarded as abnormal'. It might be regarded as abnormal if Greece allowed too many years to pass after 2015 before staking a legal claim, or requesting UNESCO or the General Assembly to do so on its behalf.[152] Legal action may, in this respect, be now (or in the next few years) or never.

The museum has cherished and cared for and promoted the Marbles –
they belong to us. Please do not take them away
The short answer to this (hypothetical) plea is 'Yes, you have. But that was then, this is now.' There can be no doubt that from the time the Marbles were first exhibited in the Elgin Room of the British Museum they produced a sensation and a new appreciation of classical art in Europe. Their exhibition partly inspired the nineteenth-century

'Romantic Hellenism' movement, 'a fad for anything Greek – from art and architecture to philosophy, literature and myth, hairstyles, garden ornaments, household furniture, fabrics, ceramics and pots and pans'.[153]

Keats visited and wrote 'On Seeing the Elgin Marbles' – not a great poem, but his recollection infused others that were – 'that heifer lowing at the skies', led to the altar by the mysterious priest in 'Ode to a Grecian Urn', for example, describes a panel of the south frieze.[154] Shelley also visited and proclaimed, 'We are all Greeks.' Buildings in Edinburgh were modelled on the Parthenon style, as was the blue frieze around the Athenaeum Club. Most importantly, the British Museum sent plaster casts to academies in Rome, Florence, Venice and St Petersburg, which were soon on display in cities throughout Europe, with books in various languages extolling their beauty. So the museum can legitimately claim to have put the Marbles on the cultural map, reviving interest in classical art not only in Britain but in Europe as well, where beautiful young (but ancient) Greeks were seen battling barbarous centaurs in many galleries and museums. This did come initially with a good deal of contempt for the 'backward' Greeks and their 'primitive' Orthodox Church: 'If the native custodians of ancient Greece were not capable of conserving the cultural heritage of their ancestors because they were indifferent towards it, they had to be replaced by a more suitable force, the British [who] assumed the role of the morally legitimate heir.'[155]

Passing over the cleaning scandal, it can be accepted that the Marbles have been well cared for and extensively promoted by the museum. They have become 'integral' to it, but only in the sense that they have featured in all its books and DVDs and promotional materials. They would be just as 'integral', in this sense, if replaced by plaster casts identical to

the originals: viewers would then be able to appreciate the work as a whole, as they do at the New Acropolis Museum, which interleaves its original marbles with moulds of those taken by Elgin. In the Duveen Gallery, pieces from the pediment are jumbled with metopes and parts of the frieze. Visitors with ears pressed to the audio guide are taken to a dozen or so individual marbles, but in no particular order. To view the entirety of the remaining frieze, scholars and connoisseurs must travel to the Skulpturhalle Basel, in Switzerland, where the Parthenon sculptures are laid out in a plaster re-construction, making much more sense than the desiccated pieces in the Duveen Gallery.

<p style="text-align:center">* * *</p>

By the turn into the twenty-first century, the self-styled 'universalist' museums of America and Europe were being rocked by restitution claims and needed a good argument to rebut them. The British Museum was particularly shocked by the force of submissions about the 'Elgin Marbles' made to the select committee in 1999 and by that committee's recommendation for changes to the rule against de-accession. In 2002, a number of big Western museums came up with a public relations strategy: they would make a legal-sounding 'Declaration on the Importance and Value of Universal Museums', in which they declared that objects acquired in the past had become 'an integral part of the museums that have cared for them, and by extension part of the heritage of the nations that have housed them'. The Marbles, in other words, should now be regarded as part of the heritage of the British nation!

This 'declaration' fooled nobody and was widely condemned as an arrogant post-colonial ploy by overendowed elite museums in the West, which

wished to protect their decontextualised displays from repatriation on the novel ground that they really 'belonged' culturally to the colonisers. They had not thought to enlist even the great museums in Cairo, Istanbul or Shanghai and seemed to be suggesting that they had a morally superior mission to that of smaller museums in underdeveloped and undervalued countries. Many smaller museums objected: the head of Glasgow Museums condemned the institutions which issued the 'declaration' as exclusive, elitist and serving the interest of smaller groups of intellectuals and wealthy patrons.[156] They could have added amorality to their list of criticisms: the 'declaration' insisted that 'objects acquired in earlier times must be viewed in the light of different sensitivities and values reflective of that earlier era' – in other words, the values of imperial greed and colonial aggression and looting. The 'declaration' was published on the official website of the British Museum, but was later removed – presumably because this patronising proclamation had been so widely derided.[157] It nonetheless had been the platform for Neil MacGregor to tell the BBC, 'The Parthenon Marbles in the British Museum are in the best possible place for them and they must remain here if the museum is to continue to achieve its aim, which is to show the world to the world.'[158]

The aim can only be to show the ancient world to the modern world and it must be the humanitarian values of that modern world which decide what gets shown, and where.

CHAPTER SIX

INTERNATIONAL LAW
TO THE RESCUE?

You are going to have to tell me when things do become part
of international law and when they do not. It is a point
I have never understood since I was at Oxford.

PRESIDING JUDGE (LORD BROWNE-WILKINSON) IN PINOCHET

CASE, OPENING QUESTION TO COUNSEL[159]

International law – its creation, application and enforcement – is a
mystery to most people, and even to most lawyers. The rules of do-
mestic law are laid down by parliaments or by political parties or by
despots, and are enforced by police and by criminal courts, or in civil
cases by the decision of judges or adjudicators. International law has
no legislators, no police and few enforcement procedures available to
its limited number of courts and tribunals. Some of its rules are created
by treaties or flow from the Charter of the United Nations and from
international conventions (at least if ratified by the majority of states)
negotiated under its auspices. But other sources of international law
derive from 'general principles ... recognised by civilised nations' and
from what is curiously called 'custom' – that is, the actual practice of
most states. Then, as subsidiary sources, there are decisions on the issue

by judges of national courts and writings by distinguished jurists.[160] If these sources point to a rule – called a 'norm' – which is (or should be) binding on all states, it may be declared as such by the International Court of Justice (ICJ), either in an adversary case brought by one member against another (if the defendant state allows this, which many do not) or by way of an 'advisory opinion' sought by the UN Security Council or the General Assembly or certain other bodies (including, crucially, UNESCO).[161] This process of detecting what the law is, or whether a principle has over time become elevated to the status of a norm, imposing an obligation binding on all (an *erga omnes* duty, as international lawyers say when they resort to Latin, which they frequently and confusingly do), involves a careful consideration of all these sources, to see whether they have 'ripened' or 'crystallised' into what is called customary international law.

The purpose of this chapter is to consider whether there can now be said to be a norm, waiting as if in suspension for the ICJ to declare it, requiring the return of important cultural property, illegally or improperly acquired, to the states where it originated, either because it forms part of their national heritage or because additionally it is part of the world's heritage which can best be appreciated in its state of origin.

CONVENTIONS

Modern international law is said to begin in 1648 with the Treaty of Westphalia: a massive document negotiated between the Holy Roman Empire and the kings of France and Sweden and all their various allies, making up most of the kings, bishops, principalities, states and tribes of Europe, which had been locked in civil and religious war for the

past thirty years. It bestowed a general amnesty and a promise of some religious toleration, but mainly it provided for restitution – unravelling and returning all the estates, assets, castles and properties that had been seized by one side or another in the course of the conflict, unless they had been destroyed in the fighting. It did not specify cultural property, although artworks, monuments and the contents of churches and palaces were within its purview. Significantly, it provided for the appointment of commissioners who would arbitrate on claims for restitution. It can be invoked as a precedent for the principle of 'no peace without justice', in the sense that justice after a war, no matter how long ago, requires restitution of whatever can be returned after seizure or confiscation during hostilities. There was, however, no losing side in this long conflict: in later centuries, as we shall see, victors insisted on their 'spoils of war' as reparations for having to engage in battles that many of them had started.

There are today many international conventions and declarations concerning culture: the International Covenant on Economic, Social and Cultural Rights is endorsed by 170 countries and recognises the right of everyone to take part in cultural life.[162] The World Heritage Convention (the 1972 Convention Concerning the Protection of Cultural and National Heritage) has been ratified by almost all states – anxious, some of them, for the tourist dollars that flow from having one of 'their' sites on a list that currently numbers over 800. These must, to achieve the rating of 'world cultural heritage', fall under three headings – monuments, buildings and works of man (with or without nature) – and in each case be adjudged 'of outstanding universal value'. This determination is made by a 21-person committee which must include representatives from Africa, the Asia-Pacific region and

Latin America, as well as from Europe and North America. Although it has no tribunal or enforcement procedure, and although its obligations are general – to take 'active and effective measures for the protection, conservation and preservation of the cultural and natural heritage' – it is sometimes invoked in cases in domestic courts. In the *Franklin Dam* case, the state of Tasmania wanted to build a hydro-electric dam which would flood a listed World Heritage area around the Franklin River, and dismissed the convention as 'non-binding'. But the federal government incorporated the Convention into its law, and the High Court of Australia upheld the constitutionality of this means of stopping the dam by fulfilling Australia's international obligations, in this case to preserve the heritage area.[163] This was in keeping with the purpose of the convention, adopted after the Egyptian government decided to build the Aswan High Dam on the Nile, potentially submerging ancient Nubian monuments in the rock temples of Abu Simbel.

The convention covers a broad spectrum of natural and man-made heritage, namely:

- Monuments: architectural works, works of monumental sculpture and painting, elements or structures of an archaeological nature, inscriptions, cave dwellings and combinations of features, which are of outstanding universal value from the point of view of history, art or science;
- Groups of buildings: groups of separate or connected buildings which, because of their architecture, their homogeneity or their place in the landscape, are of outstanding universal value from the point of view of history, art or science;
- Sites: works of man or the combined works of nature and man, and

areas including archaeological sites which are of outstanding universal value from the historical, aesthetic, ethnological or anthropological point of view.[164]

This definition plainly covers the Parthenon Marbles, and the Acropolis site is duly listed as a World Heritage area. The convention does not in its terms require restitution, even of severed but integral parts, although Article 5 requires 'effective and active measures' for 'conservation and preservation', which would surely extend to restitution and re-unification. No international law rule to this effect arises directly from the convention, but it is a significant stepping stone in the 'ripening' of such a norm, and it makes no distinction, in the description of the obligation, between times of peace and times of war. During conflicts, however, it does have a 'list of World Heritage in Danger', and military commanders responsible for that danger are amenable to prosecution for war crimes at the International Criminal Court (ICC). The Bosnian Serb generals responsible for the shelling of Dubrovnik were sent to prison in The Hague, a fate also suffered by the fanatical Islamist Ahmad al-Faqi for destroying a World Heritage site in Timbuktu.

The preamble to the 1970 UNESCO Convention on the Means of Prohibiting and Preventing the Illicit Import, Export and Transfer of Ownership of Cultural Property recites that 'it is essential for every State to become increasingly alive to the moral obligations to respect its own cultural heritage and that of all nations' and calls on museums to ensure their collections conform with 'universally recognised moral principles' – which begs, of course, the question of whether repatriation is the 'moral' response to demands for return of cultural property. This is not to be decided objectively – the convention applies only to

property stolen or illicitly exported since 1970 which has been 'specifically designated by the requesting state as being of importance for archaeology, prehistory, literature, art or science'. It places an obligation on state parties 'to take appropriate steps to recover and return' cultural property illegally imported since 1970.

Although American scholars like John Henry Merryman and James Cuno have criticised the 1970 Convention for giving the power to designate to the state rather than to an independent entity, the European Court of Human Rights has ruled that 'the control by the state of the market in works of art is a legitimate aim for the purpose of protecting a country's cultural and artistic heritage' – hence the Italian state could legitimately stop a foreigner purchasing the only good Van Gogh in its national galleries, so long as it paid adequate compensation. But the court recognised, in relation to works of art lawfully on its territory and 'belonging to the cultural heritage of all nations' (such as a Van Gogh painting), that 'it is legitimate for a state to take measures designed to facilitate in the most effective way wide public access to them, in the general interest of universal culture'.[165] This is an important ruling that the right to private property (protected by the first protocol of the European Convention of Human Rights) may be subject to state initiatives (e.g. to take great art from private homes for exhibition in a national gallery) so long as fair compensation is paid and the exhibition (clearly, in the case of a Van Gogh) is in 'the general interest of universal culture'.

In 1995, the UNIDROIT convention sought to effectuate the international return of stolen or illegally exported cultural property by setting out agreed procedures for the surrender and repatriation of smuggled artefacts. Interestingly, this convention says in terms that

the fact it applies only to post-1970 illegalities 'in no way confers any approval or legitimacy upon illegal transactions of whatever kind which may have taken place before the entry into force of the Convention'. In other words, it leaves the course clear for the development of an international rule requiring the return of specially significant cultural property, and although this is outside its temporal remit, it shows a general predisposition in favour of return of art stolen no matter how long ago. Importantly, Article 5(3)(b) requires the return of any object the removal of which significantly 'impairs the interest in the integrity of a complex object', which is exactly the case with the Parthenon Marbles.

Although a right of return arises under these conventions only in respect of property unlawfully taken after a state has signed up to them, their principles can be applied by analogy to underpin an international law rule governing cultural property wrongfully taken at an earlier time, and requiring restitution and (in particular) re-unification. Some 140 states have signed up to the UNESCO Convention,[166] including most major countries, as well as those suffering from illegal exportations, but only forty-seven have thus far ratified UNIDROIT. Nonetheless, the general support for UNESCO 1970 does evince 'state practice' in favour of the principle that it is wrong to take cultural property and that dispossessed states have a right of recovery. The conventions apply to antiquities irrespective of value or importance, although only if stolen or smuggled since 1970 (or later, after both the deprived state and the acquiring state had ratified the convention). Any rule which were to relate to property acquired at an earlier time would have to be limited to artefacts of real and continuing heritage importance, but otherwise the conventions make clear that they do not inhibit or stand

in the way of the development of such a rule. Thus in 2015 UNESCO promulgated Operational Guidelines, which said in terms:

> For items of illegally exported, illegally removed or stolen cultural property imported into another State Party before the entry into force of the Convention for any of the States Parties concerned, States Parties are encouraged to find a mutually acceptable agreement which is in accordance with the spirit and the principles of the Convention, taking into account all relevant circumstances.[167]

The UK was, almost immediately, in breach of the spirit of this guideline by refusing to mediate over the Parthenon Marbles, but the rules and guidelines of the UNESCO and UNIDROIT conventions may be seen as important stages in the 'ripening' process of a wider *erga omnes* rule of customary international law covering important cultural property whenever it has been wrongly taken from its own place of creation.

In 2007, the UN General Assembly promulgated an important Declaration on the Rights of Indigenous Peoples which said in terms, 'States shall provide redress through effective mechanisms, which may include restitution, developed in conjunction with indigenous peoples, with respect to their cultural, intellectual, religious and spiritual property taken without their free, prior and informed consent or in violation of their laws, traditions or customs.' Many indigenous people are now states or a significant part of a state, and this declaration, although it is not a binding convention, is nonetheless an important source for an international law which requires restitution of wrongfully taken cultural property.

STATE PRACTICE

Since 1972 the General Assembly has accepted twenty-seven resolutions supportive of repatriation of cultural property – the most recent, on 13 December 2018, was adopted unanimously after 105 member states supported a Greek resolution calling for all countries to 'address the issue of return or restitution of cultural property to the countries of origin'. The Security Council has twice supported this position, as have major states: the US, for example, has returned stolen cultural objects to Italy, Jordan, Egypt, Peru and Turkey; Germany to Bulgaria, Turkey and Cyprus; France to Burkina Faso, Egypt and Nigeria; and Switzerland to Tanzania.

In 2019, the Metropolitan Museum of Art in New York made a cringing apology to 'the people of Egypt' when it returned a 2,000-year-old gold coffin, acquired in 2017 from a Paris dealer for $3.5 million and displayed as a centrepiece for one of its exhibitions.[168] The Met told the district attorney (Cyrus Vance Jr, a dab hand at tracking down cultural fraud) that it had absolutely no idea the coffin had been looted as recently as 2011, but that is probably because it did not look very closely at, or think to check, a forged Egyptian export licence and the bogus claim that it had been in a 'private collection'.

The extent to which states and politicians publicly accept the principles of the 1970 Convention is evidence of state practice that favours the restitution principle, not only as a rule of law but as a rule of moral conduct that should prompt the return of important cultural property wrongfully taken and acquired before 1970. There are increasing examples of the restitution principle being applied by states to return such heritage items.

This is now accepted by most states in respect of human remains claimed by descendants or groups acting in their name: as we have seen, Germany has returned the remains of Herero victims of its genocide in Namibia in 1905 and the skulls and bones of Australian Aboriginals that found their way into its museums, while Britain has amended its de-accession laws to allow return of the latter, thus enabling the Tasmanian Aboriginal Centre to pursue its case against the Natural History Museum. State practice may therefore be said to acknowledge at least an ethical duty to restore human property which has meaning for indigenous peoples.

In relation to the return of notable artistic artefacts, Italy (conscious of the loot of its own art by Napoleon) has led the way, returning the Lion of Judah and the Axum Obelisk to Ethiopia and the Venus of Cyrene to Libya. Cyrene is on the World Heritage list, a fabulous archaeological site of an ancient city founded by Greeks about 650 BC (according to legend, on the direction of the Oracle at Delphi) with a temple of Zeus larger even than the Parthenon. It was occupied by Italy in 1913, when its troops extracted the statue of Venus, which ended up in the Roman National Museum, where by law it became the property of Italy. In 2008, the Council of State – the highest court for administrative law – ordered the statue's return, on the basis of what it determined was a rule of customary international law that obliged states to return treasures taken as a result of colonial domination or armed conflict. This was despite the fact that in 1913 Libya did not exist as a state (like Greece in 1801) and was occupied territory (like Greece in 1801). But, like the Parthenon Marbles, the Venus had been extracted from its original context although it was integral to the Temple of Zeus. The decision is important, as the first

enunciation by a senior national court of the suggested international law rule.

There have been other important restitutions, as seen recently in Norway's return in 2019 of the artefacts taken from Easter Island by Thor Heyerdahl. In that year, too, Germany returned to Namibia, at its request, a fifteenth-century stone cross that had been erected on its shore by Portuguese sailors as a navigation aid, and souvenired by a German warship during colonial conquest. A bible and whip belonging to a Namibian hero, who resisted the German occupation, were also returned.[169] Shortly after the UNESCO Convention was adopted, Denmark presented to Iceland, over which it had held dominion until 1945, precious historical manuscripts which had been collected, quite legitimately, for study in the early eighteenth century. Iceland's campaign for their return from a private foundation was hotly opposed by Danish scholars and the foundation challenged through the courts a law eventually passed by Parliament to allow their return by way of presentation to the government of its former colony.[170] The case exemplified two familiar emotional responses to the return of cultural heritage – the demand of a formerly oppressed country for possession of a key to its history, and an insistence by the possessor's intellectuals that the items had been cared for and would be better studied where they were – in this case, in a university in Copenhagen. Post-colonial guilt affected public and legal opinion in Denmark in favour of return, plus a desire for an amicable relationship with Iceland. Although few disputes are decided so pacifically, the handover (celebrated by both countries) served as a precedent for others – notably the return of the Negro of Banyoles from Spain to Botswana, the remains of Sarah 'Saartjie' Baartman, the 'Hottentot Venus', from France to South Africa, and even the

Stone of Scone, the coronation seat of ancient Scottish kings, captured by Edward I (the 'Hammer of the Scots') and brought to Westminster Abbey in 1297. It was stolen by Scottish nationalists, to some local acclaim, in 1950 (police found it hidden under a saltire in a ruined abbey near to where the Declaration of Arbroath had proclaimed Scottish independence in 1320), but it was finally returned from England as an act of reconciliation in 2002.

There can be said to be a recognition by most states of the duty to return important cultural property wrongly taken before, even centuries before, the 1970 UNESCO Convention. This was evidenced in December 2018 when 105 countries supported a motion to that effect in the UN General Assembly, introduced by the Greek government, anxious for the return of the Parthenon Marbles. Although Britain (and Russia) remain resistant, it must be remembered that China, India and Brazil frequently make legitimate restitution claims, as do many former colonial countries, while France under Emmanuel Macron has had its recent *volte-face* in favour of returning looted items to African countries. The US is now unpredictable, but it has never supported nineteenth-century colonial looting (it missed out) and has signed and supported the 1970 Convention. It can be said with confidence that no state today would approve of an ambassador behaving like Elgin, despoiling a monument in occupied territory for his own personal profit and prestige, or an army commander like his son, who plundered the Old Summer Palace in Beijing before razing it to the ground. Nor could 'punishment raids' of the kind that seized the Benin Bronzes ever be contemplated – they would amount to 'crimes against humanity' and British commanders would be prosecuted at the International Criminal Court. Using underhand methods to extract a big diamond from a

little prince, as with the Koh-i-Noor, would be regarded as despicable and Queen Elizabeth II would not contemplate accepting it from a brain-washed schoolboy. Fundamental (even elemental) 'principles of civilised nations' as a source of international law require recognition of the progress from the practice of states in the nineteenth century to their practice today, which broadly speaking is to ask for the return of items of their cultural heritage (or of the heritage of their indigenous groups) from collecting states which are increasingly willing to comply.

Another aspect of 'state practice' that is relevant to claims for return – of Egyptian obelisks and Parthenon Marbles – is the almost universal practice among developed states of protecting war memorials and national monuments, usually by specific legislation which carries criminal consequences if they are defaced or damaged and requires planning and export permissions if they are to be taken outside national boundaries. These legal systems may be disparate, but they all protect the integrity of public monuments in peace as well as war. Britain began with the Ancient Monuments Protection Act in 1882 and later imposed by statute extensive restrictions on removing any fixtures from buildings listed on account of their historical or artistic importance. The nations of Europe, and the United States, Canada and Australia – the countries whose private collectors pay prices that drive up the profits of looting – all have laws to protect their own heritage and to stop interference with their own graves and churches and museums. This makes it hypocritical, of course, for Western governments to deny to less developed countries a heritage protection that they claim for themselves, but more importantly it proves that state practice conduces to an international law rule that states are required to protect their cultural heritage and to

claim restitution of monuments (or the fixtures thereon) and artworks of significance to that heritage.

CASE LAW

The International Court of Justice has never considered whether international law imposes a duty to repatriate cultural property. The closest it has come is a decision in 1962, relating to a dispute over ownership of the Temple of Preah Vihear, situated on the border of Cambodia and Thailand. Cambodia alleged (but could not in the event prove) that the Thai authorities had removed and should restore 'sculptures, stela, fragments of monuments, sandstone models and ancient pottery'. The court found that Cambodian sovereignty extended to the temple and that restitution of its property was 'implicit in, and consequential on, the claim of sovereignty itself'.[171] This ruling, by assuming that title to ancient antiquities belongs in public ownership of the state as part of its national sovereignty, may provide a basis for legal claims on behalf of people or groups whose culture has been taken or given away by foreign powers or their agents at a time when they were not independent or organised geographically as a country. If the antiquities were taken from sites which now fall within the borders of a sovereign state, they may be considered to belong to that state, which in consequence has a legitimate right to pursue their return. This approach has been followed by several national courts, which have declared that state sovereignty includes the power to reclaim cultural objects that provide 'the keys to their ancient history'. The first ruling came in 1988 from the Chief Justice of Ireland, tasked to decide who owned some ninth-century ecclesiastical treasures – those individuals who had discovered them on public land, or the Republic of Ireland. Chief Justice Finlay had no law

or precedent to guide him, but his ruling rejected the collector's creed of 'finders' keepers' in favour of the principle that state sovereignty necessarily included ownership of cultural heritage of the state:

> It would, I think, now be universally accepted, certainly by the People of Ireland, and by the people of most modern States, that one of the most important national assets belonging to the people is their heritage and knowledge of its true origins and the buildings and objects which constitute keys to their ancient history. If this be so, then it would appear to me to follow that a necessary ingredient of sovereignty in a modern State ... is and should be an ownership by the State of objects which constitute antiquities of importance which are discovered and which have no known owner. It would appear to me to be inconsistent with the framework of the society sought to be protected by the Constitution that such objects should become the exclusive property of those who by chance may find them.[172]

This was certainly a solution that people generally would accept, although in Britain and other countries finders (who now use metal detectors and earth-scanning equipment) are generally rewarded with part of the cash raised by sales of their discoveries to museums (owners of the land on which they are found receive a share of the proceeds, too). This puts paid to 'finders' keepers', although it allows finders to be compensated. Chief Justice Finlay was unimpressed by arguments that the state did not exist at the time the items were made or deposited, being then a constituent of Britain, which ruled Ireland for many centuries. The principle he adopted is capable of universal application and his judgment has guided common law tribunals ever since.

An English example is found in a 2009 case, in which Iran claimed ownership of objects which had been stolen from a grave site in the Jiroft Valley. The English Court of Appeal emphasised the importance of the UNESCO Convention as representative of international practice about displaced cultural treasures, and followed the Irish precedent, although the state of Iran had not come into existence for 4,000 years after the objects were buried:

> It was essential for every State to become alive to the moral obligations to respect the cultural heritage of all nations and that the protection of cultural heritage could only be effective if organised both nationally and internationally ... In the Supreme Court of Ireland, Finlay CJ said that it was universally accepted that one of the most important national assets belonging to the people is their heritage and the objects which constituted keys to their ancient history; and that a necessary in-gredient of sovereignty in a modern State was and should be an owner-ship by the State of objects which constitute antiquities of importance which were discovered and which had no known owner.[173]

There are similar comments made by national courts as they order res-titution of stolen artefacts. One judgment frequently quoted, which expresses the principle in terms which provide the rationale for an in-ternational law rule, is by the Supreme Court of Indiana when deciding to return to the Greek Cypriot Church and the Republic of Cyprus some sixth-century mosaics of Christ:

> A short cultural memory is not an adequate justification for partici-pating in the plunder of the cherished antiquities that play important

roles in the histories of foreign lands. The UNESCO Convention and the [US] Cultural Property Implementation Act constitute an effort to instill respect for the cultural property and heritage of all peoples. The mosaics before us are of great intrinsic beauty. They are the virtually unique remnants of an earlier artistic period and should be returned to their homeland and their rightful owner. This is the case not only because the mosaics belong there, but as a reminder that greed and callous disregard for the property, history and culture of others cannot be countenanced by the world community or by this court ... we should not sanction illegal traffic in stolen cultural property that is clearly documented as belonging to a public or religious institution. This is particularly true where this sort of property is important to the cultural heritage of a people because of its distinctive characteristics, comparative rarity, or its contribution to the knowledge of the origins, development, or history of that people.[174]

These decisions demonstrate how national courts have been prepared to allow claims over cultural heritage asserted by states which may not have been in existence at the time the material was created or even at the time it was taken, so long as its people have retained a significant historical or cultural attachment which is attenuated or diminished by its presence in a foreign museum. In these instances, the right to possess, to enjoy and to claim (i.e. the right to demand return) attaches to the state because of its entitlement to dominion over 'the keys to its ancient history'. There is a duty on states to co-operate in returning national treasures to the nation that most treasures them, because they contribute to its national identity and its people's knowledge and appreciation of their own history. As the 1970 UNESCO Convention's

Preamble puts it: 'It is essential for every state to become increasingly alive to the moral obligations to respect its own cultural heritage and that of all nations.' Fifty years after this 'increasing moral obligation' was identified, it must be time for the ICJ, or a new convention, to declare that returning important ancient heritage, stolen in the past, is now an *erga omnes* obligation in international law.

HUMAN RIGHTS LAW

The return of cultural property is invariably described as a 'right' of states or groups that have lost it, and as an 'obligation' on states and museums that have benefited from its wrongful acquisition. Human rights is an important part of international law, governed by its own treaties (notably the International Convention on Individual and Political Rights, the ICCPR) and its own courts, such as the European Court of Human Rights (ECtHR), the Inter-American Court and the international criminal courts set up to punish crimes against humanity and war crimes. It must be accepted that the right to restore wrongly taken cultural property does not appear as such in human rights conventions – it did not loom as an issue when they were drafted – but it can nonetheless be inferred from their principles, beginning (as modern human rights law does) with the Universal Declaration of Human Rights, drafted by a committee chaired by Eleanor Roosevelt and presented on 10 December 1948 to the president of the UN General Assembly, Dr H. V. Evatt, as 'the Magna Carta for Mankind'. Article 27(1) provides: 'Everyone has the right freely to participate in the cultural life of the community, to enjoy the arts and to share in scientific advancement and its benefits.' More recently, in 1976, the International Covenant on Economic, Social and Cultural Rights came into force. Its very first

article provides: 'All peoples have the right of self-determination. By virtue of that right they freely determine their political status and freely pursue their economic, social and cultural development.'

It follows from individual and group rights to pursue cultural development that this includes the right to pursue cultural identity and to seek restoration of iconic symbols of that identity, whether foundation manuscripts for Icelanders, bronzes from Benin for south-eastern Nigerians or marbles from the Parthenon for Greeks. The 1970 UNESCO Convention delivers on this right only in relation to cultural items illegally exported after 1970, and 'to facilitate recovery of such property by the state concerned in cases where it has been exported'. Human rights courts should have no difficulty in extending this principle to cultural property wrongly acquired at any time before 1970 if restoration is established as necessary to allow the enjoyment of national or group culture. The ECtHR in Strasbourg has held that human rights guarantees extend to the protection of 'minority identity' and 'ethnic identity': there is no reason why they should not extend to 'cultural identity' or to the right to appreciate a culture's history and traditions.

Human rights treaties invariably include a right to the peaceful enjoyment of property, which cannot be expropriated (other than in the public interest and with suitable compensation). Does this right extend to cultural property, expropriated usually in colonialist interests and without any compensation, centuries ago? The Inter-American Court has confirmed that property rights include collective rights asserted by indigenous groups against their own or other states, even in the absence of any formal title. Thus traditional customs that have treated state land as collectively owned by a tribe could entitle its representatives to stop the government granting a licence to log its forests.[175] In this way, the

property 'right' is derived from immemorial custom and even from religious practice, given the spiritual attachment of most indigenous groups to their land – as well as to their cultural heritage objects. For such peoples, the court has held, 'their communal nexus with the ancestral territory is not merely a matter of possession and production, but rather consists in material and spiritual elements that must be fully integrated and enjoyed by the community, so that it may preserve its cultural legacy and pass it on to future generations'.[176] The corollary being, of course, that the cultural legacy must be returned in order to be passed on to those future generations.

Courts are bound to interpret human rights treaties as 'living instruments', outliving certainly the relaxed attitude at the time they were adopted to colonial theft from indigenous peoples. There is already (and the case law continues to develop) sufficient material to underpin a declaration of a human right of peoples to enjoy their cultural heritage, and in consequence to have returned to them important indicia of that heritage, if taken illegally or without authorisation or simply taken – bought, begged or borrowed – in previous centuries by foreign armies or colonial administrators or unauthorised opportunists like Lord Elgin.

WAR LAW

The other doctrine of international law, well developed over centuries and in favour of the return of cultural property, albeit confined to that seized in or in consequence of war, is, curiously, called 'international humanitarian law'. The notion of a 'humane war' is a contradiction in terms, but states inured to conflict have tried to make wars more bearable by agreeing to fight them according to rules. From the earliest

times, heralds and emissaries were guaranteed safe conduct, and Greek and Roman armies declined to attack women or the wounded or each other's temples, and in 1419 Henry V of England promulgated ordinances that forbade the rape of women and desecration of churches. Shakespeare's *Henry V* features a Welsh captain, Fluellen, who describes killing by the French of the boys in the baggage train as 'expressly against the law of arms' (an episode invented by Shakespeare to excuse Henry's actual order to put all French prisoners to death, which would have been recognised by Captain Fluellen as a barbaric breach of the law of arms). The three armies that fought the English Civil War in the 1640s – for the King, Parliament and Scotland – all had regulations which prohibited 'pillage', that is, plunder of civilian houses or goods, and on his way to annihilating the defenders of Drogheda, Oliver Cromwell scrupled to hang a soldier who had stolen a chicken from a local farmer. Pillage – by setting fire to civilian houses after taking their contents – was a charge against Charles I, and it resurfaced as a war crime at Nuremberg in connection with looted art and at the International Criminal Court, where it was the basis for the conviction of Ahmad al-Faqi for destroying monuments in Timbuktu.

The first modern set of war rules was compiled by Dr Franz Lieber in 1863 at the direction of Abraham Lincoln, and his code, which synthesised the rules as they had developed to that date, became a model for European armies, for the Hague Conventions of 1899, 1907 and 1954, and for Article 8 of the ICC Statute, which spells out, for both international and civil wars, the crime of 'intentionally directing attacks against buildings dedicated to religion, education, art, science or charitable purpose, historic monuments, hospitals ... provided they are not military objectives' (a proviso which the Israeli army uses to justify

attacks on schools in Palestine which it claims are used for military purposes). The first criminal trial for 'looting cultural property' was at Nuremberg, when General Wilhelm Keitel and museum director Alfred Rosenberg were convicted of plundering more than 21,000 artworks from occupied Europe, many held in a specially built bunker beneath the Belvedere, awaiting display in Hitler's projected 'Führermuseum' in Linz.[177] There is now a Convention on the Protection of Cultural Property in the Event of Armed Conflict and, as UNESCO has declared, 'the fundamental principles of protecting and preserving cultural property in the event of armed conflict could be considered part of international customary law'.[178]

The most important of the several conventions to this end is the 1954 Hague Convention, Article 1 of which defines 'cultural property' as covering 'moveable or immovable property of great importance to the culture of every people' and includes monuments, archaeological sites, books and works of art and buildings of historical and artistic interest. The convention even offers culture's equivalent of the red cross – a blue shield – to signal to the enemy the presence of heritage that should not be damaged or destroyed. (Failure to display a blue shield was the basis of the unsuccessful defence of Slobodan Praljak, the Croat who destroyed mosques at the Old Bridge in Mostar; it was rejected because the mosques were obviously mosques.[179]) An additional protocol to the convention was added in 1977, prohibiting belligerents from 'making such objects the objects of reprisal' – a retroactive condemnation of 'punishment raids' of the kind used by the British and French armies in colonial wars to seize treasures in reprisal for attacks on their diplomats. A second protocol was added in 1999. In 2003, after the dynamiting by the Taliban of the Buddhas of Bamiyan, UNESCO issued a declaration

urging that intentional destruction be made a war crime – apparently unaware that it already was (under Article 8 of the ICC Statute and under customary international law which stretched back for centuries). In 2015, it designed a new emblem – a blue shield now on a red background – although this was likely to help ISIS and the Taliban identify the targets they would really want to destroy. What has stopped them doing so, in many cases, has been the money they can make from stolen antiquities, however objectionable to their religious sensibilities, which they have trafficked relentlessly through dishonest dealers in Europe and the US and even, so it has recently been discovered, through Facebook.[180] The British Museum, to its credit, was first to offer a refuge to artworks and monuments in Iraq at risk of despoliation from ISIS – and this time it was careful to insist that it would return them when the war was over.

It is odd that the plethora of post-Second World War conventions and declarations prohibiting the looting of cultural heritage contain no express provisions about their return, although that is an obvious inference – criminal law always requires that burglars surrender their ill-gotten gains, even when stashed in Swiss bank depositories, while English civil law deems a thief and the receivers of his stolen property to be involuntary trustees liable for its return to its owner. That was certainly the conclusion of a British Admiralty court in 1812, when the plaintiff, owner of paintings stolen from Italy, sued to recover them when the American vessel carrying them to the Philadelphia Academy of Arts and Sciences was seized by the Royal Navy, which claimed its cargo as a prize of the war with the US. The court ruled that objects of artistic value were 'part of the heritage of mankind' and thus 'protected from seizure during war' and ordered that they must be returned to

the plaintiff.[181] Just three years later – ironically, shortly before Britain bought the 'Elgin Marbles' – came the great precedent for the return of 'spoils of war', set by the victors of Waterloo.

By the time of his historic defeat in 1815, Bonaparte had over the previous twenty years seized many of the great art treasures of Europe, mostly for display in the Musée Napoléon in Paris. He usually made their surrender a term of his peace treaties with conquered nations, and had thereby obtained possession of such treasures as the Bronze Horses from San Marco in Venice, the Medici Venus from Florence and the Apollo Belvedere and the Laocoön from the Vatican. After Waterloo, a military convention was held, dominated by the Duke of Wellington and the British Foreign Secretary, Lord Castlereagh, who declared that Napoleon's looting was 'contrary to every principle of justice and the usages of modern warfare'. Various denuded states had petitioned for the return of their artworks from the Louvre (as the Musée Napoléon was re-named) and Castlereagh insisted that France should not be allowed to keep artworks 'which all modern conquerors have invariably respected as inseparable from the country to which they belonged'.[182] Wellington wrote that 'artists, connoisseurs and all who had written on it [the subject of the return of cultural property taken in war] agree that those works ought to be removed to their ancient seat'. It was plain enough, to British soldiers and scholars alike, that nations forced to give up their cultural treasures should have an enforceable right to reclaim them, if and when they or their allies overcame the plunderer. Insistence on this principle by Britain was all the more remarkable because it thereby denied itself – i.e. the British Museum – the spoils of the war it had won.

A century later, return of seized culture items was provided for in the Versailles Treaty (Articles 245 and 247) and by Franklin Roosevelt's

so-called Roerich Pact (1935), which he persuaded ten Latin American states to join. On the outbreak of the Second World War he sought to persuade Germany, Britain and France to avoid damage to heritage buildings and churches – and even Hitler hypocritically said that Roosevelt's wish for mutual embargos on bombing civilian targets was 'a humanitarian principle corresponding to my own views'.[183] Hitler claimed that the British were first to breach this unspoken accord by bombing the city of Lübeck, so the Luftwaffe in reprisal bombed Bath and Coventry Cathedral. Then came the Blitz, and the manic looting of European art treasures by Göring and Keitel and for the 'Führermuseum'. Towards the end of the war the Allies set up a Monuments, Fine Arts and Archives programme (the 'Monuments Men') to search for, retrieve and restore looted artwork. Stalin, however, had his own Trophy Brigades, which were searching for, retrieving then stealing for the Soviet Union all the artworks they could lay their gloves on. This included, from a Berlin museum, 'Priam's Treasure' – gold jewellery, coins and artefacts smuggled by Heinrich Schliemann from the site of the ruined ancient cities of Troy he had discovered in Turkey. Germany now wants the treasure back, but the Russians, as recently as 2019, refused even to discuss removing it from the Pushkin Museum in Moscow, where it will remain – unless, perhaps, Mr Putin decides that *realpolitik* requires a friendly gesture to an alternative claimant, namely the Troy museum in Recep Tayyip Erdoğan's Turkey.

International humanitarian law has otherwise laid to rest the primitive 'spoils of war' doctrine; other military powers reject it in their laws and their army conduct codes. The Soviet practice, which vested in the state all artworks seized by the Red Army from Germany and Poland, has been rejected by courts in England[184] and the United States,[185] and

should not be invoked today to oppose repatriation demands for the many cultural heritage items seized by British and French armies in Africa and China. Some were looted in 'punishment raids' – the practice of putting to the sword (or the British bayonet) people of disrespectful kingdoms which had captured or killed colonial officials. Such reprisals are specifically condemned by war law, and commanders of the worst examples (the destruction of innocent villages and villagers in Czechoslovakia in revenge for the assassination in Prague of the Holocaust architect Reinhard Heydrich) were hanged at Nuremberg. It does not matter (although museums pretend it does) that the first of several Hague conventions was not promulgated until 1899: the rule against pillaging and looting of cultural property has been part of customary war law for centuries. Today, these 'punishment raids' would be classed as crimes against humanity as well as war crimes, and the moral objection to museums continuing to profit from displaying their spoils is compelling – and has compelled President Macron in France to order their return. There should be real shame attached to their permanent exhibition in museums of nations – Britain, Germany and Belgium in particular – that so barbarically acquired them.

CONCLUSION

The sources of international law that have been surveyed in this chapter indicate that a norm requiring the restitution of wrongfully extracted high-value cultural heritage to states of origin has by now crystallised: analogous conventions, state practice, principles shared by civilised nations and decisions of domestic courts cohere to point in that direction. There is now what international lawyers call an *'opinio juris'*, a general view (if not shared by states in respect of particular claims

on their museums) that, in principle, there is an obligation to return looted property of historical significance. What it will take is some authoritative enunciation of the rule: either by a specific convention, or an amendment to the 1970 UNESCO Convention, or a decision or advisory opinion from the International Court of Justice. A specific convention would be the most appropriate vehicle, as it would identify the classes of objects liable to be returned and would set out the conditions and procedures for claiming and enforcing repatriation, ideally establishing an arbitral tribunal to adjudicate disputes and identifying the factors which should weigh for and against that decision (a convention to this effect is outlined in Chapter Eight). Alternatively, or as a prelude to international agreement on a convention, an ICJ opinion should be sought to articulate the rationale for the rule, whether as a sovereign entitlement of a nation state to retrieve 'the keys to its ancient history' or more broadly as an obligation on those states which wrongfully acquired the cultural property of other states or their peoples to restore it to the monuments or museums from which it had been stripped.

The ICJ is difficult to access, because some powerful states do not submit to its jurisdiction, while others impose conditions and time-bars. To take the case of the Parthenon Marbles as an example – and it is the best example for a test case, not only because it is the most prominent but because it concerns cultural depredation in peacetime – Greece and the UK accept the court's jurisdiction, but only in relation to 'disputes arising after 1 January 1984, with regard to situations or facts subsequent to the same date'.[186] Although retention of the Marbles in London might be thought to be a continuing wrong, that is, continuing after January 1984, there is an ICJ decision that says that

the critical time is when the dispute first arose – if not 1801, then after Greek independence and its first demand, i.e. 1833.[187]

There is a simple and appropriate way around this problem, namely that any nation in the world may be a subject of an ICJ 'advisory opinion', if such is requested by a major UN organ – the General Assembly, the Security Council or UNESCO.[188] Although the opinion is not technically binding, one of the great things about Great Britain is that it usually does comply with the 'advisory' rulings of international courts.

Apart from the ICJ, there is always the possibility of approaching regional human rights courts – in Europe, Africa and Latin America – to obtain an order for restoration of property taken unlawfully. The prospects would depend on the actual terms and procedural requirements of the treaty – when an Athenian cultural association tried to call the UK to account over the Marbles in the European Court of Human Rights it was quickly thrown out, because an association had no standing to obtain a ruling[189] – unlike the Greek government itself, which has thus far lacked the gumption to take action against the UK.[190] Any such action, brought in relation to Lord Elgin's despoliation of the Acropolis 150 years before the convention was drafted and ratified by Greece and the UK, would have to show that UK possession was a continuing wrong (which it is), that the 2015 refusal of UNESCO mediation was an interference with the convention's right to property, and that this right includes the right of a state to possess and peacefully enjoy its cultural heritage.[191] If Greece overcame these hurdles the burden would shift to the UK to show that Elgin's taking was lawful and its acquisition of the Marbles under the 1816 Act and its continuing possession was justified in the public interest; the case for their retention in the interests of

the British Museum would then be pitted against the stronger case for having them reunited in the New Acropolis Museum.

It is extraordinary – in fact, a dereliction of its duty to resolve questions arising within the scope of its activities – that UNESCO has not yet asked the ICJ to rule on the return of the Marbles, at least since 2015, when the UK adamantly refused its request to engage in mediation. If UNESCO continues to drag its feet, Greece could mobilise the 105 member states which supported its 2018 resolution in the General Assembly to ask the ICJ for an advisory opinion. As the UN has 196 members, the request should succeed by an easy majority. The case would be heard at the UN's 'Peace Palace' in The Hague, and the advisory opinion procedure would allow other states to take part: many would support Greece. The UK would have to defend itself (perhaps without US support), and it would probably be opposed by Macron's France and by China, keen to get back the Old Summer Palace loot. As for its traditional allies (from the former 'British' Commonwealth), they include the very countries whose cultures it has despoiled. Nigeria, Kenya and New Zealand would be obvious supporters of the restitution principle, and the Caribbean Commonwealth is beginning to stir: as recently as August 2019 Jamaica demanded return from the British Museum's storage of wooden sculptures made by Taino people, indigenous inhabitants wiped out by war and disease introduced by European settlers.[192] In the case of Australia, where Greeks have migrated in numbers large enough to be electorally significant, support for re-unification is a foregone conclusion. Whether an ICJ opinion would find that international law now requires the return of wrongfully taken cultural property is another matter: the authorities set out in this

chapter suggest that it would, and the argument that Elgin's taking of the Marbles was wrongful, developed in earlier chapters is compelling. It would be for Greece to initiate the process of a General Assembly reference to the ICJ, but it must be said that some of its diplomats are hesitant, not because of expense (there are no court costs), but because defeat might set back the quest for return. There can be no iron-clad guarantees, but an ICJ reference would be likely to force Britain to mediate or else expose the weakness of its case to the scrutiny of international judges – and to the world, because the proceedings would be held in public. An opinion from the world court should hold no fears: a declaration that international law requires the re-unification of the Parthenon would not only help to bring it about, but would assist the resolution of many others cases, some discussed in the next chapter. Even failure, possibly on technical or legalistic arguments, would only serve to encourage support for an international convention of the kind described in Chapter Eight. After all, the claim for restitution is a claim for justice, and fear is a reaction that Pericles – and Cicero – would deplore.

CHAPTER SEVEN

MUSEUMS OF BLOOD

DEFINING THE RIGHT OF RETURN

It is one thing to state a principle – in general terms, a right of states or ethnic groups to retrieve wrongfully taken cultural property – and another to define the circumstances which must exist – at the time of the taking and at the time of return – which justify what is, after all, a serious measure of re-expropriation. Treasures of other nations have long been cared for in Western museums and in the hands of private collectors: wresting them from otherwise benign possession is no light matter, and notwithstanding the emotions in favour of restorative justice for the descendants of those so badly treated in the past, it requires clear and generally agreed guidelines if it is to work fairly. Any international convention would need to define the level of importance of the objects within its remit, the nature of the 'wrongfulness' that must attend the original taking, and the circumstances that might justify retention, for a time or permanently. Such a convention could create a presumption of repatriation for certain classes of cultural heritage, with exceptions allowing the retentionist state or organisation successfully to resist a claim. Or it could enumerate the factors which an arbitral body must take into account and weigh in a balance that would decide the

outcome of a particular case. There must be rules for deciding other issues – for example, those where heritage is claimed by a number of states (four have asserted claims over the Koh-i-Noor diamond) – and there should be a way of determining which has the strongest claim, even before this claim is weighed against the arguments which support retention. The 'factors' which must go into the balance would include the following:

I. THE VALUE OF THE HERITAGE OBJECT

Some objects are 'priceless', in the sense that the open market could not now comprehend a sale (for instance, of the 'Elgin Marbles', notwithstanding their valuation by Parliament in 1816). Some existing conventions cover all cultural objects, while others limit their ambit to those that are 'important' or 'significant'. If a nation already possesses plenty of examples of a particular antiquity, it can hardly claim that it needs more. In relation to ancient artefacts for centuries in the hands of private collectors and museums, the severe consequences of an order for return counsel that a limitation must apply, and that claimants must prove a special significance of those they seek. Monetary value cannot be definitive, nor should propaganda value to nationalists who want the object for a political purpose: the claimant must prove either an historic connection to its early development or some religious or spiritual connection to a past that remains of relevance today.

2. INTERNATIONAL IMPORTANCE

This is readily established by consulting the World Heritage list, although a case for world importance could be made for many objects that are not yet listed. It is unhelpful to postulate, as Merryman and

Cuno do, a disjunction between 'universal' and 'national' importance, with the former items belonging in 'universal' (i.e. big Western) museums. The question should turn on where best the object can be studied and appreciated (in the case of the Parthenon Marbles, obviously the New Acropolis Museum, but the Rosetta Stone may be better off where it is – see page 179). A universal value, on top of a contribution to national heritage, would make for a very strong claim by a state of origin if the article could best be exhibited there, in terms of its study and the authenticity of the experience for visitors, even if they have to make a special visit rather than see it in London or New York.

3. SPOILS OF WAR

There should be a presumption that cultural property obtained by or in the course of war must be returned, especially if it was seized while perpetrating a war crime or crime against humanity. The looting of Benin City and Maqdala were British war crimes then and now: it should be a matter of national shame that the spoils are still displayed in the British Museum, or in the museum of any other Western country which procured them by purchase from the British Foreign Office. Heritage objects secured by a surrender treaty (like the Koh-i-Noor diamond) should also be subject to this presumption, especially those made the subject of 'reparations' to the victor for the expense of winning a war, no matter who started it.

4. 'WRONGFULNESS' OF THE TAKING

This extends to cultural items which are acquired dishonestly or deviously, most often by breach of national laws against grave robbing or exportation. Heinrich Schliemann may have discovered Troy and its

gold, but he smuggled 'Priam's Treasure' out of Turkey and bequeathed it to Germany, although the Huns were not part of that epic Greek battle on the windy plain. All the dealers and middlemen and art galleries complicit in breaking national laws, and those who buy from them without taking care to examine provenance, cannot assert good title against a legitimate claim for re-possession.

5. UNCONSCIONABLE TAKINGS

There are other forms of 'wrongfulness' which do not hinge on criminal misconduct, but rather on the principles of equity. Pressure from armed occupiers of a country can lead to surrender of heritage objects by way of 'gifts' that are not voluntary or reflective of gratitude but made from fear or intimidation. Similarly, forced purchases at an undervalue have been common, and deserve to be unravelled, however long ago they occurred. Particularly nasty are cases of undue influence exerted by foreign conquerors over royal children, exemplified by the inducing of a ten-year-old maharajah to give up the Koh-i-Noor diamond and then schooling him, a few years later, to present it as a 'gift' to Queen Victoria. Heritage items acquired in unconscionable ways should all be candidates for return.

6. LEGITIMATE ACQUISITION

Even in cases where there has been compliance with national law, there may be such historical or artistic importance attached to a cultural object that repatriation is appropriate. The cases in this category will be few, and the claimant would bear the burden of proving that the object is exceptional, if not unique, that exhibition in its country of origin would be the best place in the world for it to be appreciated, and that it is under- or unappreciated in the country where it reposes.

7. CARELESS CUSTODY

A factor which counts in favour of repatriation is when it can be proved that the heritage objects of others are being cared for carelessly or disrespectfully, or not at all. This will sometimes be the case with war graves or memorials, or with venerated physical objects of no concern to the country where they happen to be kept. It would include items not exhibited at all, or very rarely, in 'universal' museums: the British Museum puts only a tiny percentage of its treasures on display, so it can hardly resist the return of those in its storage.

* * *

The above factors will generally weigh, according to their strength, in favour of repatriation. But there are other factors which, if made out, should weigh against or actually preclude the return even of notable heritage items to countries which do not deserve to have them back.

8. SECURITY AND PRESERVATION

It must be open to governments and museums to object to the return of items that will not be kept securely, because the recipient state's museums either are unable to store them in conditions which will stop their deterioration or are plagued by corrupt administration (as with the items restored to Zaire in the '70s, which quickly returned to the black market in Europe). Another example is where the claimant state is prone to civil war: it is doubtful whether the Venus of Cyrene, restored to Libya in the seemingly secure Gaddafi era, could be sent back today to a country riven by warring armies. The exclusion applies to international wars, however started, as well as civil wars: the looting

of the Baghdad Museum, in 2003, after the US–UK invasion was a spectacle that gives a haunting example of the fate of antiquities in wartime. It is not necessary to reject such claims permanently, but they must be postponed until peace is restored and is foreseeably permanent.

The claimant must show that its museums are safe for both visitors and exhibits. Museums in some underdeveloped countries are under-appreciated and dilapidated and without the air conditioning necessary to prevent deterioration. While this is a valid objection, the claim might be postponed until the necessary improvements can be made, preferably with funding from the country responsible for looting them.

In other cases, where there is a history of corrupt museum administration, the claimant state must prove this has been eradicated before its claim could succeed. It must also show that its designated museum is secure: the massive destruction of Latin American artefacts in the fire at the National Museum in São Paulo in 2018 indicates just how devastating can be the result of negligent custody.

9. PROPAGANDA USE

It is an article of faith by 'encyclopaedic museum' lobbyists that the choice is between their museums, which are 'universalist' in the sense of exhibiting items of universal importance to 'show the world to the world', and nationalist museums concerned merely with proclaiming their own boastful narratives. These propagandistic institutions they associate with communist or socialist countries (and, although they do not put it this way, with poor countries), to be compared with the broad liberal sympathies of the great American and European museums. They overlook the unfortunate fact that major museums in former colonialist countries seem incapable of telling the full truth about the

barbaric behaviour of their looting armies (see, for example, the 2018–19 Maqdala exhibition at the Victoria and Albert Museum in London – see pages 187–8). The other interesting thing about proponents of this politically driven theory is how rarely they give concrete examples. The war museum in Hanoi, with its pictures of the victims of bombs which killed its civilians, cannot be expected to tell the same story as the Vietnam Vets Memorial in Washington, with its displays of C-ration cans, cigarette packs, basketballs and Snoopy dolls (it does throw in some dog-tags and prosthetic limbs to remind of the 58,000 dead Americans, although not the millions of dead Vietnamese). But every nation is entitled to tell its own story, within the limits of ascertainable truth. The worst example of politically driven nationalism came in the United States, with the driving out of Richard Tofel, the far-sighted director of the International Freedom Centre, whose plans for a genuinely international approach to remember 9/11 had to be abandoned as the result of a populist outcry demanding instead a Muslim-free celebration of New York rescue services.[193]

Nonetheless, if respondents can show that the item will or may well be used for deceitful propaganda purposes, the claim should be refused. Take Great Zimbabwe, a magnificent and mysterious ruin, and evidence of a highly developed civilisation in Africa as early as the eleventh century. In the time of Ian Smith's racist government in Rhodesia, archaeologists were banned from suggesting that Great Zimbabwe had been built by Africans, lest people get the idea they could be clever: they were ordered to say that it was the work of wandering Jewish or Arab architects (although it was almost certainly built by ancestors of the Shona people with their profits from trade in gold and ivory). Should a Rhodesia-type government make a pitch for return of looted items, it must be rejected:

historical antiquities, even if taken in historical inequities, should not be allowed to adorn museums that promote false history.

National (not always nationalist) feelings run strong, and can become irrational. A recent example is Benjamin Netanyahu's attack on perhaps the most moving of the many Holocaust memorials, the Jewish Museum in Berlin. It leaves most of its visitors in tears by its display of everyday family objects and the stories of Nazi brutality towards members of the family to which they belonged. A measured and impartial documentary exhibit about Palestine infuriated Netanyahu by including a few voices from Palestinians, although they made reasonable points to the articulation of which only a racist could object. The controversy did show how sensitive politicians can be about museums, which are institutions expected to give the imprimatur of history to the stories their exhibitions tell. When they cannot, as a result of political interference, their right of return for looted objects might be blocked.

10. HUMAN RIGHTS

Restitution by way of international law is itself an enforcement of the human right to enjoy one's own culture, or indeed culture relating more generally to human progress. Is it, therefore, right to order restitution of cultural objects to states that trample on the rights of the very people in the name of whose culture they seek the return? States run by oppressive governments may have difficulty claiming in the interest of human values if those values are in other respects denied to their own people. This may be a reflection of the old maxim 'He who comes to equity must do equity' (or '... must come with clean hands'), although it is also justified by revulsion at a state which consistently breaches rights necessary for culture, like freedom of speech. This was reflected

in the 'unspoken moratorium' by campaigners for return of the Parthenon Marbles during the seven years' rule by the fascist colonels.

There are those who believe in 'cultural diplomacy', but this is often counter-productive, as we have seen with the 'Cyrus cylinder', exploited by Iran as propaganda for the Basij militia, its brutal street police, and the river god Ilissos, pictured beside Vladimir Putin, comparing his puffing chest shortly after he had invaded Ukraine. The argument is reminiscent of that over apartheid, when one side recommended playing sport with South Africa to 'build cultural bridges', but apartheid ended only after – and partly as a result of – breaking sporting links. There would be a real question of whether cultural heritage items, however valuable or historically important today, should be returned to Brunei if it enforces the death penalty for homosexuality, or whether treasures should be returned to Turkey (while its jails are full of judges and journalists) or China (which locks up human rights lawyers and pro-democracy campaigners). These issues should not preclude repatriation, unless there is evidence of direct persecution of artists, but they could be a factor that weighs in the balance, and require these countries to defend and (optimistically, perhaps) ameliorate policies inimical to cultural freedom.

How would the factors identified above be weighed in relation to some well-known claims for retention of heritage?

THE BENIN BRONZES

The story of the sack of Benin City by the British army in 1897 must briefly be told. Situated in what is now the Edo state of southern Nigeria, it was a capital ruled by a king,* and had a degree of autonomy

* The king is often referred to as 'King Oda', misunderstanding that 'Oda' is the Yoruba word for 'king'. This oda's name was Ovonramwen.

resented by the British trading companies, which wanted free access to its palm oil, rubber, and other plentiful natural resources. They pressured the British government to invade in what they unashamedly described as the interests of 'commerce and civilisation', in other words of increased profits.[194] In 1892, the king welcomed British consuls, who presented him with a document which he signed with an 'X'. It ceded sovereignty to Britain and guaranteed free trade. When Oda acted as if he had no idea what the document meant (which was likely, since neither he nor anyone in his kingdom could speak English), the British prepared to use force. 'We badly want the increased revenue which would result,'[195] the British consul general reported to the Foreign Office. The first reconnaissance mission, of several hundred (mainly native porters as well as some British officials and company representatives), was not meant to be an invasion, but the Benin soldiers took it as such and decimated them after they tried to enter the city when it was closed for a taboo religious event.

That did it: 1,500 British troops, backed by nine Royal Navy ships, advanced in what was termed a 'punishment raid' on the city, killing some of its citizens and burning it to the ground, but not before taking about 3,000 artworks from the palace and its temple. Benin was henceforth open for British business, and the booty was brought back in convoys and by soldiers in their knapsacks. The Foreign Office decided it should be sold 'to defray the costs of the expedition'. The British Museum kept about 700 pieces, while museums in Vienna (167) and Berlin (the Humboldt has 580) bought some of the spoils, and others ended up in at least thirty collections in America, picked up on the European art market. The Sarr–Savoy report (see Chapter One) located some plaques, commemorative heads and an ivory tusk on display in the Musée du quai Branly – Jacques Chirac in Paris.[196]

There can be no doubt that the Benin Bronzes are unique, the product of unrivalled sixteenth- and seventeenth-century artistry in west Africa. They are not really bronze – more brass, with amalgams and often ivory and cloth adornments, taking the form of intricate metal plaques depicting the royal family, priests and retainers of one of the oldest and most highly developed civilisations in Africa. They are not only of cultural and historical importance to the people of Nigeria, but of the region, the continent and of the world – proved by their exhibition in the main 'world museums' of Europe and America, as well as at Cambridge University (where students are beginning to object) and at Liverpool World Museum, where they are proudly displayed to pay homage to a city that was the hub for the trading companies that insisted on the invasion of Benin. This 'punishment raid' amounts to a war crime, now and at the time – pillage had been a crime for centuries. The nation that insisted in 1815 on returning Napoleon's loot could never bring itself to return a single item to Nigeria, even when that country was granted independence in 1960. Nigeria had to go into the open market to acquire a few examples for its national museum in Lagos.

There have been suggestions that although the 'spoils of war' doctrine does not exist in wars between 'civilised' (i.e. European) nations, it applied nonetheless to colonial conquests of 'uncivilised' or un-Christian tribes or kingdoms. Britain tried to excuse its brutal behaviour by claiming it found evidence of human sacrifice. Even if true, this was not a motive: the purpose of preparing the invasion was profit, and the occasion for its timing was revenge.[197] It was a barbaric action in which uncounted (because nobody bothered to count) civilians were killed by bayonet and musket-shot, all the valuable cultural property was stolen and thereafter the palace, temples and houses were burned to

the ground. The Benin Bronzes were taken by force in an act of military aggression and should therefore be returned.

Do the exceptions come into play? Western museums have taken care of the Bronzes, but would not be irreparably denuded if they were forced to give them back – no doubt Nigeria would let them keep some pieces (at a reasonable rent). The British Museum has a marvellous brass ladder on which some twenty of its Bronzes are mounted, but it has other examples and there are rumours that more must be in storage. The Nigerian government is not oppressive, although it has been accused of starving museums of funds – some are said, by their own curators, to be crumbling, with leaky roofs and insect-infected storage facilities. This would be a serious objection to return, but Nigeria has now planned a new Royal Museum, near where the king's palace once stood, with the necessary facilities to house the exhibition of returned artwork. It is scheduled to open in 2020, and is designed for study and exhibition of the Bronzes.

In 2007, the Nigerian government and Edo state formed the Benin Dialogue Group, along with some of the other museums, in Britain, Germany, Austria, Sweden and the Netherlands, which hold Benin Bronzes. It was inactive until galvanised into life by President Macron's shock announcement, and in December 2018 it reported that several Western museums were finally prepared to return some Bronzes (they would decide which) but only on loan. Macron had shamed them, and a loan is a face-saving way to avoid ever parting with possession. It is also an insulting and unacceptable way – even a permanent loan is infused with the taint of colonialism, betraying a fixed belief that good title was legitimately obtained by colonial aggression and plunder. The British Museum used the excuse that it was not allowed to de-access but its trustees were

not prepared to ask the government to amend this law. They are not prepared to acknowledge the wrongful acts of the British army in wars of aggression in Africa, namely by returning possession of its plunder: the Department for International Development, which dispenses billions in British aid, often in support of British trade, has not thought to fund museums for countries which the British army once despoiled.

THE ROSETTA STONE

This iconic stone slab from 196 BC records a pharaoh's decree in three scripts – hieroglyphics, read by the priesthood (who benefited from a tax exemption announced in the decree); a demotic shorthand used for ordinary transactions; and ancient Greek, the language of government. It had been displayed in a long-destroyed temple, and had lain for centuries somewhere in the mud of the Nile Delta until fished out and used as a building block for an Egyptian fort. In 1799, French soldiers, members of Napoleon's invasion force, noticed this curiosity and dispatched it to Cairo where it was examined by the team of experts (the 'savants') that Bonaparte, that looter *extraordinaire*, had brought with him to hoover up the antiquities of this ancient (and, at the time, largely unstudied) land. After Nelson decimated the French forces at the battle of Aboukir Bay, the resultant peace treaty allowed the defeated French army to return home on condition that they surrendered their spoils – reluctantly, they handed over the Rosetta Stone. It was taken to the British Museum, where it now has pride of place – the most visited exhibit, with more postcards of it sold than any other – even the 'Elgin Marbles'. That is because comparison with the Greek text enabled the deciphering of the hieroglyphics and the demotic, thanks to the work of a British scientific genius and then a brilliant French linguist. The

wonderful world of Egypt under the pharaohs could now be studied and understood.[198]

The Rosetta Stone scores very high in terms of historical importance, to Egypt and to the world. But that importance is due to its presence in the British Museum and the work of French and British cryptographers. It was acquired as an indirect result of war, but not by a pillaging army – it had been abandoned until the 'savants' saw its significance. No illegality attended its taking, or its taking to the museum which has studied and displayed it with prominence and reverence and would be deprived of its most notable single treasure if it were to be repatriated. The Cairo Museum could not provide the same treatment, and the Muslim Brotherhood, should it ever return to power, might see it as the symbol of a religious past, unworthy of exhibition. Moreover, the stone is not unique: seventeen more three-script stelae recording the same proclamation (the decree of Memphis) have been discovered in other temple ruins and are in the Cairo Museum, so the magic in this particular stone attached to it only in London. The decree of Memphis itself is not in any event important – it is a hagiography of a short-lived and insecure king, who is giving a tax break to his clergy as an incentive for their support. It belongs in the British Museum, where it helped the modern world to understand and appreciate its earliest history.

THE BUST OF NEFERTITI

This fashion icon, whose very name means 'the beautiful one has come', is the likeness in limestone of the 'primary wife' of the pharaoh Akhenaton (ruled 1353–36 BC), who called her his 'mistress of happiness'. Just how beautiful she was in the flesh is open to question from other contemporary representations on temple walls, but there can be no

doubting the attraction of 'the swan-like neck, the dark doe eyes, the high noble forehead on a delicate featured head, crowned by a towering blue headdress'.[199] She was, however, unique in sharing power with her husband, who made love gestures to her in public and joined in the up-bringing of their six daughters – their love story is recorded in temple paintings – and they introduced a religious first, namely monotheism. This involved the worship of the sun god, supreme giver of life and joy (a relief from Isis, who was always mourning Osiris). This devoted couple seem to have been the first art-sponsoring liberals in antiquity.

The bust was dug up in 1912 from the studio of the sculptor Thut-mose, by the German archaeologist Ludwig Borchardt. His expedition was funded by a wealthy German businessman and was conducted under the *partage* system, whereby the findings would be equally divid-ed between the excavators and the host country, with the latter having the right of first choice and a further right (of second thoughts) to purchase any piece that might have been allocated to the excavator in the division. This allowed a country to stop the export of its important national treasures if they were overlooked in the *partage*. However, Bor-chardt cunningly left the bust covered in mud among the less important objects, and the representative of the Egyptian antiquities authority, a junior French official who conducted the *partage* (there were at this time no Egyptian Egyptologists), failed to identify its importance and so allocated it to the Germans. Whether the official was bribed does not matter – Borchardt rigged the *partage* system by hiding Nefertiti from him and did not identify her, as required by law, in the list of objects allocated to the Germans from the *partage* or provide a copy of the list for the national museum,[200] so the German exported the bust deceit-fully without the Egyptians ever expressly agreeing to its departure.[201] It

became the property of the merchant who had funded the expedition and who held the excavation permit; he donated Nefertiti to the Egyptian Museum in Berlin in 1920. Its exhibition caused rapture in Europe but fury in Egypt, which immediately demanded its return – as it has ever since.

Why, by the way, were there no Egyptians in Egypt's antiquities authority? Because they were considered by the French too 'primitive' to study at the antiquities institutions that they ran in Egypt or in France itself, and the British consul said publicly that they were not 'civilised enough' to look after their own heritage.[202] These were the racist views of a time when Egypt was under British occupation, and it was not until Colonel Nasser's revolution in 1952 that Egyptians were finally put in control of the country's Supreme Council of Antiquities.

Repeated Egyptian demands for the queen's head from Berlin were rejected until Hermann Göring (who cared so much about culture that he would loot it prolifically in years to come) became sympathetic. He was overruled by Hitler, that great supporter of universalist museums, who wrote to Egypt promising that the 'Führermuseum' he would build in Linz would have at its centre a large domed chamber. 'In the middle, this wonder Nefertiti, will be enthroned. I will never relinquish the Head of the Queen.'[203] The bust was hidden from the Soviet Trophy Brigades in a salt mine, retrieved by the US 'Monuments Men' and returned to Berlin.

There were furious public demonstrations in Egypt in 2003 after the Berlin State Museums allowed the head to be briefly placed on a naked female body sculpted by renowned artists, for a photograph to be used in their Venice Biennale artwork. There was a diplomatic protest – 'Egyptian civilisation never displays a woman naked,' fulminated

the Egyptian ambassador, ignoring its endless wall paintings of bare-breasted women and naked slaves. This manufactured outrage was encouraged by Zahi Hawass, Egypt's self-promoting head of the Supreme Council of Antiquities, who denied the director of the Egyptian Museum in Berlin (and his wife!) permission to excavate in Egypt in future and ended all co-operation with the museum.

This ridiculous reaction is now used as a reason for the bust to remain in Berlin, free from nationalist hysteria. The Biennale entry, 'The Body of Nefertiti' (now itself a museum exhibit), was a legitimate reflection on the way broken antiquities are exhibited and viewed: far from diminishing Thutmose's achievement, it perpetuated his art by showing a vulnerable human body beneath the immortally beautiful head. 'Egypt's reaction makes clear that a return of the bust to Egypt would place it beyond the reach of contemporary artists,' the retentionists complain,[204] and the manufactured outrage additionally serves as a warning about fundamentalists objecting because the god she worshipped was the sun rather than Allah.

However, other factors in the balance do come down in favour of her repatriation. The work is unique and of historic and cultural significance. It was acquired by deception, or at least by oversight – under no system of *partage* could it possibly have been allocated to the German excavators. The Berlin Museums cannot claim to have used it for scholarship which could not have been engaged in without its presence, and although it brings in the crowds it would do so – and the crowds would be more appreciative – in Cairo, or better still in the state-of-the-art Grand Egyptian Museum being built in Giza, near the Great Pyramid, which will open in 2020, to house the contents of Tutankhamen's tomb. There, tourists spending weeks understanding ancient Egypt might

appreciate Nefertiti's significance (and her beauty) rather more than those whose day trip to Berlin includes a visit to Checkpoint Charlie and what remains of the Kit Kat Club. Egypt's human rights record is open to question, of course, and the relic might be more vulnerable to fundamentalists of the kind who in 1997 massacred tourists in a Luxor temple. That means that Egypt must satisfy the tribunal that it will provide for the queen's physical security and the restitution agreement must have a condition that allows, at a point determined by an impartial arbiter, for it to return to Europe in the event of civil war or terrorist danger.

The rape of Egypt, by French, British and German antiquities collectors in the nineteenth century, is described in many books – some using that term.[205] It was lawful, done by their diplomats who readily obtained *firmans* from the relaxed Ottoman ruler, who saw no connection between his 'backward' subjects and the mighty pharaohs 3,000 years before, and was pleased when relics of their civilisation were shipped to Europe for display. The British consul Henry Salt, following in Lord Elgin's disgraceful footsteps by using his office for profit, formed a partnership with a dubious Italian archaeologist and together they plundered the Nile Valley. The bust of Rameses II (Ozymandias, fallen idol of the Shelley poem) was transported with difficulty to the British Museum. They uncovered the 1300 BC tomb of Seti I, father of Rameses, and took his alabaster coffin to sell in London, where it was bought by Sir John Soane and may be viewed today in his eponymous museum in Lincoln's Inn. A section of the beard of the Sphinx was hacked off that ancient monument and also found its way to the British Museum. There are so many Egyptian antiquities in museums and private collections as a result of officially approved excavations or

partage divisions that Egypt's claims for restitution should apply only to unique items of artistic or historic significance, and these three all fall into that category. The section of the Sphinx's beard should go back on the principle of the unity of monuments; the head of Rameses II could be replaced by an exact replica, large and glowering, for selfies; and the alabaster sarcophagus might also be replicated.

THE MAQDALA PILLAGE

In 1868, the British government, to popular acclaim, declared war on a Coptic Christian king, Tewodros (Theodore) II (he was thought to descend from King Solomon and the Queen of Sheba), who had a mighty citadel on a mountain in Maqdala, in faraway Abyssinia (modern-day Ethiopia). He was friendly towards Britain – Queen Victoria sent him a revolver as a gift – and he eagerly sought military alliance with Britain against his aggressive Muslim neighbours, but his entreaties were not answered. Upset that he had heard no response, he took hostages – the British consul and some missionaries – and said he would not release them until Britain replied to his request for help. It did, but in a way he could not have expected. Public outrage demanded his overthrow, and was fanned by Benjamin Disraeli in his election campaign: populism, not for the first or last time, demanded punitive war – not for territory, but to release hostages and to loot the king's citadel. For the latter reason, the British Museum disgracefully appointed its own official – Richard (later, Sir Richard) Holmes – as 'archaeologist' to help soldiers identify treasure that was worth taking. A massive force was assembled in Bombay, of 13,000 soldiers and 8,000 support workers (mainly from India) plus forty-four elephants and several hundred donkeys and horses. To get to Maqdala was a remarkable feat, over 400

miles of mountainous terrain, but the expedition was led by an engineer, Lieutenant General Napier, who built bridges and railway lines and communication devices and machinery for lifting elephants. There were journalists (and even a photographer) who sent back admiring dispatches to London and New York.[206]

When the army reached the foothills of the fortress they were attacked by King Theodore's soldiers, but the British had the latest breech-loading rifles and killed 500, for the loss of only two men. The king released the hostages and begged for a peace treaty, but Napier (spurred on by the journalists and the museum representative) refused his surrender offer. He ordered an advance and the storming of the citadel. Once inside, the soldiers were greeted by the sight of the king, his body outstretched on the ground. He had committed suicide, using the revolver gifted to him by Queen Victoria, rather than suffer the ignominy of imprisonment. The soldiers took his body for burial in the church of Medhane Alem, outside the city, and then they burned the church.

The expedition, mission accomplished, might have made a quick peace settlement with his successor and headed for home. But not the British army, with its museum advisor avid for spoil, who spied rich pickings in the grand (and Christian) Ethiopian churches. In what is probably the most blatant example of the crime of pillage when a war is over, they took gold chalices and crosses, icons and paintings, gold and silver crowns, shields and arms from the fourteenth century, and a thousand volumes of priceless manuscripts, although those without gold or silver or illustrations were torn up and trashed. The spoils were stacked over half an acre of ground for an army auction, at which Richard Holmes, 'armed with ample funds', was described 'in all his glory' purchasing the best. Holmes boasted of being inside the citadel a few minutes after the

walls were breached and buying for £4 the king's golden crown and a chalice, which were already in the hands of a foraging soldier. Fifteen elephants and 200 mules carried the treasures back to the ships. They ended up in British museums, although some were sold on to collectors and museums in Europe and the US. In the nasty but familiar British fashion, the king's heir, a seven-year-old boy, was taken into custody and sent to Rugby School to be taught civilised manners; he died at Windsor Castle, aged eighteen, before Queen Victoria's retainers could school him to govern his kingdom as a British puppet.

The most valuable of these items should be returned to the National Museum of Ethiopia or to an Ethiopian university. They are important national heritage, and they were seized in a deliberate and criminal act of pillage of the religious icons of a Christian kingdom that had surrendered. They can be replaced by replicas, in a gallery which can tell the disgusting story in terms less euphemistic than the V&A's exhibition in 2019, 'celebrating' 150 years since the expedition. This was a wretched affair – one glass case, hidden (there was no signage) in an upstairs room devoted to diamonds. The exhibition made no reference to the peace offer or the release of the hostages, or to the illegality of the pillage or to the role of the British Museum representative in urging on and participating in the despoliation. Visitors were presented with these weasel words: 'As is often the case with items of this nature in Museum collections, there are many questions surrounding their history and provenance. The 150th Anniversary is an opportunity to reconsider the role of these objects as witnesses to a controversial period in Ethiopian and British history.'

They were witness, of course, to the barbarity of the British army, urged on by the British Museum, in destroying Christian relics and

looting shrines and tombs before razing them to the ground, in an entirely unnecessary attack the objective of which (the release of the hostages) had already been achieved. The failure to mention these facts provides a good example of why British museums should never be trusted with looted artefacts, because they are incapable of telling the truth about the barbarities these have 'witnessed'. That truth would certainly be told by museums in Ethiopia, but British curators cannot bring themselves to acknowledge, other than cloaked with euphemisms, the brutality of colonialism. They seem still to have a lingering pride in the way it filled their museums: what they do not have is any real sense of shame.

The V&A's politically savvy director, Tristram Hunt, acknowledges the force of the restitution movement but adds that 'empire was a story of cosmopolitanism and hybridity' – for its rulers, no doubt – and resists 'total restitution' because 'there remains something essentially valuable about the ability of museums to position objects beyond particular cultural or ethnic identities, curate them within a broader intellectual or aesthetic lineage, and situate them within a wider, richer framework of relationships'. These are portentous, Cuno-erque words, but what do they mean? They boil down to a little glass case set among the V&A's diamonds, inviting consideration of 'a controversial period in Ethiopian and British history'. Not much curation within a 'broader intellectual lineage or aesthetic lineage' here. Hunt even writes of approving of the expedition 'under the stewardship of accompanying curator Richard Holmes', for whose greedy behaviour even the British Museum now apologises. The V&A's exhibition and its director's willingness to debate the subject are welcome, but how long can they resist the demand to give back the stolen crown of a king who is still revered and worshipped?

Mr Hunt has tentatively agreed to return the treasures, but only on loan (playing that familiar museum trick to pretend that they cannot give up possession because of the law against de-accession, although those who play it never request Parliament to change the law). It is worth remembering that Napier himself advised that the most valuable objects (the king's crown and gold chalice) should be restored 'when a Government was established with some prospect of stability', while William Gladstone, at least, stood out against popular sentiment and expressed shame that 'these articles, to us insignificant, though probably to the Abyssinians sacred and imposing symbols, or at least hallowed by association, were thought fit to be brought away by a British army'. He added that they should be restored.²⁰⁷

Emboldened by Gladstone's speech, the Ethiopian emperor (Theodore's successor) requested the return of a precious manuscript, 'The Glory of Kings', which told of the Queen of Sheba's visit to King Solomon, and a picture of Christ with the crown of thorns, which Coptic Christians had always taken as a talisman into their battles with Muslim forces. The British Museum had two copies of the manuscript, one good and one bad, so they offered the bad one for repatriation. The museum informed the Foreign Office that it did not have the painting in its collection, which was true – Sir Richard Holmes, its representative on the expedition, had misappropriated it for his private collection. He subsequently became Queen Victoria's librarian, and his possession of the icon was well known. Nonetheless, the Queen dishonestly (and no doubt at her librarian's dictation) wrote to the emperor that 'of the picture we can discover no trace whatsoever, and we do not think it can have been brought to England'.²⁰⁸

The establishment of the time regarded restitution to 'lesser breeds' as

crazy. One Lady Meux acquired some precious Maqdala manuscripts, but on realising their value to the Maqdala people, she left them in her will to be returned to the emperor. When the will was read, there was a scandal: she was condemned by *The Times* and the judges struck down her bequest, thinking it proof that she had been suffering from dementia. In 1924, the Foreign Office needed to find a gift for the visiting empress of Ethiopia, who indicated that what she wanted most from Britain was the crown of King Theodore. It was quickly established that the V&A held two of his crowns, one of solid gold, and one of silver and of little value. She was presented with the silver crown (and the Foreign Office noted that this 'must not be regarded as a precedent for the return of the Elgin Marbles').[209] The only dash of decency and respect for Maqdala loot has come recently from the National Army Museum, which possessed a lock of Theodore's hair, cut off his head by a souveniring soldier. It was returned as a human remain of what Ethiopia has described as its 'most revered and beloved leader'.

A current and most curious controversy relates to some sacred *tabots* – holy icons wrapped in cloth that may only be unwrapped and viewed by Coptic priests. Twelve were looted, one ended up in Westminster Abbey and the others in a sealed storeroom in the British Museum where staff are not permitted to enter or touch them – their only occasional visitors are Ethiopian churchmen.[210] This is appropriate, as the right to religious observance must accommodate such taboos, but obviously they belong in a church, and a church in Ethiopia. Once again, the museum trustees claim to be hamstrung by the de-accession rule (without asking for it to be relaxed), while Westminster Abbey refuses even to allow Ethiopian churchmen to view their own icon. Thus the consequences of colonial crimes still haunt. The museum trustees could

simply deploy their power (under Section 5 of the 1963 Act) to decide the *tabots* are 'unfit to be retained in the collections of the Museum' because they can never be shown to their visitors and staff, but they lack imagination as well as sensitivity to the needs of other cultures whose stolen relics they harbour.[211]

THE GWEAGAL SHIELD

In an unobtrusive cabinet in the long Enlightenment Room of the British Museum stands a lump of bark wood with a bullet-sized hole and some scrapings of ochre paint. The description says that it was collected by Captain Cook, when his ship HMS *Endeavour* arrived at Botany Bay in 1770 and encountered a group of apparently hostile Aboriginal people. The museum label says that his landing party fired warning shots after attempts to communicate failed, and that the shield was dropped when they fled.[212] But that is not what Cook says in his journal. He admits that he fired a first warning shot, but then the Aboriginals' failure to flee 'caused my firing a second musket load with small shot and although some of the shot struck [a] man, yet it had no other effect than to make him lay hold of a shield to defend himself'.[213] If its effect had been to kill the man (a warrior later identified as Cooman), who indigenous history says later died from the wound, Cook would apparently have been little concerned. Other shots were fired until the shield and spears were dropped and the Aboriginals fled into the bush. Cook did not regard himself as invading their territory, because British law at the time regarded land unclaimed by colonial powers, however full of native people, as *terra nullius*, open for claiming and colonising. He had no means to communicate (his interpreter from Polynesia was no help), but shooting at them was disgracefully disproportionate.

Cook should have retreated. He had seen that the Aboriginals had their homes on the shore and noted their cowering children, and he must have realised that his party of forty men would seem threatening. His successor, Captain Arthur Phillip, who arrived in Botany Bay eighteen years later, did find a way of communicating by ordering the landing party of marines, instead of shooting, to pull down their trousers – to show that they were men and not invading gods. The sight of their wrinkled scrota produced giggling, and some welcoming noises.

Cook landed to inspect the huts and souvenir the shield and the spears dropped on the beach and brought them back to London in the *Endeavour*. This shield is iconic for Aboriginal people, and should be returned to them.[214] It has no commercial value or particular importance for the world, but is a searing reminder of a past that began with musket shots and ended (the last Aboriginal massacre was in 1928) with up to 60,000 indigenous deaths from white settler violence and many more from the diseases and the alcohol that they brought to the country.

There can be no doubt that the shield is of little meaning to the British and to the tourists who visit the museum (few notice it, a piece of bark in a small bottom cabinet in the long and gloomy 'Enlightenment Room') and will be securely looked after in Australia. Its hole could be forensically examined to decide whether it was made by a musket ball or (as is sometimes suggested) a spear cast in previous tribal warfare.[215] It qualifies as an item seized in war (for its curiosity value) and although the Australian government is cruel to asylum seekers, its record on human rights is generally quite good. There are unresolved issues with its indigenous people, but that makes it even more important that they should have this icon back, because it represents all too starkly the first

shot fired in anger by white invaders. The British Museum certainly will not miss the shield – it has an estimated 6,000 Australian Indigenous artefacts, including paintings, spears, headdresses, boomerangs, axes and shields, the great majority never displayed in its exhibition. (Many more languish in the Museum of Archaeology and Anthropology in Cambridge, including four spears that Cook also picked up at Botany Bay.[216]) Of course, the museum is willing to send them on brief 'touring exhibitions', so long as it always retains possession. In 2004, Aboriginal activists took some shields and spears from one of these exhibitions, but the courts refused to recognise their native title and after threats from the British Museum, the Australian federal Parliament passed the 2013 Protection of Cultural Objects on Loan Act to make it a crime for the disinherited to reclaim their heritage from touring exhibitions. A few years later, however, the New South Wales Parliament acknowledged that the Gweagal people rightfully owned the shield, and demanded its repatriation. It should go back, but the British Museum trustees will not lift a finger to ask the British Parliament to allow its de-accession.

As for Cook's ship, the *Endeavour*, it sailed up the east coast of the 'great South Land', enabling the drawing of the first maps and charts, until it foundered on the Great Barrier Reef, was repaired and sailed back to London with the shield and spears. It later served as a troop ship in the war against America and was scuttled off Newport, Rhode Island. In 2018, its hull was detected by an underwater photographer, and there are now plans to salvage it. Which nation could claim it as heritage? For quite a few Pacific island states it was their first sight of Western colonisers, although its exploits under Cook make it the vehicle used by one of the world's great explorers. For Australians, however, the boat is iconic, both as the forerunner of British settlement and, for

its indigenous people, as the harbinger of invasion. For both reasons the Australian government should claim what is left of it and set it on a monument at the Australian National Maritime Museum in Sydney, where commuters could gaze in astonishment at a ship smaller than the ferries that ply their harbour, but which circumnavigated the world and brought such consequences – good and ill – to the Great South Land. However, Australians care more for sport than for history – when one yacht won the America's Cup in 1983, it paid $2 million to purchase it and built a special museum in Western Australia (where it had been designed and built for a local corporate criminal) to 'recognise the value of conserving objects in their original place'. The Australian yacht had sailed to victory over America at Newport Rhode Island, on a course that would have taken it over the wreck of *Endeavour*, from which it might have received some mystic encouragement.

PRIAM'S TREASURE

The Trojan War, as told by Homer in the *Iliad*, is the best known of all ancient legends. It began with the judgment of Paris, King Priam's son, who presented the gold apple for goddessly beauty to Aphrodite, after accepting her bribe – the love of the world's loveliest woman. Unfortunately, this turned out to be Helen, the face that launched a thousand ships, because she was already married to a king whose fellow Greeks took Bronze Age revenge, in about 1300 BC. The story of the fall of Troy so gripped a wealthy German businessman, Heinrich Schliemann, that he named his children Agamemnon and Andromache and set out to discover and then to excavate this fabled city in north-western Turkey, not far from Gallipoli. There were several cities built, over the centuries, on top of each other, and the cauldron in which Schliemann found

what he dubbed 'Priam's Treasure' probably dates from an earlier time than Homer's Troy. But it was Trojan nonetheless, and the name has stuck for these beautiful golden artefacts which Schliemann, having spent a fortune to find them, could not bear to give up, although Turkish law at the time (1873) required excavators to share their finds with the government, and forbade export.

Schliemann smuggled the gold out, first to his home in Greece, and then for exhibition at the Victoria and Albert Museum in London, before sending it to a museum in Berlin for the German nation to enjoy in perpetuity. The Turkish government sued for its return, and there was a voluntary settlement under which Schliemann paid a substantial sum, but the settlement did not extinguish the rights of Turkey, which remained, in Turkish law, the owner of the hoard. Nonetheless, it stayed in Germany, and towards the end of the Second World War was hidden at Berlin Zoo, where it was discovered by one of Stalin's Trophy Brigades and taken to the Pushkin Museum in Moscow. It was not publicly exhibited (or its presence admitted) until 1993. Why the delay? It may be that the hoard lay forgotten in the basement, but it is more likely to be because of embarrassment, since the Trophy Brigade heist was palpably unlawful, although Stalin defended it as 'reparations' for Russia's war expenditure in repelling the Nazis. Mikhail Gorbachev made a tentative agreement to return the hoard, but this was later rescinded by Vladimir Putin, whose director of museums refuses even to discuss the subject. But the gold has no connection with Russia or with Pushkin. It should go back, but not to Germany.

One contender is Greece, which has put in a claim. Priam was, after all, conquered by the Greeks and the hoard (if it was his) would have been hidden from the victors just outside the walls of the burning city

(where it was actually found) so that they would not take it as their 'spoils of war' (which would have been lawful, back in 1300 BC). But the strongest contender must be Turkey, which has maintained the World Heritage site at Troy and spent $45 million on a new museum, which opened in 2018, with remarkable artefacts from the region dating back 5,000 years.

Its existence helps to refute the main objection to sending treasures back to Turkey, namely the corruption, lack of security and lack of visitors that have blighted museums outside Istanbul. This is epitomised by the scandal of the gold of King Croesus (as in 'as rich as Croesus'), which was excavated by robbers in the mid-1960s and then smuggled to a Madison Avenue dealer, who sold it on to the Metropolitan Museum (its officials knew of the illegality) and Turkey had to sue for its return. But a few years after it had been restituted to the local museum, its centrepiece, a brooch with a golden hippopotamus, was stolen with the connivance of museum staff.

To defeat a Greek claim for Priam's Treasure, were Russia prepared to give up this ill-gotten gain, Turkey would have to show that in its Troy museum, the treasure would be as safe as it would be in Athens. It would have the problem of defending the human rights record of President Erdoğan, who continues to lock up judges and editors and members of the archaeological service, and has yet to explain why an international team of 100 experts who were to use new archaeological techniques to examine the site of Troy suddenly had their visas cancelled. A country which does not allow World Heritage sites to be examined by world experts might have some difficulty in convincing an arbitral tribunal that it is a worthy custodian for ancient Trojan treasure that is of value for citizens of the world to see and to study.

THE KOH-I-NOOR DIAMOND

This jewel, the 'Mountain of Light', was for several centuries the largest diamond in the world – 'a diamond the size of a hen's egg', weighing 173 carats.[217] Its provenance is uncertain: it was probably mined in southern India in the thirteenth century and it enters history first when seized by the brutal Mughal warlord Nader Shah during his sack of Delhi in 1739. It reposed in the eye of the peacock atop the fabled peacock throne in what is now Iran, although Nader christened it the 'Mountain of Light' and took it out to wear on his armband as a talisman in his battles. After his death, it fell for seventy years into the hands of Afghan warlords. Then it was retrieved by Sikh rulers of the Punjab (a territory now divided between Pakistan and India), and in 1813 began its modern history on the arm of Ranjit Singh, who wore it in Lahore as a symbol of his puissance and good fortune. He was a respected ruler, less brutal than most (he abjured the death penalty, for example, although at his funeral in 1839 his three wives and their seven slave girls were victims of the practice of *sati*, which he failed to abolish, and were incinerated with his body).

Meanwhile, the wealth of the Punjab had attracted the greedy attention of the East India Company, that commercial surrogate of the British government, which invaded with its own massive army to win the first Anglo-Sikh War in 1846. The Koh-i-Noor diamond was by then on the pudgy arm of Ranjit's eventual successor, a ten-year-old boy. This baby maharajah was forced to sign the Treaty of Lahore, drawn up by the East India Company to cede to it the lands it craved, dressed up as 'reparations', and, specifically, the Koh-i-Noor diamond, which by Clause III of the treaty 'shall be surrendered by the Maharajah of Lahore to the Queen of England'. Company officials took it to Windsor and presented it ceremoniously to Queen Victoria (making the point that it

was worth £500,000), after which and to intense public excitement it was made the star attraction at the Great Exhibition of 1851. Its seizure, albeit from a child, and its display showed that Britain ruled not only the waves but the world.

The maharajah, young Duleep Singh, was given the devious treatment accorded to deposed young royals from the colonies. He was cruelly separated from his beloved mother, whom the company regarded as an unreliable influence – she was exiled to a prison fortress so she could have no contact with him. In her place was put a British schoolmaster who tutored him in English language, manners and religion (his public conversion to Christianity shocked his Sikh people) and then took him to finishing school at Windsor Castle. There a problem had arisen: Queen Victoria had refused to wear the diamond, perhaps feeling (as well she might) some sense of shame at its capture from a child by the East India Company. She wanted it as a genuine tribute, so the boy – by now aged fifteen – was manipulated and pressured to 'gift' it to her at a ceremony staged at Buckingham Palace in 1854. Once the boy had been satisfactorily rehearsed, the diamond was placed in his hand and he was made to present it to the Queen, who thereafter wore it on state occasions.[218] Its size had been reduced – the public and press at the Great Exhibition had evinced disappointment that it did not shine very brightly, so expert diamond cutters were brought from Amsterdam to rework its egg shape to 'oval stellar brilliant'. This began with a public ceremony: the grand old Duke of Wellington, too old, perhaps, to recall his rule after Waterloo about returning seized heritage, was prevailed on to make the first cut, and by the end of the process the gem sparkled brightly, but in a reduced size (it is now just over 100 carats and is only the ninetieth largest diamond in the world). In the next century it

was worn in the coronation crown of queens consort, beginning with Mary and ending with the Queen Mother, who wore it to Elizabeth II's coronation in 1953. It will presumably grace the head of Queen Camilla at the coronation of Charles III. For the present, it is securely locked in the Jewel Room of the Tower of London.

Should it be repatriated, and if so, to where? The Indian government has consistently requested its return ever since that country gained independence in 1947 but has regularly been told that this is non-negotiable, because British title was explicitly granted by a peace treaty. It has become a popular cause in India, with a campaign led by Bollywood stars and local billionaires and the publicity-hungry British MP Keith Vaz, but when questioned about it by the Indian media on his 2015 visit, Prime Minister David Cameron pithily replied, 'If you say "yes" to one request, you suddenly find the British Museum would be empty.'[219] He did not consider the possibility that this might be a good thing, at least in respect of some of its stolen exhibits, or that the 'Mountain of Light' (now more the 'Foothill of Light') was actually in the Tower of London. India is not the only claimant. Iran has put in a bid on behalf of the peacock throne, and Prime Minister Zulfikar Ali Bhutto did so on behalf of Pakistan, since Lahore is within its territory. In 2000 came a demand for its return to Afghanistan by the Taliban, then in government and well known for destroying historic monuments. 'It was taken from us to India and from there to Britain; we have a much better claim than the Indians,' said their foreign affairs spokesman.

Even were the Taliban to return to government in Afghanistan, their claim would be rejected, given their hatred of human rights, and of the cultural heritage of other religions. Bhutto's claim was opportunistic: the modern state of Pakistan has little beside a geographic ground for

advancing it. From India, however, it was first seized and later made an emblem of independent Sikh power. It is plainly of great national heritage and it was taken as a spoil of a colonial war – the fact that it was expressly included in a peace treaty makes no difference. The staged 'gift' by the schooled fifteen-year-old would be struck down by any decent equity court for undue influence. India is not prone to war (other than with Pakistan over Kashmir), and would certainly keep the jewel in safe custody, probably displayed under lock and key in Parliament House. Its absence from the Crown Jewels in the Tower of London would hardly be noticed: tourists pass it on a moving staircase, giving a view of no more than thirty seconds. It does not particularly sparkle, and in its reduced size on the Queen Mother's Crown (the last in a line of imperial crowns), it does not stand out. Viewers are merely told that it was 'presented to Queen Victoria' (hardly the full story) and that it 'is only set in queens' crowns as it is said to be unlucky for men to wear it' – which would come as a surprise to Nader Shah and Ranjit Singh, who wore it for luck in their victorious battles.

There is one objection that could be raised: the diamond is not a cultural object, because it has not been the product of human creativity but is merely a jewel unworked by human hand until the Amsterdam diamond cutters refashioned it in London. But if ships and shields can be heritage items, so can jewels, if they are impressed with history and have become national symbols. The scales are tipped in favour of India by shame at the way in which the East India Company manipulated the young maharajah, cruelly separating him from his mother. Repatriation of the jewel would be a long-delayed apology for the country's exploitation by Britain under the Raj and its commercial arm, the venal East India Company. It would not be right to return it to Iran just because

it had once served as an emblem for a warlord as brutal as Nader Shah, but at least Ranjit Singh was relatively benign (*sati* notwithstanding).

The eventual fate of the 'Mountain of Light' will probably be diplomatic rather than legal. Perhaps after being worn by Camilla in her crown at her husband's coronation, it could be removed from the Tower and presented to the Indian Prime Minister in the interest of British trade (the interest in which it was originally taken) after Brexit.

DAHOMEY, 1892

The battle for the Kingdom of Dahomey, now located in the state of Benin, ended with the citadel and its palaces burned to the ground by order of its own king, to protect its sacred relics from spoliation by the French army. This colonial war came in the course of the 'scramble for Africa' by the major powers of Europe after the Congress of Berlin in 1885. Anxious to exploit the continent's wealth, they carved it up for their 'protectorates' – a supremely ironical word, since they were not interested in 'protecting' its people at all, but in protecting their conquered territory from each other. The French had been slow off the mark and were anxious to grab some of west Africa before it fell to the British and the Germans, so they targeted first the powerful Kingdom of Dahomey and successfully fought the first war against it in 1890 at Cotonou.

After a temporary peace the king insisted on retaining some independence, so both sides prepared for renewed hostilities. The king had the larger army, but it fought with old rifles and machetes, while the invading French army had gunboats and modern rifles with 20-inch bayonets. The king's most surprising weapon was his regiment of courageous and highly trained female soldiers – dubbed 'the Amazons' by

the French and 'the King's Wives' by themselves: they targeted French officers, whose gentlemanly reluctance to kill women caused them to delay shooting long enough for the women to shoot them first (although their proto-feminist credentials were belied by their war cry: 'We are no longer women, we are men'). The war ended after a battle in 1894 when the French conquerors sent the king into exile and declared their 'protectorate' of French West Africa.

One interesting feature of this kingdom had been its encouragement of culture and the unique form of art that had resulted, uninfluenced by religious belief and typically involving the assembling of different components – ivory, wood, silver, iron and brass – into metal people with triangular facial masks (representations not seen in Europe until Picasso).[220] The most famous of these 'savage beauties' is the fearsome Gao, god of war, seized along with many other examples and presented to the Ethnological Museum of the Trocadéro in Paris, where they were described as 'modern primitivism'. The young Picasso viewed them and was inspired – he could not forget the masks, which he described as 'magical things'.[221] The state of Benin in 2016 formally requested their return, as items which have a spiritual and historical value for the nation, not only as witnesses of a bygone era but 'as living support for the collective memory of Benin'. The French government merely pointed out that the 1970 UNESCO Convention was not retrospective and under French law 'the treasure' was inalienable. Only two years later came the Sarr–Savoy report, which treated the treasure as a textbook example of art that must be repatriated.

The art is unique, certainly in Africa, and can be considered as important to the world as well as to the national heritage of a people who had cultivated a remarkable civilisation prior to colonial conquest.

It had been taken as spoils of a war of aggression, which is now an international crime (it was added to the jurisdiction of the International Criminal Court in 2017). Of course almost all colonial wars could today be regarded as wars of aggression, but that does not legitimise them, nor does the excuse, much promoted in France at the time, that the invasion of Dahomey was to stop slavery and 'human sacrifice' (although this was not cannibalism but really an annual execution of the year's worst criminals). It was in fact a war to gain territory and to exploit it in the interests of trade and the notion of 'Greater France'. The artworks were studied and cared for at the Trocadéro, and subsequently at the Musée du quai Branly – they have served a purpose in Europe by inspiring Cubism, but they should now return to inspire the descendants of their imaginative creators. That, at least, and at last, is the view of the French government, which in July 2019 announced that it would put its money where its President's mouth was and loan €20 million to the state of Benin to create a new museum in Dahomey to hold the first returns to the kingdom from the 5,000 objects of looted art overflowing the vaults of the aforementioned museum.[222] The new museum is expected to open in 2021, and although only twenty-six artworks are scheduled for the first return, more are expected to follow. However, to circumvent French inalienation laws, they are to go on 'long-term loan', which undermines the sincerity of the gesture: both France and Britain must abolish these colonial 'finders' keepers' laws and make restitution in full by transfer of title.

THE OLD SUMMER PALACE, BEIJING

Like father, like son. The atrocity that was perpetuated by the Seventh Earl of Elgin in stripping the Parthenon was rivalled by the Eighth Earl

when he ordered the burning down of its oriental equivalent, the Old Summer Palace complex outside Beijing, with the emperor's servants incinerated inside it. This was the culminating act of the Opium Wars – the worst crime against humanity committed by any country (even including Belgium in the Congo) during the nineteenth-century colonial era. In essence, it was a conspiracy between the British government and its commercial trading arm, the East India Company, to supply opium and to addict many millions of Chinese to the drug, in order to reverse a trading imbalance largely caused by British fondness for Chinese tea.

In 1839, after he saw the disastrous effects on his people of the large quantities of opium smuggled into China from India by the East India Company, the emperor ordered the trade to end and seized crate-loads of the drug from the Company's stores. You can't treat the British like that, so they went to war to restore free trade – that is, free trade in opium – with 'gunboat diplomacy' and a large army. Under the humiliating Treaty of Nanking (1842), the emperor had to cede Hong Kong, pay a vast sum in silver to the East India Company and open five of his ports to the import of opium.

This still did not satisfy the British drug traffickers, notably William Jardine and James Matheson: they wanted the whole country open to their vile trade. The emperor resisted (partly on health grounds – twelve million of his subjects were by now addicted, and many died from frequenting opium dens). So Britain went to war again in 1856, this time with help from the French, anxious as well for free trade in the drug. In 1860, they formed with the British an army of 23,000, which having won various battles moved on to take Beijing and the emperor's surrender. They stopped to loot Yuanmingyuan – the Old Summer Palace, 'The Garden of Perfect Brightness'. It was a complex of palaces and

temples, surrounded by lakes and gardens and crammed with treasures – jewellery and precious stones, silks, jade ornaments, golden thrones, vases, sculptures, porcelain of all kinds, imperial sceptres and ancient books. The French looted riotously while the British troops did so systematically, the soldiers taking what they could carry and, in accordance with regulations, putting the rest in a 'booty auction' to raise money to be divided between them. They even captured the empress's pet Pekingese, whom they christened (very appropriately) 'Looty'; later presented to Queen Victoria, the dog lived for eleven years at Windsor Castle, although disliked (perhaps on racial grounds) by the other royal dogs.[223]

The armies, once satisfied with spoils, were about to move on to force the emperor's surrender when news came that some of the envoys sent to negotiate it, under a 'flag of truce' (a form of immunity, developed by commanders during the American War of Independence, with complicated rules which the Chinese may not have understood), had been tortured and murdered. In fury (a correspondent for *The Times* had been a casualty) Lord Elgin ordered his men to burn the palace to the ground. The French refused to join in, recalling their war law and pointing out that this was beyond any military necessity. Elgin was undeterred: it took him three days to destroy the complex, with its temples, schools, museums and libraries. No concern was shown for the lives of over a hundred courtiers, maids and eunuch servants who were hiding there. One British officer, Garnet Wolseley (whom we shall soon meet again in Ashanti), boasted how 'when we first entered the Palace gardens they reminded one of those magic grounds described in fairy tales; we marched from them leaving them a dreary waste of ruined nothings'.[224] As Victor Hugo commented, 'We call ourselves civilised and them barbarians. Here is what civilisation has done to barbarity.'

There was no criticism in Britain of Elgin's actions, and no Byron to call him to account: *The Times* was particularly gratified for having its reporter's death avenged. Of the art looted by the French army, more than 800 items have found their way into the museum at the Palace of Fontainebleau, where they make a display so wonderful that President Macron has not dared to suggest that they should be repatriated. Elgin's loot found its way into many British and army museums (the most precious vases are in the Wallace Collection in London), and there have been auctions at which Americans have paid many millions of dollars for the best porcelain. On occasion in recent years there has been an 'Antiques Roadshow' flavour to discoveries in southern England attics of dusty souvenirs brought back by great-granddads who fought in the Opium Wars – at auctions, they often reach over £400,000. The auctioneers brazenly tout them as spoils from the Old Summer Palace, confident that they cannot be repatriated, although they usually receive a letter from the Chinese embassy, which they ignore, asking them to cancel the auction. In one 2018 case, the embassy publicly asked 'all humanitarian-minded people' to boycott the auction of an Old Summer Palace antiquity, but its anonymous purchaser (either a humanitarian convert or an undercover Chinese agent), having paid $515,000, donated it to the National Museum of China.[225]

China now wants its other stolen treasures back: in 2014, as the result of the sale of precious ancient manuscripts by a crooked monk in Dunhuang, it even declared that there should be an international law requiring the return of cultural property. China usually opposes any new (or old) international law, but its 'Dunhuang Declaration' is supported by other states robbed of their heritage. There are other ways, of course, to re-acquire it. It may not be morally objectionable to steal your property

back from its thief, and in 2018 there were allegations that the Chinese government was behind a series of thefts of Old Summer Palace plunder, from Fontainebleau and from the Museum of East Asian Art in Bath.[226] Otherwise, you can simply ask a favour from those who need it. When the billionaire owner of luxury firms including Gucci, Saint Laurent and Christie's had difficulty in 2013 with customs in Beijing, his troubles ended when he sent to the National Museum of China two bronze heads, one of a rabbit and the other of a rat, which had been broken off an Old Summer Palace Zodiac fountain. In no time, Christie's received its licence to operate in China.

Infuriating though it may be for China to have to buy back its stolen artefacts, or rely on the kindness of strangers seeking favours, does justice require repatriation? Certainly it does, when these precious relics of 3,000 years of Chinese craftsmanship are considered as important parts of the country's heritage, and their looting was the low point of China's 'century of humiliation' (1840–1949). Although they were not venerated by Mao (his Red Guards actually attacked with knives the remains of the palace, which they perceived as a symbol of hated Imperial China), the present Chinese government would wish to commemorate them as emblematic of its people's advanced culture. They have international resonance, as things of beauty created in an inventive but isolated society whose ancient artworks are now universally acclaimed and studied. They were taken in contravention of war rules against pillage and damage to temples and places of religion. The burning of the Summer Palace was a war crime which could not possibly be justified as a reprisal, or excused by the necessities of war: Elgin knew that the Chinese were on the verge of surrender, and his killing of the palace servants, albeit indirectly, was foreseeable. There

is no doubt that the treasures will be safely kept and expertly curated in Chinese museums, with more visitors than they presently receive, since these treasures are dispersed across dozens of Western galleries and private collections.[227]

However, the question deserves a more nuanced consideration than it would receive under the Dunhuang Declaration. There is, for a start, the question of propaganda. Every country is entitled to tell its own story about its wars, but observers have noticed that the story China tells about the burning of the Old Summer Palace – in its official statements, its textbooks and its guided tours of the palace remains – fails to make any mention of the reason for Elgin's brutal action, namely the torture, mutilation and murder of some of his envoys.[228] This omission falsifies history and perverts scholarship, just as British museums do when they exhibit these items without reference to the scandalous way in which they were acquired. Elgin was culpable because he knew surrender was at hand, and could have included in the settlement agreement a provision for the handover and trial of those responsible for the murders (of course, a trial might have revealed his own ineptitude by relying on the misunderstood 'flag of truce'). But any account of the matter in a Chinese museum should give the reason why Elgin acted, if only to explain why it was an insufficient reason for such a barbaric reprisal.

There is also the matter of China's human rights record: a nation which demands the right of its people to re-possess the keys to their culture must explain why it continues to deny them the right to speak, by jailing for long periods any critics of its government and the human rights lawyers who defend them. As for its efforts to take back Taiwan, it should be grateful that after the war its finest art was taken by Chiang Kai-shek to what was then Formosa and is now resplendently preserved

in the National Palace Museum in Taipei – it would otherwise have been destroyed as decadent during the Cultural Revolution.

That said, China has suffered more than any other country from the despoliation of its heritage. The Opium Wars opened it to free-for-all trade, and soon all the major colonial powers plus Japan had parcelled it up, through unequal treaties, into 'spheres of influence'. They came together in 1900 to put down the Boxer Rebellion and to plunder all the antiquities of Beijing – their treasure hunt went through all its museums, and yielded 1,372 precious artefacts from the history museum alone. Many more were forcibly taken from private homes, and almost every Buddha on display in the city was decapitated and heads (more easily transportable) were sold in Europe and America. Control of the Forbidden City was divided between the conquerors – it was said that the Americans (new to the game) looted most prodigiously, followed by the British and the Italians – only the Japanese, perhaps with some oriental fellow feeling, preserved the culture in their sector. That was not their behaviour, however, in the 1930s, when the League of Nations turned a blind eye to Japanese aggression in China which culminated in an orgy of murder, rape and looting in Nanjing – one of the twentieth century's worst single atrocities. Today, China's efforts to beg, buy and burgle back its culture, lost by unlawful and brutal behaviour by its foreign enemies during the 'century of humiliation', is understandable. Western allies which accepted the imperative of returning Nazi loot have never insisted on the return of heritage looted by Japanese forces – or by their own armies.

THE EASTER ISLAND MOAI

Rapa Nui, known to tourists as Easter Island, is a World Heritage site that lies 2,000 miles into the Pacific from Chile, of which it is now

part. It is remarkable for its massive *moai*, statues with giant heads made of lava and basalt, about 1,000 years old. The best example is Hoa Hakananai'a (meaning, appropriately, 'stolen friend'), which was found buried in a ceremonial hut by sailors from a British warship in 1868. They dug it up and took it back to the Admiralty, which presented it to Queen Victoria. This 8-foot-high, 4-ton reminder of some ancient islander (each *moai* is said to embody the spirit of an heroic ancestor) disturbed the Queen, with its jutting chin and pursed lips, long flat ears and prominent nose with deep, flaring nostrils, so she quickly got rid of it to the British Museum. There it now stands just off the Great Hall, and serves as the most popular spot for selfies, taken against its awesome granite presence (at least it is more respected than its comrades on Easter Island, where tourists take pictures of themselves with fingers outstretched, picking the ancient noses).

Some accounts of its provenance say that it was 'taken without permission' by the crew of HMS *Topaze*, in other words that it is stolen property. Others report that it was a gift from island chiefs, although why would they give away the spirit of an ancestor?* But on either view, the relic should return: it has a continuing spiritual meaning for the Rapa Nui people, whose representatives travelled to the UK in 2018, accompanied by Chilean diplomats, to demand it back. They visited Hoa Hakananai'a at the museum and no doubt read the sign that elliptically describes its provenance as 'a gift from Queen Victoria'.

This *moai* should be repatriated, just as the King of Norway has brought back, in person, artefacts 'taken without permission' from

* Neil MacGregor speculates that island chiefs had embraced Christianity and 'perhaps the old ancestral sculpture was seen as a threat to the new Christian faith'. In that case, why did they not give away other *moai*? See *A History of the World in 100 Objects* (Penguin, 2012), p. 387.

Easter Island by Thor Heyerdahl and other Norwegians. Hoa Hakana-nai'a has a continuing spiritual relevance to the Rapa Nui people, who have offered to make an exact replica for the museum in exchange.

Moreover, as indigenous people, the Rapa Nui are given special protection for their culture in international law. In 2007, the United Nations Declaration on the Rights of Indigenous People (UNDRIP) recognised such people's right 'to practise and revitalize their cultural tradition and customs' and placed a duty on states to 'provide redress through effective mechanisms, which may include restitution'.

There are, however, two practical objections to the simple solution of repatriation. Firstly, as with the Rosetta Stone, the museum has promoted the statue and has added to its importance by discovering and deciphering marks on the back of its head. These marks are linked to a mysterious 'Birdman' cult (involving a canoe race to outer rocks to bring back the first bird's egg of the season and be appointed chieftain for the following year). The work on interpretation of the hieroglyphics continues – there may have been birdwomen, too – and the best place for this scholarship is the British Museum. Then there is the issue of preservation. Hundreds of the statues still standing have been infected by lichen – its white spots are eating away their faces and turning them to a form of clay. There is also climate change, as rising sea levels bring coastal erosion and flooding: it would be no favour to send Hoa Haka-nanai'a back to gradual destruction in the open air, although the British Museum has said (it always does) that it is open to the idea of loaning it back for short visits, so long as it returns and always remains in the museum's lawful possession.

The mayor of Easter Island has suggested a neat compromise: the statue stays in the British Museum until scholarly studies are finished

and the islanders can build a suitable museum to protect it from the elements. In the meantime, the museum would transfer ownership to Chile, and must pay a lease-back fee for every year that it remains in London as a tourist attraction. This is a Solomonic solution, which could be adapted for other stolen heritage objects in Western museums: if they cannot be brought back, at least the thief can be obliged to pay rent to keep them.

THE ASHANTI WARS

These wars began, reasonably enough, with Britain's crackdown on slave trading from the west African coast early in the nineteenth century. The inland kingdom of Ashanti was heavily involved in the trade, but its government was well organised and had democratic aspects, and its capital, Kumasi, could boast indoor toilets and regular rubbish collections. After several skirmishes, the last, in 1831, being won by the British through superior firepower, the Ashanti retreated to their kingdom and lived in peace. But the lure of gold – they called it the 'Gold Coast' – combined with fear that it might fall to France or Germany, determined the British government to mount a war of aggression against the kingdom, and Britain's top general, Sir Garnet Wolseley, was appointed to prepare it. A pretext was found in the capture by the Ashanti king of two missionaries (although they were not British) and in 1874 Wolseley's army began its lethal trek. The Ashanti had not wanted war – they released the two hostages and made an offer to surrender, to pay gold and to put themselves under British 'protection', but Wolseley was not a man of peace: he made conditions he knew the king would not accept (his mother, his heir and others of his family to be held as hostages and a massive amount of gold to be surrendered) and stormed on, with modern weapons – and life-saving quinine to protect his own

soldiers from malaria. When he captured Kumasi, it was British army business as usual – seizure of all valuable property from palaces and private homes, then burning the city to the ground. (Wolseley had been with Elgin at the Old Summer Palace in 1860.) They took all the gold treasures they could find – masks, breastplates, knives of gold and silver, carved stools mounted in silver and gold, embroidered silks and other treasures, stuffed into soldiers' knapsacks or placed in the 'booty store', which Wolseley took back to auction in London to defray the cost of this 'punishment expedition', which had ended with no crime to punish. It was a simple war of colonial aggression, for gold and for 'free trade' (the surrender treaty required both). The artworks ended up in the V&A and the British Museum, with many others bought by a private collector named Sir Richard Wallace, hence the Wallace Collection where they can now be found, including the 8-inch-high mask which is the largest known gold work from Africa.

Despite their 'punishment' in 1874, the Ashanti did not learn the lesson of what happens to 'insolent natives': they were prepared to go quietly but were reluctant to become a British 'protectorate'. They did not resist when another invasion force entered the re-built capital in 1886, this time including Major Robert Baden Powell, adept at looting notwithstanding his later creation of those exemplars of good behaviour, the Boy Scouts. The royal family was packed off to the Seychelles, a popular dumping ground for inconvenient heirs, and more golden artefacts were taken back to London as booty. The last revolt against British 'protection' came in 1900, led by the king's mother. It was dubbed 'the War of the Golden Stool' – a fabulous throne believed to have dropped from the sky as a gift from God to uplift the soul of the Ashanti people, so sacred that no one – not even the king – was allowed

to sit on it. The British ambassador thought it an excellent idea to sit on it himself, to humiliate the Ashanti once and for all. He ordered a search – it had been hidden (as in 1874 and 1886) and he insisted that it be found. All who might know its whereabouts – including some women and children – were rounded up and tortured, but, fortified by their religion, they did not tell. It was discovered by roadworkers twenty years later, but stripped (perhaps by them) of its gold, so no one bothered to send it to London.

The Gold Coast became independent in 1957 as the state of Ghana and has regularly asked for its looted gold. The British have always refused. In 1974, a Labour government spokesman in the Lords claimed it was legitimate to seize it in order to pay for the 1874 war – a war, of course, that the Ashanti did not start. The debate in the Lords was marked by racist humour at the prospect of retuning anything to Ghana, although it may have jogged the conscience of relatives of one of Wolseley's soldiers, who returned a ceremonial stool souvenired from the sack of Kumasi.

The Victorian hero-worship of Garnet Wolseley serves as a reminder of just how popular was the killing and looting of colonial peoples among Parliament, the people and the Queen in the late nineteenth century. The boast of the heavy dragoons in Gilbert and Sullivan's *Patience* to having 'the skill of Sir Garnet in thrashing a cannibal' may puzzle audiences today but was appreciated by everyone after he had brought back the gold from Kumasi. Wolseley had begun his colonial crusade by suppressing the nascent Indian independence movement (known to the British as the 'Indian Mutiny' of 1857) and went on to fight the Second Opium War as one of Elgin's officers at the looting

and destruction of the Old Summer Palace. He took some time off to advise the Confederate forces in the civil war in America, notably justifying their conduct in killing black soldiers after they had surrendered a fort as 'not evincing any very unusual blood-thirstiness'. His notion of 'usual blood-thirstiness' was soon visited upon rebellious Aboriginal Indians in Canada where, promoted to colonel, he suppressed them at the battle of Red River, successfully enough (he was a most efficient organiser) to receive his knighthood. Then came his campaign against the Ashanti, for which he received the thanks of both Houses of Parliament, a vote of £25,000, an upgraded knighthood and honorary doctorates of law from Oxford and Cambridge Universities.

He was sent off to command British forces in the Zulu Wars and to subdue the natives in the Transvaal, and then to seize the Suez Canal and supress revolts in Egypt – for which he was made Baron Wolseley of Cairo (although not of Khartoum, where he failed to rescue General Gordon) and in due course viscount, field marshal, and 'Gold Stick in Waiting' to Queen Victoria. He was the embodiment of the army of the British Empire, which he trained and led to the approbation not only of the Queen and the ruling class but of the people, who celebrated his inevitable victories in their common parlance – 'all Sir Garnet' being the Victorian equivalent of 'no problem', 'she'll be right' or 'no worries'. It would, of course, be all wrong for his many thousands of victims of so many indigenous races. There is no denying his efficiency or his calculated bloodthirstiness. Most importantly, for the question of British repatriation of the cultural property he stole, there is no denying that his barbaric behaviour was celebrated and endorsed at every level of late Victorian society.

A NOTE ON REPLICAS

Western museums can obtain exact replicas of plundered objects. For centuries replication was achieved by casting and moulding, and by the mid-nineteenth century new technology aided the precision that can be seen in Michelangelo's *David* in the Cast Courts of the V&A. The advent of precision casting – which allowed viewers to have their eyes ravished by the beauty of masterpieces, albeit without that special awe that comes from travelling to see 'the real thing' – so enthused European nations that nineteen agreed the 1867 Convention for Promoting Universally Reproductions of Works of Art for the Benefit of Museums of All Countries. The idea was later abandoned, however, as the big museums became wealthier and more exclusive, and preferred to boast about the originals in their galleries. This attitude is elitist, in a digital age where recent developments in digital scanning, photogrammetry and 3D printing provide the opportunity for museums to capture treasures in every detail before returning them to rightful owners. This may not overcome the elitism – they say 'the soul with which an artist imbues his or her hand-drafted work cannot be replicated…'[229] – but it can, and if the artwork really is imbued with the artist's soul, all the more reason to send it back to where that soul went into it.

In 2017 a number of international museums led by the V&A sought to breathe new life into the 1867 Convention through ReACH – the Reproduction of Art and Cultural Heritage through digital technology. It was a fine declaration, and it listed the reasons why 'stewards' of artworks should reproduce objects in danger from environmental hazards, wars, terrorism, mass tourism, theft and 'rapid economic development'.[230] The only reason the declaration does not list is the best, namely, to allow 'stewards' to reproduce the stolen cultural property before they return the original.

CHAPTER EIGHT

TOWARDS JUSTICE

We saw in Chapter Six that there is by now sufficient source authority for an international law rule requiring the return of wrongfully taken cultural property, and Chapter Seven explained, in relation to well-known examples, the factors that would have to be considered. But under what procedure? How do we design and put in place a mechanism for adjudicating claims that will operate reasonably and, above all (since this is a question of justice), fairly? Hardly a week goes by without one country or another making a demand for restitution, on a museum or to stop an auction. The National Museum of Kenya has just announced that it is making an inventory of all its lost cultural property as a preparation for demanding repatriation. Doubtless it will begin by seeking the return from the British Museum of the hand axe and chopping tool, over a million years old, discovered at Olduvai Gorge, the first evidence of creative human thinking. Neil MacGregor's popular book *A History of the World in 100 Objects* begins with their story, and could serve as a detective's guide to stolen heritage in the British Museum. There are thousands of museums in the world, and 195 countries – most of them bereft of heritage purloined by or on behalf of a dozen or so once-great powers.

By what procedure should restitution be judged? The need for an

international convention with fair rules and some prospect of enforcement will be considered in this chapter.

Cicero's indictment of Gaius Verres for looting cultural treasures from Sicily remains iconic, both because he explained how cultural objects had a spiritual and emotive significance beyond their value as possessions and because the trial rendered justice for these crimes: exile, and compensation for victims. That is not always the case: Edmund Burke modelled his prosecution of Warren Hastings, the governor who despoiled India, on Cicero's prosecution of Verres, but the case dragged on for years before an inappropriate tribunal (the House of Lords) and ended in an acquittal.

It is satisfying, today, to see dishonest dealers and smugglers of unprovenanced antiquities being sent to jail, and the possibility of a prosecution under national laws has some deterrent effect on curators and collectors who might otherwise be tempted to act dishonestly or to turn a blind eye. They do not forget the five-year ordeal of Marion True, the Getty's curator of antiquities, who was prosecuted in Italy, accused of purchasing art that she knew was stolen. Attacks on cultural property are now indubitably a war crime after those who ordered mortar fire directed at the Old Town of Dubrovnik ('an especially important part of the world's cultural heritage') were convicted and jailed,[231] and the International Criminal Court condemned Islamist Ahmad al-Faqi for his part in destruction of shrines in Timbuktu and Mali.[232]

But what is required for restoration of tainted antiquities which have long ago fallen into the hands of museums and private collectors is an international procedure for making claims that they and their country can oppose, if they wish, and which can be enforced against them if they lose. This is a likely outcome if the claimant state ratified the 1970

UNESCO Convention, but only if the property in question was illegally exported after the ratification. Otherwise, such actions are impossible or highly problematic: the plaintiff must surmount time bars (often merely three or six years), estoppel (if there has been delay) and the common law's refusal to allow national courts to enforce the penal laws of other countries. In what should have been a straightforward case for restitution of New Zealand's 'most valuable indigenous antique', a set of carved Maori panels illegally removed from the country and advertised for sale at Sotheby's with false provenance, New Zealand lost for technical reasons (although the case did shame Sotheby's into withdrawing the item from auction). Lord Denning declared:

> The retrieval of such works of art must be achieved by diplomatic means. Best of all there should be an international convention on the matter where individual countries can agree and pass the necessary legislation. It is a matter of such importance that I hope steps can be taken to this end.[233]

That was in 2003, and although New Zealand quickly ratified the 1970 Convention in order to secure some protection against future illegal exports of Maori culture, there has not been any move towards a convention of the kind Lord Denning envisaged, under which claims prior to 1970 could be adjudicated.

RESTORATIVE JUSTICE

This is available in most domestic legal systems, as a remedy for unjust enrichment. The first international treaty to impose it was that of Westphalia, in 1648, which appointed commissioners to adjudicate on

questions of castles, palaces and property that had changed hands in the
course of the Thirty Years War between the Catholic Hapsburgs and Prot-
estant forces led by King Gustavus of Sweden, whose queen, Christina,
was a voracious looter determined to make Stockholm 'the Athens of the
North'. The commissioners seem to have worked efficiently in restoring
ownership of castles, although less so with items of cultural property.
(Christina took many of her Titians and Correggios and even her Brue-
ghels with her to Rome when she abdicated and embraced the Pope.[234])

Seventeenth- and eighteenth-century scholars like Hugo Grotius and
Emmerich de Vattel began to shape international law so as to prohibit
pillage and attacks on churches and monuments. Vattel argued:

> For whatever cause a country be devastated, those buildings should
> be spared, which are an honour to the human race and which do
> not add to the strength of the enemy, such as temples, tombs, public
> buildings and all edifices of remarkable beauty. What is gained by de-
> stroying them? It is the act of a declared enemy of the human race thus
> wantonly to deprive men of these monuments of art and models of
> architecture.[235]

The rule against attacks on churches and museums became part of cus-
tomary international law and found expression in the Lieber Code and
in the Hague Conventions of 1899, 1907 and (currently) 1954. But, as
we have seen, if it is breached, there is no express provision for return
of stolen or pillaged property. The Lieber Code went no further than
to insist that if works of art were captured by armies of the United
States, 'in no case shall they be sold, or given away, nor shall they ever
be privately appropriated or wantonly destroyed or injured'.[236] But their

ultimate ownership was to be 'settled by the ensuing treaty of peace', which might, of course, bestow these unspoiled spoils on the victor. For the idea that they should, if taken, be repatriated, we must turn back to 1815 and the remarkable decision of Wellington and Castlereagh after Waterloo to repatriate Napoleon's loot, despite French beseeching that such treasures as the Apollo Belvedere, the Medici Venus and the Lao-coön would be best appreciated in the 'encyclopaedic' museum of the Louvre, or (as a last resort) even in the British Museum. The repatriation order was not made from motives of revenge, although women wept in the streets of Paris as they watched these treasures depart, and they could of course have been sold to defray the cost of a war which had taken the lives of 47,000 men and some 200,000 horses.* It is clear from the correspondence on the subject between Castlereagh and Wellington that the restitution decision was made from consideration of what justice required. The art in the Louvre had been torn from other countries 'contrary to the practice of civilized warfare', so the allies 'should not omit this opportunity to do justice' and return the artworks to 'their ancient seat'.

Notwithstanding conventions in place against attacks on cultural heritage, when the First World War began, the German army malicious-ly destroyed the historic library at Leuven in Belgium and subsequently bombarded Rheims Cathedral. There was an immediate international outcry, and armies on both sides thereafter showed some respect for the conventions. The Treaty of Versailles required 'restitution in kind' for Leuven (in the form of an equivalent number of historic books

* Not all Napoleon's loot escaped restitution. The massive and magnificent *Wedding at Cana*, painted by Paolo Veronese for a monastery at an island off Venice, was stolen by French troops but still hangs in the Louvre.

delivered up from German libraries) and the return to Belgium of two notable triptychs taken from its churches. It added an order for the Germans to restore 'the trophies, archives, historical souvenirs or works of art carried away' from France – not only in the 1914–18 war but, for good measure, in its 1870–71 war with Germany.[237] This last provision did emphasise that wartime looting, even fifty years previously, may become the subject of restitution.

Wellington's spirit was invoked by the British and American teams of 'Monuments Men' which scrupulously restored Nazi loot to the museums and families – not only Jewish – from whom it had been plundered. Hitler had expropriated 8,000 artworks which were waiting to be displayed at his Führermuseum, and his collector-in-chief, Alfred Rosenberg, was hanged at Nuremberg.

The 1954 Hague Convention, and then Article 8 of the 1998 Rome Statute of the International Criminal Court, put beyond any question that destruction or capture of art and monuments in war is an international crime, but again, there is no provision for repatriation of stolen property. That is an inference, of course, just as national laws require thieves to restore pilfered items to the victim, no matter how well they may have conserved them. For property stolen or illegally exported in peace, there are the 1970 UNESCO and 1995 UNIDROIT conventions, which call upon state parties to 'recover and to return' property which has been exported contrary to local laws protecting heritage, although, as we shall see, this obligation only applies once the 1970 Convention is ratified and is not retrospective. For property taken from indigenous peoples, there is the 2007 General Assembly Declaration (UNDRIP) – but it is not binding (it is not a convention) and has no enforcement mechanism. There is no convention governing the cases

discussed in the previous chapter (and the many others) which offers restitution for antiquities wrongfully taken in previous times.

THE UNESCO CONVENTION AND ITS LIMITS

This 1970 Convention on the Means of Prohibiting and Preventing the Illicit Import, Export and Transfer of Ownership of Cultural Property was inspired by the momentous 1960 General Assembly Declaration on the Granting of Independence to Colonial Countries and Peoples. They did not receive their heritage along with their independence, however, and were soon losing what remained through the looting and grave robbing that poorly resourced new governments were unable to stop. The 'market states' that had allowed the importing of these stolen antiquities for the benefit of their museums and private collectors were not prepared to re-visit the past, but they were willing to help the new 'source states' stem illegal exports of their stolen property. After six years of difficult drafting sessions, an agreement was reached: source states would have a duty to pass laws to identify and to protect their heritage, and market states would at their request 'recover and return' any such property which had been stolen and illegally imported after both states had ratified the convention. This was a compromise: it served the interests of market states to retain existing antiquities in their museums, but source states could get back those that were exported in the future, after the convention entered into force. But at least it did enter into force, and was ratified by the US in 1983, France in 1997, the UK in 2002, Germany in 2007 and Belgium in 2009. It now has 140 member states.

The convention has been criticised, reasonably enough, for its lack of retroactivity (1970 is an arbitrary cut-off point) and lack of any system of enforcement, which is dependent upon laws and police

action in market states. Another criticism is that it allows source states to designate for export control what amounts to cultural heritage of importance, and they tend to designate everything, no matter how insignificant. American free-trade ideologues want an open market in antiquities and object that the convention says nothing about the overriding need to preserve them rather than to send them back to un-derdeveloped countries with insecure museums and desperate people who need the money they can make by prospecting for antiquities and selling their finds to dealers in the West. They argue that they would be better conserved in secure Manhattan apartments or gated Malibu beach houses, eventually donated to the Getty or the Met and displayed in secure galleries bearing the full names of their donors. It is fair to say that preservation must always be a factor in any decision as to whether or not to repatriate, but a free-for-all in antiquity trading would only be an added inducement to grave robbing. As the European Court of Human Rights has held, states may legitimately control the market in art and antiquities to protect cultural heritage.[238]

The convention's achievements, over its almost half-century, have been considerable.[239] It has influenced the debate in favour of restitu-tion and 1970 is now accepted by most museums and cultural institu-tions as the date after which a marketed item must be 'provenanced' – that is, proved to have been legally found and exported. If that proof is lacking, the item will be difficult to sell or to be auctioned on the open market. Customs and law enforcement authorities in the West have seized many such items and sometimes brought prosecutions, or at least returned them to the countries from which they were smuggled. The convention has placed an obligation on states to protect heritage, which many have fulfilled by passing national laws to that effect, and

it has inspired other conventions, notably those on World Heritage (1972, ratified by 193 states), on the Protection of Underwater Cultural Heritage (2001, ratified by sixty-one states) and on the Safeguarding of Intangible Cultural Heritage (2003, ratified by 178 states), which includes protection of items used in traditional ceremonies. Its principles now appear in most codes of ethics for museums and even for dealers. One unsung achievement is that the convention principles have contributed to many settlements and mediations which resolve claims in camera because the museums concerned do not want their dirty secrets and turning of blind eyes to be publicised.

Its widespread acceptance has confounded its free trade critics, who resort to claiming that it does not work because the black market in antiquities still exists. It does, but the 1970 Convention has made it blacker, and has deterred museums, art houses and otherwise reputable dealers from becoming knowing participants.[240] An illegal market in antiquities always will exist, thanks to the wealth and ego of collectors, but before the convention took hold it was estimated to be second in size only to narcotics.

Nonetheless, something must be done to resolve disputes over the return of antiquities wrongfully taken before the 1970 Convention applies. That is necessary to deal with all the cases set out in the previous chapter, and it should cover post-1970 cases which fall through the convention's cracks, for example the historic Maori panels denied return to New Zealand and the failed prosecution of the art dealer who brought to Canada in 1981 a Nok terracotta sculpture illegally removed from Nigeria, a party at that time to the convention. Canada had not become a party until 1985, so its law implementing the convention could not retrospectively incriminate the dealer.[241] What is required is

a convention which covers all important cultural property whenever wrongfully taken or dealt with.

Might the 1970 Convention be amended? The experience of international lawyers is to let well alone: the convention serves its limited purpose as a compromise that has slowly gained widespread state support and serves to deter many potentially illegal transactions, and any amendment to expand its ambit and particularly to allow claims to be submitted to an adjudication body would take years and open it up to divisions and withdrawals. Moreover, it has been badly drafted and amendments of this nature could not easily be integrated. It does not cover any of the cases discussed in the previous chapter, and it is time for a new convention that does.

A CONVENTION FOR THE REPATRIATION OF IMPORTANT CULTURAL HERITAGE (CRICH)

There is now the prospect that international customary law will be declared by the ICJ as including a norm requiring return, in certain circumstances, of wrongfully acquired cultural heritage. That 'emerging norm' has not yet emerged in any decision by the ICJ because it has not been called upon to decide, and it is time that UNESCO, or else the General Assembly, use their power to have the court render an advisory opinion, preferably taking the Parthenon Marbles as the test case. The kind of 'advisory opinion' predicted in Chapter Six will be welcome if it leads to the return of the Parthenon Marbles, but questions raised in other cases may require more nuanced answers, and a balancing of factors that cannot be decided by a simple formula or extrapolated from lengthy opinions by up to fifteen ICJ judges. A new international

convention would in any event be required, to identify the rules and procedures for recovery of antiquities wrongfully acquired in the past. What might such a convention – say the 2025 (it will take that long to agree) Convention for the Repatriation of Important Cultural Heritage (CRICH) – look like?

PREAMBLE

Lawyers tend to gloss over preambles to statutes and treaties, because they are seen as window dressing and are not operative provisions. But others read them, and they do supply a context and an explanation of the document's purpose that would otherwise be lacking. They sometimes exaggerate to placate the states which sign them – an example being the preamble to the European Convention on Human Rights, which piously declares that European countries all 'have a common heritage of political traditions, ideals, freedom and the rule of law' – which comes as a surprise to those who fought Hitler and Mussolini. It is a mistake made by the 1954 Hague Convention, which portentously declares its purpose as 'being convinced that damage to cultural property belonging to any people whatsoever means damage to the cultural heritage of all mankind, since each people makes its contribution to the culture of the world'. Well, not necessarily, not each and every people and not every piece of cultural property. There are enough amphorae in circulation to sink the ships in which they are found, but it cannot be pretended that smashing a few could damage the cultural heritage of all mankind, other than perhaps an ability to calculate the intake of alcohol in parts of ancient Greece. Many antiquities are excavated from what were once garbage dumps or market stalls – interesting, no doubt, but not regarded as culture at the time and sometimes as

mass-produced as the Buddhas and Garudas in tourist shops are in Asia today. Hyperbolic language should be avoided.

The Hague 1954 preamble is invoked by John Henry Merryman in his once-influential *American Journal of International Law* article 'Two Ways of Thinking about Cultural Property', one being this Hague 'charter for cultural internationalism', which he interprets to mean that the people of Britain (and their tourists) should keep the Parthenon sculptures instead of the mean-minded 'cultural nationalism' of the Greek people (the other way). There is only one way to think about cultural property, which is to accept that it should belong to the people to whose culture it has contributed, so long as they are safe and willing custodians, and that if it has had an impact as well on human progress and civilisation then it should be shared with the world in the place where it can best be appreciated. A convention for that purpose might have a preamble like the following:

Recalling the developments in the law of nations which favour a rule that cultural property wrongfully taken from other nations in the past should be repatriated;

Conscious that peoples have a right to possess, study and see property that has made an important contribution to their heritage;

Aware that such property may also have an international significance, in so far as the culture of which it is representative has contributed to the progress of humankind or is reflective of its history;

Concerned that disputes have arisen between states and repositories of cultural property within states about the ownership of antiquities and the location where they may best be appreciated;

Desirous of providing a fair and equitable means of settling such

disputes, by setting down the principles that should apply and establishing an adjudicative body to consider and advise on claims made by state parties under this Convention.

ARTICLE I: THE PROPERTY IN QUESTION

The convention should not apply to every antiquity (the 'not another amphora' objection). Nor should it cover antiquities that are merely designated subjectively as 'important' by the claimant state. There must be limitation to items of real significance – 'particularly important', perhaps, to cultural heritage, and certified as such by independent experts. This could be decided as a preliminary issue by the arbitral tribunal once a claim is made, and its decisions will be precedents deterring future claims over objects of no great significance. It must always be open to the respondent state to question the claimant state's evaluation and argue that the property in question lacks sufficient salience to be taken away.

Article 1 might read:

> For the purpose of this Convention, the term 'cultural property' shall mean property which, objectively considered, is of high value to the culture of peoples, by virtue of the fact that it is particularly important to their history or prehistory or to archaeology, philosophy, literature, art, science or style of past life, or of the lives of past intellectual or political leaders, and shall include monuments or parts thereof, books and archives, artwork, sculpture or any matter of ethnological or other scientific or anthropological interest that is of cultural concern.

This definition should be wide enough to include, prima facie, any objects of real cultural interest. The limiting factor is that the claimant

must be able to demonstrate that it is 'particularly important' to heritage or history.

ARTICLE 2: CLAIMANTS AND RESPONDENTS

There are two important issues here. The convention must be drafted on the assumption that it will be ratified by most states, but that will only come in time. States of origin are likely to sign up quickly. But retentionist 'market' states might not for some time come to the party by becoming a party. And claims under any international treaty can only be enforced against parties who have ratified it. One answer would be for the arbitral tribunal to allow claimants to bring a case against a non-party state, but to issue only an 'advisory opinion' which would not be binding. It would have a strong persuasive effect, however, and add to pressure on the retentionist state (in effect, its retentionist museum) to give up the stolen treasure. The opinion would have more force were that non-attending state represented in its absence, and even against its wishes, by legal *amici curiae* experts who would put its case as powerfully as possible.

A more troubling question is whether minority groups should be entitled to claim, as well as state parties. International law permits only state interventions pursuant to treaties to which they are parties. This works grave injustice to minorities if their state will not take up their case. Another state might do so, but if not, cultural property claims would have to be limited in this unfair way, excluding groups oppressed by their own state and unable to obtain the support of another. Minorities have rights to restitution declared in UNDRIP, and the answer may be for the tribunal to give standing to an ethnic or religious or indigenous group, if it can show a good prima facie case for repatriation of a religious or sacred totem or icon important to its continuing culture.

Assyrians, for example, the most persecuted people, have greater presence in their diaspora than in their homelands. Their sculpture and art features in many museums, and their church should be entitled to claim it for them as spiritual heritage.

Article 2 might read:

1. Claims for return of property within the class defined by Article 1 above may be made by state parties. In the case of indigenous, ethnic or religious groups without the support of a state party, applications may be made in relation to property in the above class which the applicant group can prove is of use in its continuing and customary practices or traditions. The claim may be permitted to go ahead if the application is granted by the tribunal, subject to hearing objections from any state party.

2. Claims against state parties must be responded to by those states. If the claim is against a non-party state or a state that has not become a party prior to the listed hearing of the claim, the tribunal shall appoint *amicus curiae* to present the case for retention.

ARTICLE 3: TIME LIMITS

We have seen that the failing of the UNESCO Convention is that it imposes an arbitrary cut-off point – 1970, or a later date by which time the retaining state has ratified. The UNIDROIT Convention has complicated limitation periods, relaxed for antiquities and musical instruments more than 100 years old, and for stolen objects within fifty years from the theft, and (importantly for the Parthenon Marbles) abolished for restitution of objects 'forming an integral part of an identified monument or archaeological site, or belonging to a public collection'. But the catch is

that any claim must be brought within three years 'from the time when the claimant knew the location of the cultural object and identity of its possessor'. This is a time-bar more restrictive than many in domestic laws.

It would of course be absurd to allow Greece to go back 2,000 years to demand the return of items stolen by the Roman Empire. Two hundred and seventy-five years has been suggested as a limitation period for claiming antiquities, which would cover all the thefts in the nineteenth century and just catch the Gweagal Shield and spears taken by Cook at Botany Bay. A few of Napoleon's requisitions were not returned, as the Treaty of Paris required (Paolo Veronese's *Wedding at Cana*, for example): they are still in the Louvre and should be reclaimable. It may be that the 1648 Treaty of Westphalia, the first to protect cultural property in wars between states, should provide a hypothetical starting date.

International law, like most domestic laws, bars claims that have been unreasonably delayed under various doctrines – of estoppel, waiver, laches or acquiescence. It is fair to bar a claim, even for the return of important cultural property, if the claimant, knowing of the expropriation, has not protested about it for a long period during which, for example, a museum in the respondent country has assumed it has been abandoned and has therefore proceeded to study and exhibit it. Other examples might be provided of property which owners have disclaimed (without doing so under duress) or have sold on commercial terms.

As international treaties are not normally retrospective, this feature would need to be spelled out, and so Article 3 might read:

Claims may be made to recover property in the above class which has been stolen or otherwise wrongfully acquired within 275 years before the date of this Convention unless there has been a prolonged lapse

of time from the taking, and the claimant has unreasonably delayed in protesting about its expropriation. This may be raised by the respondent state as a ground for exclusion under Article 7(3) below.

ARTICLE 4: THE BURDEN OF PROOF

Many court cases involving complicated facts and the balancing of pros and cons are ultimately decided on what is called the burden of proof, which must be placed on one party or the other. The standard of proof is also important: in Anglo-American criminal justice, for example, guilty defendants are often acquitted because the prosecution (on whom the burden falls) cannot meet the standard of proof 'beyond reasonable doubt'. In civil cases, however, the standard is lower – 'on the balance of probabilities', and this seems appropriate for cultural heritage cases. On the principle that 'those who bring the case must prove it', the burden of establishing, on the balance of probabilities, the factors on which the claim must be based (i.e. the importance to culture) and that establish the wrongfulness of the taking (e.g. war spoils, duress or trickery) should fall on the claimant. It must, however, be for the respondent to establish the grounds relied on to prevent repatriation, such as delay or lack of security.

Article 4 might read:

1. It is for the claimant to establish, on the balance of probabilities, that the contested property falls within the class defined in Article 1.

2. The claimant must establish, to the same standard, any of the grounds on which it relies for repatriation under Article 6.

3. The respondent must prove, on the balance of probabilities, any

ground on which it relies to bar or postpone repatriation under
Article 7.

ARTICLE 5: PRESUMPTION OF OWNERSHIP

Our convention might simply list the factors that are to be considered
by the arbitral tribunal and leave them to be balanced by its judges.
However, it would create greater certainty if the cultural property in
question, once its particular importance was established, were presumed
to belong to its state of source, once the wrongfulness of its taking had
been proved. Even so, the respondent state would be entitled to raise
objections which would bar its return, at least until the claimant could
show that a particular objection, such as a state of war or museum
insecurity, had passed.

Article 5 might read:

> Where it is established that the property in question falls within Arti-
> cle 1, and the claimant can show that it has been wrongfully acquired
> on any ground set out in Article 6 below, then unless the respondent
> can prove that repatriation is barred under Article 7, an order for
> restitution shall be made.

ARTICLE 6: WRONGFUL TAKING

The claimant must prove that the property was seized in war (whoever
started it and whatever the outcome) or otherwise by the behaviour
of persons in authority – normally, but not necessarily, those of the
respondent state. Where wrongful taking cannot be proved, the im-
portance of the item may exceptionally entitle the claimant to its
repatriation under Article 8.

Article 6 might read:

Cultural property proved to fall within a class defined in Article 1 shall, subject to Article 7, be ordered to be repatriated if the claimant can prove it has been wrongfully taken in ways which include the following:

1. In the course of or consequent upon what would, at the date of this Convention, be regarded as genocide, a crime against humanity, a crime of aggression or a war crime;

2. By any act of force, or use of physical or mental duress, by persons in authority who represented the respondent or whose actions were adopted by the respondent;

3. By any act reasonably regarded as unfair, or as the result of undue influence, trickery, bribery or any other unconscionable behaviour;

4. By any act of illegal excavation, exportation or importation of cultural property.

ARTICLE 7: BARS TO REPATRIATION

Having established its case for repatriation, the claimant must face objections which will prevent re-possession of its property, in order to safeguard it or from other considerations of fairness or justice. The respondent would be entitled to show that property of importance not only to the claimant state but to the world is better studied or appreciated in a place like the British Museum – the Rosetta Stone, for example. It could demonstrate that the claimant has no safe or appropriate museum in which to display it, in which case the bar could be

temporary (say for five years) and thereafter the claimant could apply again. A decision made today to restore Nefertiti or the Benin Bronzes could await, respectively, the expected opening of the Grand Egyptian Museum in Giza or the Benin Royal Museum.

The question of human rights breaches by the claimant's government should be considered, especially if they impact on its museums or cultural organisations, for example by curbing freedom of expression or information. Although Egypt is virtually a military dictatorship, with unfair trials and hundreds sentenced to the death penalty, it has not interfered with museums, so Sisi is no reason to keep Nefertiti in Berlin. The tribunal should take independent advice, perhaps from the UN commissioner of human rights (an office that has to date always been filled by well-informed persons of integrity). As for the danger of propagandistic presentation, this would be a matter of evidence in relation to government censorship or historical falsifications by existing museums. Rhodesia's dishonesty about the origins of Great Zimbabwe could have provided a good reason not to return its artefacts (there were several 'Zimbabwe birds' stolen by Cecil Rhodes) until the Smith regime ended. Delay may also be a reason to bar repatriation if the property has found a 'home' abroad and could not be returned without serious detriment to the respondent or its museum or collector.

Article 7 might read:

No cultural property shall be returned to its state of origin if:

1. The respondent proves that there is a real risk that it will not be preserved, because of corruption or lack of security in the

place where it is to be displayed or because of war or terrorist activity;

2. The respondent proves that there is a serious prospect that the property would be used or exhibited in a way intended to propagate false narratives about the past;

3. There has been unreasonable and unexplained delay by the claimant in protesting against the loss or the wrongful taking of the property, and it would in consequence unfairly impact on an institution where the property has been studied and curated, or on any person who has legitimately purchased the property without knowledge of the wrongfulness of its taking;

4. Where the institution in which it currently reposes and has done so for many years has enhanced its cultural significance by scholarship, exhibition and study which is continuing and would be detrimentally affected by its return, other than to an institution in the respondent state which can offer comparable opportunity for scholarship exhibition and study;

5. The claimant government has so seriously breached the human rights of its own people in relation to their culture that any claim for restitution based on human rights principles can be characterised as hypocritical. Before reaching a decision in whole or part on this ground the tribunal may seek the advice of the UN Commissioner for Human Rights.

Provided that, where return is refused on grounds 1 or 5 above, the tribunal may adjourn the claim for five years, whereupon the claimant may renew it if a change of circumstances can be shown.

ARTICLE 8: RETURN OF MEANINGFUL OBJECTS

Most countries can point to objects quite legitimately acquired by and present in other countries which have special meaning to their people, and little or no meaning at all to the country which happens, quite legitimately, to possess them. The people for whom they have meaning can visit them as tourists, but they would be better appreciated by the public as a whole if they could be given pride of place in a national monument or museum. Such objects – they range from the human remains of heroes to national constitutions – are often presented as diplomatic gifts – they do not necessarily 'go back' as they may never have been there in the first place and there was nothing wrongful about their acquisition, but they 'belong' in the country where they have the most cultural or historical resonance. This would be a con- troversial provision, in the sense that it would be the most extreme example of a right to cultural heritage that would trump rights of ownership, in cases where there has been no wrongdoing. There may be no objection when it comes to bringing back national heroes from some foreign field where they fell or died in exile, or a constitutional document drafted and remaining in London but of great legal or sym- bolic importance to the independent nation that has later emerged, but iconic objects lawfully in private possession would have to be very meaningful in order to be handed over to those for whom they have meaning, and the handover would have to be in return for satisfactory compensation.

There is an analogy with return of human remains. The Church of England's court has ruled that the bodies of 'national heroes' may be ex- humed from its graveyards in the UK and returned to the nations their spirits have inspired. This principle could apply to objects of spiritual or

historical meaning which are not appreciated or are under-appreciated where they stand in a country which has no interest in them.

An example is provided by the extraordinary wall illustrations of St Luke's gospel which gave succour to its imprisoned Australian soldiers and helped them to endure torture by the Japanese guards at Changi prison in Singapore during the Second World War. These murals are locked away in Singapore army barracks, while replicas stand in a prison museum that seems permanently closed.* Singapore, proud of its own history, obviously does not care about them. If Australian diplomacy cannot effect their purchase, then the country should be entitled to make a claim to repatriate the undisplayed murals to pride of place in the Australian war memorial in Canberra. Cultural heritage should belong to the people who care for it most. In most cases, diplomats of a potential claimant will be able to negotiate a transfer, by way of gift or purchase. But the convention should allow for exceptions.

Article 8 might read:

A state party may enter a claim for cultural heritage property within Article 1, notwithstanding that it has been legitimately acquired, if it can show exceptional spiritual or historical relevance to its own people, and that it is held in the territory of another state where it has little or no relevance or spiritual meaning. The claimant must pay costs of transportation and fair and reasonable compensation to the owner of the property, unless it can show that it has been kept carelessly or disrespectfully, in which case the award of costs shall be at the discretion of the tribunal.

* At least, it has been closed over in recent years, although TripAdvisor foretells it will reopen at the end of 2020.

ARTICLE 9: ABOLITION OF DE-ACCESSION LAWS

The legal stumbling blocks for the return of the 'Elgin Marbles' from Britain or the implementation of the Sarr–Savoy recommendations in France are the inalienability laws, in both countries, and in some other retentionist states, which aim to 'lock up' for ever the cultural property of former colonies. These laws are the ultimate expression of 'finders' keepers', the justice of the school playground. They are a hangover from a colonial mentality which regarded 'natives' with amused curiosity and, even after independence, as incapable of looking after their own artworks. Despite the recommendation of the parliamentary select committee in 2000, the UK laws against de-accession remain absolute, while in France, the principle of inalienability is enshrined in Article L451 of the French Heritage Code and in the General Code for Public Ownership. Sarr and Savoy have proposed an amendment to exclude property taken from French colonies and protectorates (Senegal and Côte d'Ivoire have already made claims) but it is hard to understand why the projected amendment should not relate to all cultural property in French museums.

There is no reason other than imperial pride for inalienability laws. De-accession is, for museums and galleries in the US and elsewhere, a normal and useful way of balancing collections – selling items of which they have many examples or which are kept in storage because they do not have room or interest in exhibiting them, and using the money to buy antiquities of a kind or period that they lack or wish to add to their special collections. Donations and bequests often provide them with items surplus to requirements and which are appropriate for sale or for return to countries of origin. Recently the San Francisco Museum of Modern Art sold a mediocre Rothko for $50 million – they had better Rothkos on display and had kept this one in storage for years. In 2019, the Art

Institute of Chicago went on a 'de-accessing spree', putting 300 works of Chinese art up for sale at Christie's, hoping no doubt to cash in on China's buy-back of its own looted art. De-accession became disfavoured in the 1930s because of some scandals around secret sales, and most US museums have in consequence an ethical policy that money raised must be used for new purchase of works of art, but otherwise there can be no objection to giving museum trustees a free hand to shape their collection with due attention to their moral responsibility to return looted heritage.

Ridding a country of laws against de-accession requires parliamentary action, which has already been taken by *ad hoc* amendments in Britain for paintings stolen by Nazis, for the Australian Constitution and for human remains, and in France to enable the return of Maori heads to New Zealand in 2010 and the 'Hottentot Venus' to South Africa in 2002. For the present, museums sometimes circumvent the laws by offering a country its cultural property back by way of a long-term loan. This at least provides a physical return, but with the insulting consequence that possession will always reside with the nation that dispossessed them. It reduces the guilt now felt by the thief, but does not assuage the feelings of the victim, especially in the usual case where the receiving state or institution must sign a loan agreement admitting that the lender is legally entitled to possession for ever. Precious Korean manuscripts were stolen by the French navy in 1866 and stored at the Bibliothèque Nationale de France until 2010, when they were returned – avoiding the inalienability rule by framing the return as a five-year renewable loan. No one expects that the loan will not be renewed, but such pathetic and insulting pretences should not be necessary. Of course, care must be taken not to discourage genuine cultural exchanges, or travelling exhibitions like Troy (mainly exhibits

from German museums) and the Chinese Terracotta Soldiers, or the contents of Tutankhamen's tomb.

Article 9 might read:

1. In order to effectuate the purpose of this Convention, all member states which have laws which prohibit de-accession or alienability of cultural property in the possession of its museums and other public institutions must resolve as quickly as possible to repeal or amend such laws so that claims for return of cultural property may, if appropriate, be acknowledged and granted by trustees or directors of such institutions.

2. Nothing in the above subsection, or elsewhere in the Convention, should be taken to discourage temporary loans of cultural property or other forms of cultural exchange or exhibitions, or agreements between contracting states and others for voluntary return of cultural property.

ARTICLE 10: COMPETING CLAIMANTS

Provision must be made for rival claimants – a feature of the competing demands to recover Priam's treasure (Turkey, Germany and Greece) and the Koh-i-Noor diamond (India, Pakistan, Iran and even the Taliban). The lodging of a claim by one state party would be publicised and, within a given time, rival state parties could come forward: if they have not ratified the convention, they could do so in order to contest the claim. The decision must favour the state which has the closest connection to the heritage which the artefact represents, and not necessarily to the location from where it was taken.

Article 10 might read:

1. Every claim lodged with the tribunal must within ten days be notified to the public and to potential respondent states. Any rival claimants must register their interest within three months.

2. States can become parties to the case only if they have ratified the Convention. However, the tribunal may permit non-member states, or any cultural institution which holds and wishes to retain the item, to make submissions.

ARTICLE II: INNOCENT PURCHASER

Some stolen cultural property, especially items found in the possession of private collectors, will have been fraudulently sold to them with false evidence of provenance or dishonest assurances that the property had been legitimately acquired. If purchasers had no knowledge of the existence of facts or circumstances that makes the item returnable under the convention, and there is no reason to believe that they should have known, then it would be unfair to take away the property without providing reasonable compensation – reasonable enough to amount to a refund of the price (in real terms) they paid for it, rather than any exorbitant price that could be obtained once the real value is known. The UNIDROIT Convention addresses this question by a provision (Article 6) that allows the innocent possessor of an illegally exported cultural object to obtain 'fair and reasonable compensation' paid by the state that has requested it back after failing to enforce its export controls. In the case of museums, a higher standard of care should be expected because they are on notice of the danger of unprovenanced works.

Article 11 might read:

1. In the event that the tribunal finally orders repatriation, it may

in its discretion issue a further order requiring the successful claimant to compensate an innocent purchaser of the item who did not know and had no reason to suspect that its provenance was such as may require its restitution.

2. Such compensation will not be ordered if the purchaser has an effective claim for compensation under domestic law against the seller of the antiquity.

3. Museums may seek a compensation order, or it may be sought on their behalf by the respondent, but it must be shown that they exercised due diligence when purchasing the item and that they honestly described what they knew of its provenance in their catalogue or in other publicity attending its exhibition.

ARTICLE 12: THE ARBITRAL TRIBUNAL

Intractable disputes generally require arbitration – a binding decision publicly delivered by an impartial tribunal, similar to a court although not bound by strict rules of evidence. It would be preferable, however, and much cheaper to have cultural property disputes settled by agreement (before the expense and potential embarrassment of public proceedings) or else by mediation. This is a procedure whereby an expert third party, respected and selected by both sides, attempts to bang their heads together (preferably in the absence of their lawyers) and achieve a compromise. Mediation was firmly refused by the UK government when offered by UNESCO over the 'Elgin Marbles', although mediation succeeded in achieving agreement between the Natural History Museum and the Tasmanian Aboriginal Centre. Many courts now require an attempt at mediation before hearing a case and the convention should follow this course by requiring a meeting

between the parties to see whether they can negotiate a settlement and, if not, requesting them to consider mediation.

Then comes the question of the composition of the arbitral tribunal. The most successful has been the World Bank's tribunal for determining disputes between states and foreign investors who have had their businesses expropriated or damaged by wrongful actions of the government or its agents. States nominate a panel of distinguished arbitrators from which each party to the case selects one, and these two arbitrators then agree on a third, who chairs the tribunal. There are other models, and it may be desirable for the convention to have a panel of five or seven, including experts on archaeology, anthropology and curating. One problem is that most such experts will have expressed views, one way or another, on the burning question of return of cultural property, but it should be possible for an appointment authority (e.g. the UNESCO director general) to draw up a list of twenty or so unbiased experts from which the parties could select an equal number, whether one or two or three, who would meet and pick a legally qualified chair.

The tribunal would hold hearings in public, followed by a written decision. This is particularly important as it would allow interested observers – and people around the world will be interested – to hear and see (the proceedings should be televised) and assess for themselves the justice of the case, and the justifications offered by claimant states for e.g. their denial of human rights to their contemporary artists. Rules of evidence would be relaxed, representatives (not necessarily lawyers) would be allowed to make the case and to call evidence, and directly interested parties other than states, such as the museum holding the item in question, or an ethnic or religious group claiming back its cultural heritage – would be entitled to representation. It is not necessary to go

into detail, but the convention would need to spell out the basis upon which the tribunal would be constituted. For example (Article 12):

1. There shall be an arbitral tribunal comprising five members, two of whom shall be nominated by the claimant and two by the respondent, in each case from a list of available experts drawn up by the director general of UNESCO, and comprising not less than twenty-four persons distinguished by their contributions to law, archaeology or museums. These four members shall meet to appoint a chair from the same list, who shall be legally qualified.

2. There shall be a registrar of the tribunal, a full-time appointment made and resourced by the United Nations. He or she shall have an office provided and publicised by the UN and shall receive and publish as soon as possible after receipt, complaints made under this Convention.

3. Such complaints must be forwarded, within ten days of being lodged, to the respondent state. The registrar shall arrange a meeting between the parties, and if no settlement results, shall offer mediation which if both parties agree shall take place as soon as may be convenient to them.

4. In the event that mediation is not agreed or is unsuccessful, the registrar shall provide the panel with a list of distinguished experts and supervise the constitution of the tribunal as provided in Subsection 1 above.

5. The tribunal thus constituted shall adopt rules of evidence and procedure suitable to the case before it and the convenience of its members and the parties. It may accede to requests by

interested parties to join in the proceeding, either by representatives or by providing written submissions.

6. The tribunal hearings shall be in public and its members will deliver their reasoned judgment (or concurring or dissenting judgments) in a form arranged and published by the registrar. There shall be no appeal.

7. In the event that the tribunal makes an order for repatriation, this shall be arranged by the respondent as expeditiously as possible and no later than twelve months from the date of the order.

8. The tribunal may make a finding that the claimant has established that the property in question is within the class identified in Article 1 and has been wrongfully taken pursuant to Article 6 but decline to order repatriation on one or more of the grounds listed in Article 7. In this event the claim may be renewed after five years have elapsed in proceedings in which the findings under Articles 1 and 6 shall not be reopened but in which the claimant shall bear the burden of proving that the Article 7 grounds for rejection of the claim are no longer valid.

CONCLUSION

There are other, more technical, provisions that will be required for a convention that will take some years to draft and receive sufficient ratifications to become operative. Regrettably, UNESCO has not yet started this process, despite the General Assembly resolution in December 2018 calling for the repatriation of stolen cultural property, upon which it should have acted. But this was not even an agenda item in June 2019, at its fifth meeting of state parties. Incredibly, there have only been five such meetings in almost fifty years – an indictment both

of UNESCO and its member states' interest in their culture. Some African states were only woken up to its importance by Macron and Sarr–Savoy: Benin, Botswana, Djibouti and Togo suddenly became parties to the 1970 UNESCO Convention in 2017–18.

UNESCO's main problem is funding: its current budget for administering its 1970 Convention is just US $1,404,700, which mainly goes on its tiny staff of six (only one of them a senior post), some training for European judges and customs officials (financed with help from the EU), and alerting Interpol to the smuggling of antiquities.[242] The unnecessary political alienation of the United States (a supporter of this convention) has lost UNESCO more than one fifth of its income, and 1970 Convention business is kept going thanks to small hand-outs from Germany and the Netherlands.

The low esteem in which UNESCO is held as a result of some overtly political decisions irrelevant to its core mandate means that CRICH would have a better prospect if it were taken up by the UN itself under the aegis of the General Assembly. Implementation would necessarily devolve on UNESCO, however, which would need proper funding to set up the registrar and tribunal. The organisation, under its recently appointed director (former French culture minister Audrey Azouley), has lifted its game (it now, at last, supports Holocaust education) and would be capable of hosting the new convention, certainly if some post-Trump President were prepared to stump up the $600 million the US has accrued in unpaid dues since 2011, when it stopped payment.*

* In 2001, UNESCO recognised Palestinian statehood, a decision which attracted a US congressional ban on funding it, which Obama duly implemented although he did not formally pull out from UNESCO. That step was announced by Trump in January 2019, and US withdrawal will become final in 2020, depriving the organisation of 22 per cent of its income.

CONCLUSION

I give a wry smile when I read my first advice to the government of Greece, urging them to emphasise that return of the Parthenon Marbles would not create a precedent for emptying the British Museum. I was channelling the fear of every politician and pundit who opposed re-unification – this terrible prospect that other nations might also want their stolen heritage back and returning the Marbles might imply that this is the right thing to do. Having reflected, I think it is the right thing to do in many cases. The moral challenge of Macron and the Sarr–Savoy report is compelling: it demands the same justice for conquered countries that Britain, after Waterloo, insisted should be given to victims of Napoleon. Of course, there is nothing the British hate more than to be taught morality by the French (remember those excruciating Security Council debates in 2003, where the suave Dominique de Villepin upbraided the Blair government for joining the invasion of Iraq?) and it may well be that British museums will come to acknowledge the ethical imperative of returning stolen treasures to those who care for them and can care for them in safety as well as with reverence. This would not, of course, empty museums – they would still hold thousands of antiquities, many currently in storage, and with 3D printing can produce replicas to remind visitors of the civilisations plundered by the British Empire.

We live in a weird time for the world (as reactionary populism propels extremists to power that they do not exercise rationally, while progressive parties cannot work out how to fight back) and for an art world increasingly dominated by billionaire collectors, in which $90.3 million is paid for Jeff Koons's stainless steel sculpture of a child's inflatable bunny rabbit, while $450 million is the cost of a questionable Leonardo, *Salvator Mundi*, apparently bought by the murderous Saudi crown prince Mohammed bin Salman and lost to sight aboard his yacht. Meanwhile, antiquities are being discovered in much greater numbers, thanks to scientific advances in metal detecting, infra-red imagery and new techniques that can spot underground cities and underwater galleons; these may one day locate something akin to the Golden Fleece or the Holy Grail (which country would get to possess them, I wonder). Antiquities can offer more than a modern painting or sculpture – they not only embody classic beauty but add the 'gee-whiz' element of imagining life long past and conjuring thoughts of eternity. There are reports of apartments being designed for the wealthy in Manhattan with an alcove for antiquities – a domestic shrine, so to speak – to be stocked with objects too often procured by smuggling. This is more reason to enforce the 1970 UNESCO Convention and to begin drafting sessions for an international Convention for Repatriation of Important Cultural Heritage.

This book makes a number of criticisms of the 'encyclopaedic museum' advocates, when the concept is used – illogically – to deny repatriation of stolen cultural property. I focus on the influential work of Merryman, Cuno and MacGregor – not only because I think them morally mistaken, but because their influence has made museums boring. 'Encyclopaedic' museums are now out of date, like that figure of my childhood the door-to-door salesman of the *Encyclopaedia Britannica*, offering poor

parents this bulky key to their children's future. A little knowledge may
be a dangerous thing, but too much is overwhelming and superficial. The
challenge for museums is to make the past interesting, and to connect it
to the present and the future, by depicting it accurately, and bringing it
to life with the help of replicas, technology such as 3D printing, holog-
raphy and casting, and dramatisations, in galleries where visitors linger
and learn, and hopefully return. A whistle-stop tour of an 'encyclopaedic'
museum is more like the 'world cultural discovery' tours of Edna Everage
(before she was ennobled), from which she returned to her native Aus-
tralia, consoling herself with the thought that 'at least you can say you've
seen it'. If that is all that visitors can say of a museum, then it has failed to
advance beyond its beginnings as a cabinet of curiosities.

Acceptance of the right of return of cultural heritage will also be a
challenge to those countries who claim it. They will have to show that
they have the institutions to preserve it securely, that their museums are
reasonably well resourced and independent of government, and that their
own human rights record is defensible. That will not be a problem for
Greece, whose custom-built museum just below the Parthenon awaits the
Marbles. It will be a problem for some other claimants where museums
and cultural institutions have been disgracefully neglected, although the
very prospect of displaying returned treasures has already, in some cases,
worked as an incentive to improve them. It would be a sign of sincerity
if return of plundered treasures was accompanied by aid and assistance to
the museums in the global south to which they are returned: the Depart-
ment for International Development's failure to recognise them as deserv-
ing candidates for aid is deplorable, while the massively rich American
foundations like the Getty open their offshoots in Europe or (attracted
by petrodollars) in the UAE. Insulating local museums not only against

the climate but also against government interference is important: return must be conditioned upon the receiving state's willingness to tell their story without propagandist distortion. That might mean admitting that a looted kingdom practised slavery (as did ancient Athens) and some offered humans as sacrifices. The full story must be told so visitors can make up their own minds about earlier societies and the conditions that led to their extinction, as well as about colonial conquests. There must be efforts to engage young people in studying the history of their own nation, warts and all. It may give them the confidence to see a culture they have moved on from in a way of which they can feel proud.

What role should be played by museum trustees? The British government always passes the buck to them when it comes to answering requests for the return of cultural property. Who are they, the trustees of the British Museum, for example? There are, as we have seen, up to twenty-five at any time – one is appointed by the monarch and four are nominated by royal institutions, fifteen by the Prime Minister and five by the trustees themselves. The Prime Minister has delegated this role to the Department for Digital, Culture, Media and Sport, whose website says that trustee appointments are made 'on merit'.[243] What sort of merit? The most conspicuous in twenty of the twenty-five current trustees is the merit of making large sums of money, for themselves and their multi-national companies. These trustees are CEOs, directors and partners of McKinsey (two trustees), Merrill Lynch, Allianz Global Investors, Bloomsbury, GlaxoSmithKline, Blackrock (the world's biggest investor in fossil fuels, which has two trustees), Salomon Bros, Goldman Sachs, John Lewis, British Telecom, Lansdowne Partners, Jardine Matheson (once the opium pushers of China), Mitsubishi Finance, Chubb ('the world's largest property insurer'), Prudential, Goldfields, Slaughter and May, De Beers and (in

various capacities) the Bank of England and the Confederation of British Industry. They are, as you would expect, estimable people who variously support charity and the arts, but is a board so connected with big (very big) business sufficiently representative and equipped to take difficult moral decisions? Trustees of art institutions are increasingly being called upon to make such decisions, especially over the acceptance of 'conscience money' donations from oil and drug companies, and it may be questioned whether boards mainly composed of elite bankers and businesspeople, without any representation of museum users, are appropriate to make them.

These are not easy decisions: I have sat on committees at the Middle Temple agonising over whether to sell Sir Walter Raleigh's globes to America to fund law scholarships, and at the Institute of Contemporary Arts deciding whether to sell our Picasso to pay for necessary repairs. But does the business ability of the preponderance of British Museum trustees equip them to decide whether to repatriate pieces of stolen art? There is only one archaeologist, no anthropologist or sociologist or historian, and no educationalist other than a former headmistress of London's most exclusive girls' school. Six of the trustees are peers of the realm, five are knights and three dames, and six are, appropriately, members or commanders of the Order of the British Empire. At least there is reasonable diversity – nine are women – but there is still an impression that the minority – a famous geneticist, a renowned criminologist who is a director of Liberty, a Scottish broadcaster, a novelist and a renowned artist – are, if not tokens, at least likely to be outspoken by all the voices from the world of the free market. The novelist, Ahdaf Soueif, resigned in July 2019 in protest against the failure of her fellow trustees to consider the ethical question over demands for repatriation and the different (but important) issue of BP sponsorship.[244] She was replaced by an international banker.

Two new trustees announced at the same time were the managing partner of McKinsey and the CEO of Associated British Foods (which owns Primark), who declares an interest in supporting the Conservative Party.

The minutes of trustees' meetings are deliberately uninformative and delayed in publication,* but it does not appear from the museum website that they have ever discussed the new French promise to return stolen cultural property or the Sarr–Savoy report. The only reference to the Parthenon Marbles is a report that a letter was sent to UNESCO and an acknowledgment received – no reference to the fact that the letter rejected mediation, or any discussion about the reasons – which raises serious questions of who wrote the letter and whether the trustees have ever debated the issue.[245] There is a brief reference to loaning 'a major sculpture' to the Hermitage, without identifying it as the Parthenon river god, or discussing the appropriateness of reaching out to Russia at that time. For a public institution, this lack of transparency, and of ethical awareness, is unacceptable.

The only interesting thing the minutes reveal, because they have to, is that the trustees meet only four times each year, often (surprisingly) at places nicer than Bloomsbury, such as Berlin, St Petersburg, and Amsterdam, where trustees and staff are taken on what must be expensive (and unnecessary) away-days. The trustees are a self-perpetuating elite of ladies and gentlemen bountiful, rewarded by status and the privilege (shared with sponsors) of holding parties in its galleries (their guests can wander among the Marbles, so long as they first down their drinks and ash their cigarettes). The real backbone of the museum is its 80,000 'friends', who pay a minimum of £64 per year for free access to its

* At time of writing – August 2019 – there have been no board minutes posted for 2019.

special exhibitions and a regular magazine, but they have no power and are allowed no say in museum policies. They should elect the trustees, in place of government or royal society nomination.

There are other ethical questions confronting museums and their trustees, most concerning acceptance of donation and sponsorship from unattractive corporations. There is no consensus: the Met and other big American museums now refuse Sackler money, and the Louvre has actually removed the name from its galleries (although France does not have an opioid crisis). The V&A, on the other hand, boasts a Sackler Courtyard, a Sackler Education Centre and a real-life Sackler as a long-term trustee. The Science Museum permits BP and Shell to fund climate change exhibitions, while the Wallace Collection allows a benefactor (a maker of fashionable shoes) not only to hand out advertising pamphlets at its door, but to have its shoes 'curated' in various galleries – displayed as if they were part of the nineteenth-century furniture. This 'product placement' undermines the museum's integrity, although not so much as its refusal to return stolen Ashanti gold. There is, incidentally, a simple solution to dubious donations – museums should accept money from oil, arms and drugs, on only one condition – that they are given anonymously. The question of returning stolen property is not quite so simple.

This is a time for humility – something the British, still yearning for the era when they ruled the world, do not do very well. Before it releases any of its share of other people's cultural heritage, the British Museum could mount an exhibition – 'The Spoils of Empire' – in which the brutality of the army, the cupidity of the East India Company and the amorality of Elgins Senior and Junior are accurately depicted. The Koh-i-Noor diamond could feature, on loan from the Tower – the heritage snatched from a small boy to please the Queen of England.

Cultural property does not have to be precious or of any monetary value if it serves to stir memories and illuminate history. In 2019, I was asked by the Department of Culture to advise on whether a small book had enough cultural significance to be stopped from leaving Britain. It was just a paperback novel – readily available at every bookstore for a few pounds. But this particular copy had been a witness to history – to the trial of D. H. Lawrence's *Lady Chatterley's Lover*. It was the judge's copy, its purple passages heavily underlined by his wife, who sat beside him on the Old Bailey bench in 1960 to make sure he instructed the jury to convict a book she thought might encourage adultery (and sex with servants). Thanks to a superb defence, the jury acquitted, and three million copies of the book were immediately sold, censorship of literature ended and, for Philip Larkin at least, sexual intercourse began ('between the end of the Chatterley Trial and the Beatles' first LP'). The book, with its unusual velvet cover made by the judge's wife so no one could see her husband carrying it, had been put on auction at Christie's and bought for £55,000 by a man from Massachusetts. Should this cultural artefact be allowed to leave the country? It was a witness to the most socially impactful trial ever held in Britain, which ended sexual inhibition and ushered in the Swinging '60s. Should it not be exhibited at the British Library, along with the letters of those declining to give evidence for the defence – Enid Blyton, for example, who explained that her husband would not allow her to testify, and Evelyn Waugh, because he thought that Lawrence was such a bad writer that all his books should be banned? The point I tried to make to the tribunal – and it agreed – was that this nation should keep the relics of its cultural heritage, even if they were witness to a history that was utterly ridiculous.

ACKNOWLEDGEMENTS

For initiating my interest in restitution, I must thank Michael Mansell, who ran the Tasmanian Aboriginal Centre and asked me to stop the National History Museum from experimenting on the remains of his ancestors, and David Hill (when head of the International Association for the Reunification of the Parthenon Marbles), who recruited me to advise the government of Greece. My thinking on the international legal implications benefited greatly from discussions with my colleagues Amal Clooney and the late Professor Norman Palmer in Athens and in London in 2015 as we prepared that advice, and I dedicate this book to Norman's memory, recalling how he fought on for the Marbles through terminal illness. More recently I have benefited from discussions with Scott Cooke, Georgia Robertson, Mark Stephens, Alex Herman and a mole at the British Museum. I owe much to my partner, Dr Simona Tutuianu, for her love, support and scholarship. I am particularly grateful to my PA, Erin Leach, who has researched and prepared the manuscript for publication, which has received (like others of my recent books) expert editing by Catherine Hill (Penguin/ Random House Australia) and Olivia Beattie and Jonathan Wadman (Biteback). I wish especially to thank John Lefas and the Lefas Family Foundation for a grant to support the distribution of the book, in the

hope it will encourage politicians and diplomats, and museum trustees and other keepers of other peoples' property in the West, to recognise that opposition to restitution amounts to a commitment, not to art, but to injustice.

NOTES

PREFACE

1. Cicero, *The Verrine Orations* (Harvard University Press, 1959), pp. 181–3.
2. See generally Margaret M. Miles, *Art as Plunder: The Ancient Origins of Debate about Cultural Property* (Cambridge University Press, 2008).
3. David Lowenthal, *The Heritage Crusade and the Spoils of History* (Cambridge University Press, 1998), Prefaces.

CHAPTER ONE: WHOSE HISTORY IS IT?

4. See *The Times*, 30 March 2019.
5. See Ashleigh Wilson, 'Aussie Uni finds final piece in puzzle sparked by theft on the Nile', *The Australian*, 10 April 2019.
6. Donations increased when the law was repealed in 1991. See Shelby White, 'Building America's Museums: The Role of the Private Collector', in Kate Fitz Gibbon (ed.), *Who Owns the Past? Cultural Policy, Cultural Property, and the Law* (Rutgers University Press, 2005), p. 174.
7. Her story is told by Anne-Marie O'Connor's *The Lady in Gold* (Knopf, 2016).
8. See John Henry Merryman, 'A Licit International Trade in Cultural Objects', in Fitz Gibbon (ed.), *Who Owns the Past?*, p. 269.
9. Elsewhere, however, Cuno acknowledges that the bronzes of Oda depict his place in history 'central to the sense of identity and continuity of the Edo as a people and a nation'. See James Cuno, *Who Owns Antiquity? Museums and the Battle over Our Ancient Heritage* (Princeton University Press, 2008), p. xxvii.
10. Felwine Sarr and Bénédicte Savoy, 'The Restitution of African Cultural Heritage: Toward a New Relational Ethics' (French Ministry of Culture, November 2018).
11. William Dalrymple and Anita Anand, *Koh-i-Noor: The History of the World's Most Infamous Diamond* (Bloomsbury, 2017), p. 277.
12. David Sanderson, 'Minister rules out return of treasures', *The Times*, 22 April 2019.
13. B. F. Cook, *The Elgin Marbles* (British Museum Press, 1984; 2nd ed., 1997), p. 5. Cook was keeper of the Greek collection and his book, kept in print by the trustees for over thirty years, still has pride of place in the museum's bookshop.
14. See now the Ancient Monuments and Archaeological Areas Act 1979 and the Planning (Listed Buildings and Conservation Areas Act) 1990. The Greek equivalent is Law 3028/2002, protecting cultural monuments.
15. Mark Bridge, 'Museum's new home for hidden treasures', *The Times*, 20 August 2019.

CHAPTER TWO: THE GLORY THAT WAS GREECE

16. John Boardman and David Finn, *The Parthenon and Its Sculptures* (University of Texas, 1985), p. 12.

17. Ibid., p. 34.
18. Ibid., p. 35.
19. Plutarch, *The Parallel Lives: Volume III* (Loeb Classical Library Edition, 1916), pp. 39–41.
20. Quoted by Nigel Spivey, *The Classical World: The Foundations of the West and the Enduring Legacy of Antiquity* (Pegasus, 2016), p. 35.
21. Cook, *The Elgin Marbles*, p. 66.
22. Boardman and Finn, *The Parthenon and Its Sculptures*, p. 34.
23. Jennifer Neils, *The Parthenon Frieze* (Cambridge University Press, 2001), pp. 35–6.
24. Ibid., p. 178.
25. Ian Jenkins, 'Moving Marbles', *British Museum Magazine*, Winter 2018.
26. Joan Breton Connelly, *The Parthenon Enigma* (Alfred A. Knopf, 2014), p. 347. Joan Breton Connelly is an American classical archaeologist and professor of classics and art history at New York University.
27. Ibid., p. 345.
28. Patrick Kidd, 'Under the eye of Pericles', *The Times*, 24 July 2019.
29. Ian Jack, *Keats and the Mirror of Art* (Oxford University Press, 1967), p. 32.

CHAPTER THREE: ELGIN: THIEF OR SAVIOUR?
30. Ian Jenkins, *The Parthenon Sculptures* (Harvard University Press, 2007), p. 9.
31. See William St Clair, *Lord Elgin and the Marbles* (Oxford University Press, 4th edn, 1998), p. 63.
32. Select Committee of the House of Commons, Minutes of Evidence, p. 129 et seq., John Merritt MP.
33. A. H. Smith, 'Lord Elgin and His Collection', *Journal of Hellenic Studies*, vol. 36 (1916), pp. 163–372.
34. St Clair, *Lord Elgin and the Marbles*, p. 87.
35. Smith, 'Lord Elgin and His Collection', pp. 339–41.
36. See paras 15–20 of Professor Vassilis Demetriades, 'Was the Removal of the Parthenon Marbles by Elgin Legal?', in Department for Digital, Culture, Media and Sport, *Cultural Property: Return and Illicit Trade*, Seventh Report, Session 1999–2000, vol. III, HC 371-III, Appendix 12, 'Memorandum of the British Committee for Restoration of the Parthenon Marbles', Annex A (printed 18 July 2000), https://publications.parliament.uk/pa/cm199900/cmselect/cmcumeds/371/37102.htm (accessed 15 July 2019).
37. Ibid., p. 201.
38. Ibid., p. 232.
39. St Clair, *Lord Elgin and the Marbles*, p. 99.
40. Jeanette Greenfield, *The Return of Cultural Treasures* (Cambridge University Press, 3rd edn, 2007), p. 61.
41. St Clair, *Lord Elgin and the Marbles*, p. 100.
42. Smith, 'Lord Elgin and His Collection', pp. 235–6.
43. B. F. Cook, for example, confidently states that 'Elgin obtained documents from the Turkish government approving all that the *Voivode* and *Disdar* had done' (Cook, *The Elgin Marbles*, p. 75). Then he admits these documents have not survived, but 'had they done so they would no doubt support Elgin's claim that everything he did had been approved by the Turkish authorities'. There is *every* doubt that they would have done so: Cook is writing at this point propaganda, not history.
44. See '200 years of the Parthenon Marbles in the British Museum: New contributions to the issue' (The Society of Friends of the Acropolis, 2016) chapter by Eleni Korka, 'New Archival Evidence', p. 56.
45. Cook, *The Elgin Marbles*, p. 73.
46. Select Committee of the House of Commons, Minutes of Evidence, p. 129 et seq., John Merritt MP.
47. Smith, 'Lord Elgin and His Collection', pp. 269–72.

48. Ibid., p. 275.

48. Ibid., p. 275.
49. See Eleni Korka, 'New Archival Evidence', p. 59. She notes that even to get this approval, Adair was forced to bribe officials in Constantinople and provide a 'gift' to the official who gave it, Elgin's friend Kaimakam, who had written the letter to the *Voivode* back in 1801.
50. See Robert Browning, 'The Parthenon in History', in Christopher Hitchens, *The Parthenon Marbles: The Case for Reunification* (Verso, 3rd edn, 2008), p. 12.
51. St Clair, *Lord Elgin and the Marbles*, pp. 94–5.
52. Ibid., p. 247.
53. Jenkins, *The Parthenon Sculptures*, p. 16.
54. Marjorie Caygill, *Treasures of the British Museum* (British Museum, 2009), p. 21.
55. Hansard, HC Deb, 23 February 1816, vol. 32, cols 824–5 (per Lord Ossulston); Hitchens, *The Parthenon Marbles*, p. 129; D. Rudenstine, 'Lord Elgin and the Ottomans: The Question of Permission', *Cardozo Law Review*, vol. 23 (2001), pp. 449ff.
56. Hitchens, *The Parthenon Marbles*, p. 131.
57. Ibid., p. 129.
58. Ibid., pp. 145–7.
59. Ibid., p. 114.
60. This included forty-four cases of the Marbles on HMS *Braakel* in February 1803 and the final shipment of five cases on HMS *Hydra* in April 1811. In March 1810, forty-eight cases were taken by a chartered ship with escort from HMS *Pylades* (ibid., pp. 113, 158, 160).
61. Ibid., p. 156.
62. See Article 4(2), *Draft Articles on the Responsibility of States for Internationally Wrongful Acts*, International Law Commission, 2001.
63. See Article 7, ibid.
64. See Select Committee of the House of Commons, Report on the Earl of Elgin's Collection of Sculpted Marbles, 1816, pp. 6–7.
65. Greenfield, *The Return of Cultural Treasures*, pp. 81–2.
66. Ibid., pp. 12, 59.

CHAPTER FOUR: IN THE KEEPING OF THE BRITISH MUSEUM
67. Byron, *Childe Harold's Pilgrimage*, Canto II, stanza 12.
68. Report of the Select Committee of the House of Commons on the Earl of Elgin's Collection of Sculptured Marbles, 1816, p. 1.
69. Elgin's examination is printed as an appendix to the report, ibid., at pp. 31–50.
70. Minutes of Evidence, ibid., pp. 140–47.
71. Hitchens, *The Parthenon Marbles*, p. 61.
72. There has been confusion about the *firman* or *firmans*. There was evidence that one, 'the first *firman*', granted access to the Acropolis for general purposes with permission to draw and model but that Elgin's workmen were refused this permission by the *Disdar*, and hence their need for a 'stronger' *firman*, which Hunt obtained in July 1801 and was the document in Italian supplied to the committee. For all purposes in this book, 'the *firman*' refers to the Italian translation of the document, the letter to Athenian officials by the Acting Grand Vizier – provided belatedly by Hunt to the select committee.
73. Greenfield, *The Return of Cultural Treasures*, p. 74.
74. Report of the Select Committee of the House of Commons on the Earl of Elgin's Collection of Sculptured Marbles, 1816, pp. 16–17.
75. St Clair, *Lord Elgin and the Marbles*, p. 255.
76. Winkworth *v.* Christie Manson & Woods Ltd [1980], Ch 496, p. 513, quoting *Cheshire & North's Private International Law* (Butterworth, 10th edn, 1979), p. 527.
77. See I. D. Jenkins, *Cleaning and Controversy: The Parthenon Sculpture 1811–1939*, Occasional Paper 146 (British Museum, 2001).
78. Letter from Cosmo Lang, Archbishop of Canterbury, to Sir John Forsdyke dated 14 December 1938,

available at: http://www.britishmuseum.org/about_us/news_and_press/statements/parthenon_sculptures/1930s_cleaning/correspondence.aspx (accessed 15 July 2019).

79. William St Clair, 'The Marbles in London', in *The Parthenon: The Repatriation of the Sculptures* (Indiana University Press, 2004), p. 131.

80. See Colin Simpson, *The Partnership: The Secret Association of Bernard Berenson and Joseph Duveen* (Bodley Head, 1987).

81. St Clair, *Lord Elgin and the Marbles*, p. 294.

82. Hahn *v.* Duveen 133 Misc. 871 (N.Y. Misc. 1929).

83. See Simpson, *The Partnership*, pp. 24–5, 164.

84. Jenkins, *Cleaning and Controversy*, p. 11.

85. Letter to *The Times*, 22 May 1939.

86. British Museum, 'Interim Report by the Board of Enquiry Appointed by the Standing Committee of the Trustees of the British Museum at a Meeting on 8th October 1938', available at http://www.britishmuseum.org/about_us/news_and_press/statements/parthenon_sculptures/1930s_cleaning/the_interim_report.aspx (accessed 15 July 2019); Jenkins, *Cleaning and Controversy*, p. 46.

87. Ian Jenkins, 'Documentary Evidence for the Cleaning of the Sculptures 1937–8', available at http://www.britishmuseum.org/about_us/news_and_press/statements/parthenon_sculptures/1930s_cleaning/documentary_evidence_1937–8.aspx (accessed 15 July 2019).

88. Simpson, *The Partnership*, p. 3.

89. Mary Beard, *The Parthenon* (Profile, 2010), pp. 167–8, 205.

90. Hitchens, *The Parthenon Marbles*.

91. Victoria Ward, 'Elgin Marbles: museum must come clean over deal with Russia, says Geoffrey Robertson QC', *Daily Telegraph*, 5 December 2014.

92. Mark Brown, 'Ancient beauty comes to British Museum', *The Guardian*, 9 January 2015.

93. Ian Jenkins, 'Moving Marbles', *British Museum Magazine*, Winter 2018, p. 84.

94. Geoffrey Robertson, 'Let's do a Brexit deal with the Parthenon Marbles', *The Guardian*, 4 April 2017.

95. Cuno, *Who Owns Antiquity?*, p. xii.

CHAPTER FIVE: THE CASE FOR RE-UNIFICATION

96. Background information to ICOMOS Draft Resolution 2014, available at http://www.marblesreunited.org.uk/2014/11/icomos-passes-resolution-to-support-unesco-mediation-for-parthenon-marbles/

97. 'The Parthenon Sculptures: Facts and Figures', British Museum website (2017), http://www.britishmuseum.org/about_us/news_and_press/statements/parthenon_sculptures/facts_and_figures.aspx (accessed 15 July 2019).

98. Theodore Vrettos, *The Elgin Affair: The Abduction of Antiquity's Greatest Treasures and the Passions It Aroused* (Arcade, 1997), pp. 208–9, citing Foreign Office, *British and Foreign State Papers*, 371/33195.

99. 1941 memorandum from the Foreign Office to the Treasury, cited in Christopher Hitchens, *The Parthenon Marbles*, p. 74; Vrettos, *The Elgin Affair*, pp. 208–9, citing Foreign Office, *British and Foreign State Papers*, 371/33195.

100. 1961 statement by head of the department at the Foreign Office, during consultations with the British ambassador in Athens. See Department for Digital, Culture, Media and Sport, *Cultural Property: Return and Illicit Trade*, Seventh Report, Session 1999–2000, vol. III, HC 371-III, Appendix 12, 'Memorandum of the British Committee for Restoration of the Parthenon Marbles', Annex C (published 18 July 2000), https://publications.parliament.uk/pa/cm199900/cmselect/cmcumeds/371/37102.htm (accessed 15 July 2019).

101. *Ephor* ['director' or 'conservator'] of antiquities' designates the official appointed to guide Greek archaeological policy, a post held by the German-educated Ludwig Ross from 1833 to 1836. See S. L. Dyson, *In Pursuit of Ancient Pasts: A History of Classical Archaeology in the Nineteenth and Twentieth Centuries* (Yale University Press, 2006), pp. 73–4.

102. K. S. Pittakys, *L'Ancienne Athènes* (Athens, 1835), p. 379: '*Je crois que dans l'état d'indépendance où nous entrons, nous aurons le droit de réclamer auprès de la nation Anglaise les chefs d'œuvres de nos ancêtres, pour le remettre à la place que le divin Phidias leur avait choisie*' (unofficial translation).

103. Chiara Mannoni, 'Restoring, De-restoring, Reinventing Antiquity: How the Classical Profile of the Acropolis of Athens Was Reshaped in the Last Two Centuries', Art Association of Australia and New Zealand conference, 5–7 December 2014, available at: https://www.academia.edu/9937090/Restoring_de-restoring_reinventing_Antiquity._How_the_ classical_profile_of_ the_Acropolis_of_Athens_was_reshaped_in_the_last_two_centuries (accessed 15 July 2019).

104. Special Decree on the Creation and Competence of the Secretariat for Ecclesiastical Affairs and Public Education of 3/15 April 1833; see General Archives of the State, *Acropolis von Athen* (Alitheia, 2014), p. 19.

105. Letter from Greek minister for ecclesiastical affairs and public education, 6/18 July 1836, in General Archives of the State, *Acropolis von Athen*, p. 139.

106. General Archives of the State, *Acropolis von Athen*, p. 121.

107. Frederic Harrison, 'Give back the Elgin Marbles', *Nineteenth Century*, December 1890, pp. 980–87. This provoked a reply by the magazine's founder, Sir James Knowles: 'The joke about the Elgin Marbles', *Nineteenth Century*, March 1891, pp. 495–506.

108. Hitchens, *The Parthenon Marbles*, p. 74; Vrettos, *The Elgin Affair*, pp. 208–9, citing Foreign Office, *British and Foreign State Papers*, 371/33195.

109. Vrettos, *The Elgin Affair*, pp. 206–7, citing a memorandum from the British Museum dated 31 December 1940 received by Mr R. James Bowker on 8 January 1941.

110. See Department for Digital, Culture, Media and Sport, *Cultural Property*, Appendix 12, Annex C.

111. Hansard, HL Deb, 27 October 1983, vol. 444, col. 404.

112. See Department for Digital, Culture, Media and Sport, *Cultural Property*, Appendix 12.

113. Speech at the Oxford Union, June 1986, available at http://www.parthenon.newmentor.net/speech.htm (accessed 15 July 2019).

114. Recommendation No. 55, adopted by the conference, in UNESCO, *Final Report of the World Conference on Cultural Policies, Mexico City, 28 July–6 August 1982*, p. 96.

115. Hansard, HC Deb, 7 March 1983, vol. 38, col. 559.

116. 'Greece is pressing Britain for return of antiquities', *New York Times*, 21 November 1982.

117. See statement of Foreign Office, 12 October 1983; aide-memoire by UK government, 10 April 1984.

118. UNESCO Intergovernmental Committee for Promoting the Return of Cultural Property to Its Countries of Origin or Its Restitution in Case of Illicit Appropriation, Fourth Session (Athens and Delphi, Greece, 2–5 April 1985), 'Report by the Unesco Secretariat on Measures Taken to Implement the Recommendations of the Third Session of the Intergovernmental Committee for Promoting the Return of Cultural Property to Its Countries of Origin or Its Restitution in Case of Illicit Appropriation (9–12 May 1983)', UN Doc CLT-85/CONF.202/2, 15 February 1985, para. 4; Greenfield, *The Return of Cultural Treasures*, p. 70.

119. UNESCO General Conference, 24th Session, Paris 1987, 'Report by the Intergovernmental Committee for Promoting the Return of Cultural Property to Its Countries of Origin or Its Restitution in Case of Illicit Appropriation', 29 June 1987, UN Doc 24 C/94, para. 7; 'Final Report by the Intergovernmental Committee for Promoting the Return of Cultural Property to its Countries of Origin or its Restitution in Case of Illicit Appropriation on its Activities (1990–1991)', UN Doc 26 C/92, Annex, p. 11.

120. MORI, 'Public and MPs would return the Elgin Marbles!', 25 September 1998, available at https://www.ipsos-mori.com/researchpublications/researcharchive/2001/Public-and-MPs-would-return-the-Elgin-Marbles.aspx (accessed 15 July 2019).

121. This includes a 1998 poll by UK Channel 4, in which 92.5 per cent voted for return, a 2000 CNN poll in which 82 per cent voted for return, a 2000 survey among MPs conducted by *The Economist* indicating that 66 per cent of those interviewed would vote in favour of the return of the Marbles to Greece if the issue were put to the House of Commons, a 2002 MORI poll in which 40 per cent voted for and only 16 per cent against, a 2009 *Guardian* poll in which

95 per cent voted for return, a 2012 IQ2 debate where 75 per cent voted in favour of return, a 2012 poll run by the *Journal of the Museums Association* in which 73 per cent voted for return, and a 2014 *Guardian* poll in which 88 per cent voted for return. See also 'Stephen Fry's Parthenon Marbles plea backed in debate vote', BBC News, 11 June 2012, http://www.bbc.com/news/uk-18373312 (accessed 15 July 2019); Rebecca Atkinson, 'Should the Parthenon Marbles be Returned? Have your say', *Museums Journal*, 31 May 2012, http://www.museumsassociation.org/museums-journal/news/01062012-should-parthenon-marbles-be-returned-to-greece (accessed 15 July 2019); 'Is George Clooney correct? Should Britain return the Parthenon marbles?', *The Guardian*, 12 February 2014, http://www.theguardian.com/commentisfree/poll/2014/feb/12/george-clooney-elgin-marbles-monument-men-poll (accessed 15 July 2019).

122. All relevant documentation from the procedure before the committee is available at http://www.publications.parliament.uk/pa/cm199900/cmselect/cmcumeds/371/0060501.htm (accessed 15 July 2019).

123. Department for Digital, Culture, Media and Sport, *Cultural Property*, para. 199.

124. UNESCO Intergovernmental Committee for Promoting the Return of Cultural Property to Its Countries of Origin or Its Restitution in Case of Illicit Appropriation (hereafter UNESCO IC), Third Session, Istanbul, Turkey, 9–12 May 1983, 'Final Report', 10 November 1983, UN Doc CLT-83/CONF.216/8; UNESCO IC, Sixth Session, Paris, 24–27 April 1989, 'Final Report', 16 June 1989, UN Doc 25 C/91; 'Final Report by the Intergovernmental Committee for Promoting the Return of Cultural Property to Its Countries of Origin or Its Restitution in Case of Illicit Appropriation on Its Activities (1990–1991)', UN Doc 26 C/92, Annex, p. 11; 'Report by the Intergovernmental Committee for Promoting the Return of Cultural Property to Its Countries of Origin or Its Restitution in Case of Illicit Appropriation on Its Activities (1996–1997)', UN Doc 29 C/REP.12, p. 11, Annex 1; 'Report by the Intergovernmental Committee for Promoting the Return of Cultural Property to Its Countries of Origin or Its Restitution in Case of Illicit Appropriation on Its Activities (1998–1999)', UN Doc 30 C/REP.14, Annex 1: Recommendation No. 1; 2002–2003: 'Report on the Activities (2002–2003) and the Twelfth Session of the Intergovernmental Committee for Promoting the Return of Cultural Property to its Countries of Origin or its Restitution in Case of Illicit Appropriation', 4 July 2003, UN Doc 32 C/REP/15, Annex 3; 'Report on the Activities (2004–2005) and the Thirteenth Session of the Intergovernmental Committee for Promoting the Return of Cultural Property to Its Countries of Origin or Its Restitution in Case of Illicit Appropriation', 23 August 2005, UN Doc 33 C/REP/15, Annex.

125. 'Report on the 2006–2007 Activities of the Intergovernmental Committee for Promoting the Return of Cultural Property to its Countries of Origin or its Restitution in Case of Illicit Appropriation, 28 August 2007, UN Doc 34 C/REP/14, p. 3; 'Report on the 2008–2009 Activities and the Fifteenth Session of the Intergovernmental Committee for Promoting the Return of Cultural Property to its Countries of Origin or its Restitution in Case of Illicit Appropriation', 24 August 2009, UN Doc 35 C/REP/14, p. 7, Annex; UNESCO IC, Sixteenth Session, Paris, 21–23 September 2010, Recommendations, UN Doc CLT-2010/CONF.203/COM.16/5, p. 1; UNESCO IC, Seventeenth Session, Paris, 30 June–1 July 2011, Recommendations, UN Doc CLT-2011/CONF.208/COM.17/5, pp. 1–2; UNESCO IC, Eighteenth Session, Paris, 22 June 2012, Recommendations and Decision, UN Doc ICPRCP/12/18.COM/6, p. 3; UNESCO IC, Nineteenth Session, Paris, 1–2 October 2014, Recommendations and Decision, UN Doc ICPRCP/14/19.COM/8, p. 5.

126. See UNESCO General Conference, 24th Session, Paris 1987, 'Report by the Intergovernmental Committee for Promoting the Return of Cultural Property to Its Countries of Origin or Its Restitution in Case of Illicit Appropriation', 29 June 1987, UN Doc 24 C/94, para. 7.

127. Letter from Ed Vaizey MP (Department for Digital, Culture, Media and Sport) and Rt Hon. David Lidington MP (Foreign and Commonwealth Office) dated 26 March 2015, available at https://www.britishmuseum.org/pdf/150326_Parthenon_Sculptures_in_the_British_Museum_DCMS_and_FCO.pdf (accessed 15 July 2019).

128. See for example Civil Procedure Rule 26.4 and Norman Palmer, 'Waging and Engaging: Reflections on the Mediation of Art and Antiquity Claims', in *Litigation in Cultural Property: Papers from the International Symposium of November 11th 2011 at Geneva* (Art-Law Centre, University of Geneva, 2012), pp. 91ff.

129. The view here expressed – that Greece could not succeed in any claim for return of the Marbles in an English court – is that of a positivist-minded public lawyer, brought up to believe that if Parliament says something, plainly and unequivocally, in a statute, that something is the law of the land. I confess to having had friendly debates with my late colleague Norman Palmer, a more imaginative equity lawyer, who thought it arguable (although the argument would be unlikely to succeed) that Elgin had no more than a 'bald possessory title' (acquired unlawfully) or a 'temporarily bailment' which could not be transformed, even by statute, into a good title of ownership for the trustees.

130. See for example Kuwait Airways Corporation *v.* Iraqi Airways Company [2002] 2 AC 1075, at 114 per Lord Steyn.

131. Ibid.

132. Ian Jenkins, *The Parthenon Sculptures in the British Museum* (British Museum Press, 2007), p. 18.

133. Ibid., pp. 11–12.

134. See also William St Clair, 'Imperial Appropriations of the Parthenon', in John Henry Merryman (ed.), *Imperialism, Art and Restitution* (Cambridge University Press, 2006), pp. 94–5.

135. Cuno, *Who Owns Antiquity?*, p. xii.

136. Frederic Harrison, 'Give back the Elgin Marbles', *Nineteenth Century*, December 1890, pp. 980–87.

137. Department for Digital, Culture, Media and Sport, *Cultural Property*, Appendix 12, Annex C.

138. Smith, 'Lord Elgin and His Collection', pp. 193, 195–6.

139. Ibid., p. 225.

140. Made in the propaganda leaflet 'The Parthenon Sculptures', published by the British Museum and distributed to tourists in the Duveen Gallery.

141. HM Attorney General *v.* Trustees of the British Museum 2005 EWHC 1089 (Ch).

142. Section 5 of the Act does give the trustees power to dispose of any object which is 'unfit to be retained in the collections of the museum'. This obviously relates to indecent objects or those subsequently proved to be fakes, but it could surely apply to objects seized by the Gestapo: any museum would be thought morally unfit if it failed to return them. Curiously, this argument was not made on behalf of the trustees, even though it could be bolstered by the rights against expropriation of property, and the right to live free of race discrimination, which are found in the European Convention of Human Rights. Hence the extent of the 'unfitness' exception remains unclear, although it could be advanced by the trustees if they wished to de-access cultural property stolen in the course of war crimes and in particular the Ethiopian sacred *tabots* taken in the raid on Maqdala, which the British Museum accepts must not be exhibited (even to its staff) because of religious taboos (see pp. 190–91).

143. Miles, *Art as Plunder*, p. 359.

144. It was demolished by other legal scholars. See review of David Rudenstine, 'The Legality of Elgin's Taking', *International Journal of Cultural Property*, vol. 8, no. 1 (1999), p. 356. See also Greenfield, *The Return of Cultural Treasures*, pp. 75–82.

145. John Henry Merryman, 'Thinking about the Elgin Marbles', *Michigan Law Review*, vol. 83, no. 8 (1985), p. 1882.

146. Ibid., p. 1901.

147. See International Court of Justice, case concerning certain phosphate lands in Nauru, ICJR (1992), pp. 253–4, para. 32.

148. Merryman, 'Thinking about the Elgin Marbles', p. 1901.

149. Ibid., p. 1899.

150. UNESCO Committee of Experts to Study the Question of the Restitution of Works of Art, Venice, 29 March–2 April 1976, 'Final Report', 21 April 1976, UN Doc SHC-76/CONF.615/5.5.

151. See International Law Association, Berlin Conference 2004, Report of Cultural Heritage Law Committee, p. 7.

152. See Greece v. United Kingdom [1952] ICJ 1 (the 'Ambatielos case'), where the UK claim of delay was rejected.

153. Marc Fehlmann, 'As Greek as It Gets: British Attempts to Recreate the Parthenon', *Rethinking History*, vol. 11, no. 3 (2007), p. 364.

154. Jack, *Keats and the Mirror of Art*, p. 219.

155. Ibid., p. 370.

156. See Izidor Janžekovic, 'A Series of (Un)Fortunate Events: The Elgin Marbles', *Journal of Art Crime*, Fall 2016, pp. 70–72.

157. Ibid., p. 56.

158. Neil MacGregor, BBC interview, 1 November 2002.

CHAPTER SIX: INTERNATIONAL LAW TO THE RESCUE?

159. See Geoffrey Robertson, *Crimes Against Humanity: The Struggle for Global Justice* (Penguin, 4th edn, 2012), p. 108.

160. These 'sources' are stipulated in Section 38(1) of the Statute of the International Court of Justice.

161. See Article 96(1) of the UN Charter, which gives the General Assembly and the Security Council the right to request an advisory opinion while 96(2) extends the right to organisations and specialised agencies (like UNESCO) in respect of 'legal questions arising within the scope of their centuries'. UNESCO has only sought one opinion, in relation to complaints against itself upheld by an administrative tribunal.

162. IICESC, Article 15(1).

163. Commonwealth of Australia v. Tasmania (1963) HCA 22.

164. Article 1.

165. Beyeler v. Italy, Application 33202/96 Judgment Strasbourg, 2000, paras 112–13.

166. As at July 2019.

167. 'Operational Guidelines for the Implementation of the Convention on the Means of Prohibiting and Preventing the Illicit Import, Export and Transfer of Ownership of Cultural Property' (UNESCO, Paris, 1970), para. 103.

168. Victoria Stapley-Brown and Nancy Kenney, 'Met hands over an Egyptian coffin that it says was looted', *Art Newspaper*, 15 February 2019.

169. 'Germany to Return Portuguese cross to Namibia', *Art Newspaper*, June 2019, p. 11.

170. See Greenfield, *The Return of Cultural Treasures*, pp. 12–42.

171. Case concerning the Temple of Preah Vihear (Cambodia v. Thailand) [1962] ICJ 6, at 336.

172. Webb v. Ireland [1988] IR 353.

173. Iran v. Barakat Galleries Ltd [2009] QB 22, [2007] EWCA Civ 1374.

174. Autocephalous Greek-Orthodox Church of Cyprus v. Goldberg 917 F.2d 278, 1990 U.S. App. Decision.

175. The Mayagna (Sumo) Awas Tingni Community v. Nicaragua, judgment 31 August 2001 dealing with rights to property (Article 21, ACHR).

176. Moiwana v. Suriname, judgment 15 June 2005, para. 131.

177. Marina Lostal, *International Cultural Heritage Law in Armed Conflict: Case Studies of Syria, Libya, Mali, the Invasion of Iraq, and the Buddhas of Bamiyan* (Cambridge University Press, 2017), p. 21.

178. Ibid., pp. 13–14.

179. Ibid., p. 21.

180. The *New York Times* reported on 16 May 2019 that ninety Facebook groups were involved in trafficking antiquities offered for sale after being looted by ISIS and other fundamentalist groups.

181. *The Marquis de Somerueles* 1813 Stewarts' Vice Admiralty Reports 482.

182. Note to Allied Ministers, 11 September 1815.

183. Lostal, *International Cultural Heritage Law*, pp. 22–3.

184. City of Gotha and Federal Republic of Germany *v.* Sotheby's and Cobert Finance SA (1998) 1 WLR 114.
185. Matter of Flamenbaum (2013) 95 AD 3d 1318.
186. UK Declaration, 31 December 2014.
187. Liechtenstein tried to get back artworks confiscated by Czech army officers in 1945, but was non-suited by the fact that their agreement to submit to ICJ adjudication was limited to disputes arising after 1980.
188. ICJ Charter, Articles 65 and 96.
189. Syllogos ton Athinaion *v.* UK, Application no. 48259/15, decision of Committee of First Section 31 May 2016.
190. Most ECtHR cases are brought by individuals and bound by strict admissibility rules, which are relaxed for inter-state cases. These are infrequent but important, e.g. Ireland's case against the UK established the army's guilt of subjecting detainees to ill-treatment and the case of Cyprus against Turkey upheld the right to compensation for the invasion.
191. For an analysis of the way to bring a case involving the Marbles under the European Convention of Human Rights, see Geoffrey Robertson, Norman Palmer and Amal Clooney, *The Case for the Return of the Parthenon Sculptures* (2015), Chapter 6.
192. Henry Goodwin, 'Give us our birdman back, Jamaica tells the British Museum', *Daily Mail*, 8 August 2019.

CHAPTER SEVEN: MUSEUMS OF BLOOD

193. See '9/11 Families Protest WTC Freedom Museum', Associated Press, 21 June 2005, and Richard Tofel, 'A Fitting Place at Ground Zero', *Wall Street Journal*, 9 June 2005, p. 16.
194. Neil Brodie, 'Problematizing the Encyclopedic Museum: the Benin Bronzes and Ivories in Historical Context', in Bonnie Effros and Guolong Lai (eds), *Unmasking Ideologies: Vocabulary, Symbols and Legacy* (Cotsen Institute of Archaeology Press, 2018), p. 64.
195. Ibid., p. 65.
196. Sarr and Savoy, 'The Restitution of African Cultural Heritage: Toward a New Relational Ethics', p. 65.
197. See Philip A. Igbafe, 'The Fall of Benin: A Reassessment', *Journal of African History*, vol. 11, no. 3 (1970), p. 385.
198. See generally John Ray, *The Rosetta Stone and the Rebirth of Ancient Egypt* (Profile, 2007).
199. Sharon Waxman, *Loot: The Battle over the Stolen Treasures of the Ancient World* (Times, 2008), p. 53.
200. See Ministerial Order No. 52 of 8 December 1912, Concerning the Regulation of Excavations, Articles 14 and 15.
201. See Kurt G. Siehr, 'The Beautiful One Has Come – to Return', in Merryman (ed.), *Imperialism, Art and Restitution*, p. 118.
202. Waxman, *Loot*, p. 57.
203. Ibid.
204. See Stephen K. Urice, 'The Beautiful One Has Come – to Stay', in Merryman (ed.), *Imperialism, Art and Restitution*, p. 165.
205. See Brian Fagan, *The Rape of the Nile: Tomb Robbers, Tourists, and Archaeologists in Egypt* (Scribner, 1975); Peter France, *The Rape of Egypt: How the Europeans Stripped Egypt of Its Heritage* (Barrie & Jenkins, 1991).
206. See National Army Museum, 'Abyssinia Expedition' and 'Give back our stolen prince, Your Majesty', *Mail on Sunday*, 12 May 2019.
207. Tristram Hunt, 'Should Museums return their colonial artefacts?', *The Guardian*, 29 June 2019.
208. Daniel Trilling, 'Britain is hoarding a treasure that no-one is allowed to see', *The Atlantic*, 9 July 2019.
209. Professor Richard Pankhurst, 'The loot from Magdala, 1868: some historical ideas of repatriation',

Tigrai Online, 11 May 2009, available at http://www.tigraionline.com/loot_from_maqdala.html (accessed 17 July 2019).

210. Ibid.

211. See Alexander Herman, 'British Museum must recognise its own powers in matters of restitution', *Art Newspaper*, June 2019.

212. The museum has always presented the shield as the one which was dropped and collected by Cook and brought back on the *Endeavour*. However, perhaps because of recent demands for repatriation, it is now not quite so sure. The current label says that 'it is suggested, but not confirmed', that this is the dropped shield. The museum has always 'suggested' that it is and should know its provenance.

213. Quoted by Paul Daley, 'The Gweagal Shield and the fight to change the British Museum's attitude to seized artefacts', *Guardian Australia*, 25 September 2016.

214. See the compelling argument put forward by Elizabeth Pearson in 'Old Wounds and New Endeavours: The case for repatriating the Gweagal Shield from the British Museum', *Art, Antiquity and Law*, vol. XXI, Issue 3 (October 2016).

215. Sir Joseph Banks, also on the *Endeavour*, thought the hole was caused by 'a single pointed lance'.

216. Paul Daley, 'Preservation or plunder? The battle over the British Museum's Indigenous Australia show', *Guardian Australia*, 9 April 2015.

217. See Dalrymple and Anand, *Koh-i-Noor*, p. 12.

218. Ibid., pp. 243–7.

219. Ibid., p. 277.

220. See Lynne Ann Ellsworth Larsen, 'The Royal Palace of Dahomey: Symbol of a transforming nation', Thesis 2014 at University of Iowa.

221. Julia Kelly, 'Dahomey! Dahomey! The reception of Dahomean art in France in the late 19th and early 20th centuries', *Journal of Art Historiography*, vol. 12 (June 2015).

222. Zachary Small, 'Benin Receives $22.5 Million Loan From France for New Museum', Hyperallergic, 17 July 2019.

223. Chris Bowlby, 'The Palace of Shame that makes China Angry', BBC News magazine, 2 February 2015.

224. Erik Ringanar, *Liberal Barbarism: The European destruction of the Palace of the Emperor of China* (Palgrave Macmillan, 2013), p. 4.

225. Laurie Chen, 'Ancient Bronze vessel looted from Old Summer Palace in 1860 Returned to China', *South China Morning Post*, 12 December 2018.

226. Zama Mdoda, 'The Chinese Hared Thieves to take back looted art from European Museums', Afropunk, 24 August 2018.

227. For an application of international law to the question of the return of art looted from China, see Hui Sarah Zhong, 'The Return of Chinese Treasures taken from the Second Opium War, 1856–60,' doctoral thesis, University of Queensland.

228. Peter Neville-Henry, 'China's "stolen" cultural relics', *South China Morning Post* magazine, 9 June 2017.

229. Noah Charney, *The Museum of Lost Art* (Phaidon, 2018), p. 274.

230. See Brendan Cormier (ed.), 'Copy Culture: Sharing in the Age of Digital Reproduction' (V&A Publishing, 2018).

CHAPTER EIGHT: TOWARDS JUSTICE

231. By the International Criminal Tribunal for Former Yugoslavia (ICTY); see Jokic – ICTY sentencing judgment, 18 March 2004, para 518.

232. Prosecutor *v.* Ahmad Al Faqi Al Mahdi, ICC, 27 September 2016.

233. See Attorney General of New Zealand *v.* Ortiz (1983) 2 All ER 93 and discussion by Greenfield, *The Return of Cultural Treasures*, pp. 142–8.

234. Arthur Tomkins, *Plundering Beauty: A History of Art Crime During War* (Lund Humphries, 2018), pp. 58–62.

235. E. de Vattel (translated by C. G. Fenwick), 'The Law of Nations', as cited in Miles, *Art as Plunder*, p. 301.

236. Article 36.

237. See Tomkins, *Plundering Beauty*, pp. 89–90.

238. Beyeler *v.* Italy (2000), paras 112–13.

239. See Lyndel V. Prott, 'Strengths and Weaknesses of the 1970 Convention: An Evaluation Forty Years after Its Adoption', UNESCO, March 2011, available at https://unesdoc.unesco.org/ ark:/48223/pf0000191880.locale=en (accessed 18 July 2019).

240. See Colin Renfrew, *Loot, Legitimacy and Ownership: The Ethical Crisis in Archaeology* (Duckworth, 2000).

241. R *v.* Heller (1984) 51 AR 73 (can Alta, CA); see also Katarzyna Januszkiewicz, 'Retroactivity in the 1970 UNESCO Convention: Cases of the United States and Australia', *Brooklyn Journal of International Law*, vol. 41, no. 1 (2015).

242. Fifth Meeting of State Parties, 20 & 21 May 2019, Item 6 of the Provisional Agenda: Report of the Secretariat, UN Doc C70/19/5.MSP/6.

CONCLUSION

243. Department for Digital, Culture, Media and Sport website, available at https://www.gov.uk/ government/organisations/department-for-digital-culture-media-sport (accessed 1 June 2019).

244. 'British Museum trustee resigns over BP sponsorship and repatriation', BBC News, 16 July 2019; Ahdaf Soueif, 'On resigning from the British Museum's board of trustees', London Review of Books Blog, 15 July 2019.

245. See Minutes for July 2015 and March 2015. The minutes of 2019 meetings had not been posted by August of that year.

INDEX